SPICES IN THE
MELTING POT

Life Stories of Exceptional
South Asian Immigrant Women

PADMA SHANDAS

SPICES IN THE MELTING POT

Life Stories of Exceptional South Asian Immigrant Women

PADMA SHANDAS

ORANGE TREE PUBLISHING

Orange Tree Publishing

P.O. Box 3, Newark, CA 94560

http://www.orangetreepublishing.com

First Edition 2005

Library of Congress Control Number: 2004098211
Shandas, Padma

Spices in the Melting Pot: Life Stories of Exceptional South Asian Immigrant Women / Padma Shandas.—1st Edition.
Includes bibliography and index.

ISBN 0-9761742-0-0

Shandas, Padma. 2. Immigrant Women—United States. 3. South Asian Immigrant Women—Lives—United States. 4. South Asian Women—Lives—South Asia. 5. Cross-cultural studies—United States. 6. Feminist queries—United States. I. Title.

Manufactured in the United States of America
Cover Design: Cathi Stevenson

In loving memory of

my grandmother

and

our storytelling evenings.

ACKNOWLEDGMENTS

Sitting down to write the acknowledgment for this book is a long-awaited privilege. The idea for this book came to me many years ago as a vague concept. The only clear thought I had at the time was that I would be interviewing several South Asian women. But it took a while before I began to play with the idea as a possibility and formulate certain criteria for the women I would include in the book. The first person I discussed the project with was Achamma Chandersekaran, whom I had known as a dynamic symposium leader with strong social and political views on immigrant life. She enthusiastically agreed it would be a worthwhile effort. She was my first interviewee.

So I begin by acknowledging Achamma for her support and willingness to be a participant. She pointed me toward another woman, who happily agreed to be part of the project, and my three-year exploration had begun.

This project would not have become a reality without the keen interest, excitement, and cooperation of the many women I interviewed. I gratefully acknowledge their cheerful generosity in taking time from their busy schedules, welcoming me into their homes and offices, and sharing with me their wonderful spirit.

I am grateful to the many men and women who helped me find some of the interviewees.

My sincere thanks to all those who advised me in various ways. To Ginny NiCarthy and Roshni Rustomji-Kerns, for their interest, suggestions, and generous feedback. To Barbara McGowran, for her insightful editing. To my friends, for their support and curiosity about the project. To numerous others, for sharing their interest in reading the book.

Finally, to some, I cannot offer enough thanks for their invaluable support. To my family—Robin, Vivek, Sarah, Rujuta, and MK—whom I constantly hassled for feedback, suggestions, comments, critiques, and encouragement. And to my grandchildren, Arjun and Sarita, for their smiles that erased all my cares.

For most of history,

Anonymous was a woman.

— Virginia Woolf —

CONTENTS

PREFACE

My history teacher in elementary school was known for his ingenious teaching style and sharp sense of humor. Some days he arrived with his wit honed to a fine point. He especially loved to poke fun at the European invaders who first landed in the Malabar Coast of our Indian Subcontinent as traders. In postindependent India they were easy targets.

"Who was the first European trader to come to India?" one day he asked us quite charmingly to begin with.

"Vasco da Gama," a student replied.

"When did he come? Was it last week?"

"No! On May 20, 1498!" we shouted in unison.

"Why did he come? Was he a tourist? Did he have relatives living here?"

"No! He came to buy black pepper for the king of Portugal!" we clamored, our excitement rising.

He nodded his head slowly.

"And red pepper too!" we screamed.

Our teacher then scratched his chin, looked outside the classroom through the barred window, and smiled. We craned our necks to follow his gaze. There, by the roadside, lay several palm-leaf mats blanketed with black pepper and red pepper spread out to dry in the sun. Several bamboo baskets filled with more pepper stood beside the mats. Women came out from the nearby huts to distribute the pepper more

evenly with their feet. They would sell the dried pepper in the market for a few rupees.

"Poor king! He had a hundred ships and two hundred thousand army men. He had gold and jewels. But how sad, he couldn't eat his meal because it was so . . . so . . ." the teacher held his throat, acting as if he was going to vomit.

"Tasteless . . . and bad," we helped him. Then he described how the king wanted more and more pepper, because the royal tongue could no longer tolerate the bland food of his country, and finally decided to settle his Portuguese men in India to ensure that the supply line continued forever. The men built one church among the pepper vines and then another, then more missionaries and soldiers came, until eventually parts of the Indian Subcontinent belonged to the Portuguese empire.

The teacher gave us a lot to think about before we left for home that afternoon. The next day he followed a similar format, asking us about the Dutch traders who arrived later looking for cinnamon. The Dutch king had lost his appetite for the same buffalo-rump stew his cooks prepared every day. We also learned about the Danes, the French, and the British, all seeking to enhance their taste buds with either cumin or cardamom. They all ended up establishing territories in the subcontinent so their kings and queens could feast on something scrumptious. Finally, they fought with each other for a few cumin seeds and killed many soldiers. The winners shared the land among themselves. They made the pepper farmers and merchants their slaves and forced them to work in the tropical sun without hats or turbans.

Colonialists put chains around our legs, and then they ruled us. History class made us sad. But it made us happy, too, because we had something precious that most people were willing to kill to have.

The history teacher made us feel rich. And we felt magnanimous and proud because our ancestors were ready to share their wealth with those foreigners who, in a way, were starving. We learned about South Asian hospitality.

Giving—to anyone in need—is a South Asian legacy.

The Indian Subcontinent, also known as South Asia, is that part of the globe east of the Middle East, south of Russia, and west of China and Southeast Asia. It is a peninsula embraced by three oceans in the south: the Arabian Sea, the Indian Ocean, and the Bay of Bengal. The countries generally considered part of the South Asian region are Afghanistan, Pakistan, India, Nepal, Bhutan, Bangladesh, and Sri Lanka.

This book is about twenty-one South Asian immigrant women who were born and raised in India, Pakistan, Bangladesh, and Sri Lanka and have made their homes in the United States during the last fifty years. They live in different parts of the U.S., spanning from Washington, D.C., to Los Angeles, from Chicago to Tucson.

When immigrants settle in a new country, the native society feels the impact of their presence but has little understanding of who they are. Like their native-born neighbors, immigrants want to be remembered for the lives they lived, for the help they offered, for the positive changes they brought to the world, for the laughter they evoked, for the tears they wiped.

It is easier to leave our legacy behind when multiple generations have flourished from the same roots, when we live, grow, and die in the same soil our great-great-grandparents tilled and fertilized. Our marks have deeper contours when we live in the same geographical areas as our ancestors, when our neighboring communities taste the fruits of our labor through our children and grandchildren. The fragrances of our histories linger in the air.

But when we cross continental boundaries, move across oceans, and live on foreign soils, we simply and unceremoniously give up the advantage of generational memory. We lose the historical continuity, and we break our cultural integrity. Our destiny is to float like dry leaves across a new landscape, unanchored, fluttering at the mercy of an unfamiliar wind. We are burdened with the awesome task of laying the cornerstone of a brand-new cultural edifice. But we have no blueprints to follow, no architect to advise us. We begin our challenge one nail at a time. The tools we have are the fading memories of an ancient lifestyle and civilization that become baffling in a foreign context.

As a South Asian immigrant woman, I know how hard it is for a woman to make the transition to a changed lifestyle. A woman's burdens feel heavier. The effort needed for the unlearning and relearning processes prove tremendous. A thousand questions leap at her from all directions. An adult woman from a traditional background—by traditional I mean a few thousand years old, no less—begins to build her identity afresh. Can she do that without losing track of her trusted self? Should she abandon her past and forge ahead to the future? What if, in the process, she sacrifices her original sparkle? Or worse, she ends up being a fake? The result could be eerie.

Sandra Bullock, in the movie *Miss Congeniality*, transforms herself from a tough FBI agent to a coy beauty pageant contestant. She has to alter her talk, her walk, the way she eats pork chops, and even her laugh. She has to thrash her deep beliefs into pulp. We gasp when she leaps down the beauty pageant stage in all her finery to catch a potential thug among the audience, forgetting her new persona. Although she has Michael Caine as her coach, she stumbles over and over again. Exasperated, she confesses to her male colleague, "I am lost! I can't do this!"

An immigrant woman is likewise left rudderless and forced to confess to herself, even more dramatically, "I am doomed! I don't know who I am!" She constantly discards parts of her heirloom and redesigns her new self every day—without the help of a coach. To do that while making a living and keeping a house, feeding a family, helping children with homework, taking them to swim lessons, shopping and doing aerobics—it's no cakewalk. During the last quarter of a century of my life here in the U.S., I have been in Sandra Bullock's shoes a few times.

Then I met some South Asian immigrant women who seem to have everything together, their sense of self transformed but intact, who do wonderful things for the community and the world, who stand tall and proud of who they are. I found that they have accomplished amazing things, growing from their rootless beginnings to establish permanent structures of friendships and compassion, knowledge and entrepreneurship, art and beauty. They have achieved it without losing themselves in the process. They have done it in just one generation.

I chose twenty-one inspiring stories of these modern immigrant women for this book. For my interviews I met with them, often several times, either in their homes or offices or at other convenient places. The two women I could not meet with in person I interviewed over the telephone. I spent three years and three months conducting the interviews.

These women share much aside from their South Asian ancestry. They are astonishingly energetic individuals who don't suffer from loneliness or boredom. They have places to go, people to meet, missions to accomplish, and communities to love. Fostering a strong sense of individuality, they cannot be reduced to thumbnail stereotypes.

These are not stories of the rich and famous, although some of them are actually wealthy and well known in their fields. The first chapter

in the book gives a glimpse of America through the fresh eyes of two immigrant women. In each of the next six chapters, the stories of modern immigrant women focus on a common theme. Each of these chapters concludes with a section titled "From My Perspective," in which I attempt to connect the thematic stories with the thread of my own experience. Finally, in Chapter 8 I offer some final thoughts on the role of women—and immigrant women in particular—in American society.

Welcome to the homes and workplaces of these inspiring, exceptional, South Asian American women who have made their adopted country richer, and our lives more flavorful.

Chapter 1

At the Feet of a Man

During the heady, intoxicating first year of my American life, I felt like a new bride entering her self-righteous husband's home after an arranged marriage. Having left my habitual surroundings behind, abandoning all familiar cultural symbols like treasures sunk in a deep sea, never to be recovered, every experience was exciting and forbidding at the same time. Love-struck and nervous, I was ready to fulfill the rest of my dharma in every way I could in my new home.

My dharma—my deep-rooted awareness of a woman's domestic, relationship-based role—was born thousands of years ago. Cascading down the generations, it has consumed me as more than just duty. My dharma is my acceptance of my being, my place on earth, my sacred moral pledge based on my nature as a woman.

"It is the sun's dharma to be hot and glowing," our teacher in India used to explain. "It is the dharma of the flower to bloom." There is a dharma for everyone to follow; running away from it only causes misery.

A woman's dharma, germinating from her life-giving instincts, is to care for and nurture those close to her—husband, children, mother, father, brother, sister, the in-laws, an ever-widening circle. To fulfill her sacred duty to create and sustain life, a woman must marry and bear children. I had already fulfilled that part of my dharma. I was a loving wife and the devoted mother of two children when I entered this land the Native Americans worshipped as their sacred Mother Earth.

Fairly certain of how to fulfill my dharma while on my native ground, I now had to figure out my new dharma in America. As a woman from South Asia, I was sure of one thing, my domesticity. Primarily rooted in my motherhood and wifehood, it was my anchor and assertion beyond all else. Like most South Asian women, I equated the glory of being a woman to the prestige of being a goddess because of her status as, or her potential to be, a mother. Mother was a term of universal proportions, a word that resonated with sublime divinity, a goddesslike sanctity.

It is a well-recognized practice, even now, in India to address women and girls with words that mean "highly esteemed mother" and "goddess." Girls are often named "Devi" which means goddess. This respectful term is also added to ordinary female names like "Maya" and "Kamala", thus changing them to "Maya Devi" and "Kamala Devi", and creating an implicit goddess connection. It is not unusual to politely refer to a married woman as "blessed mother" and offer her an aura of respectability. Such traditional practices have given a common understanding among people to associate femininity with motherhood and divinity.

It was a blessed position to be in, such a coveted state, in fact, that its contraposition was also taken for granted: that a woman would fall into a bottomless pit of contempt and disregard if she, by choice or

otherwise, happened to embrace a different mode of existence—being childless, a spinster, or a divorcee. I had seen women diminish themselves to nothingness if they were not fortunate enough to be married and have children. However, depending on the prevalent rules of society, a woman could engage in any other tertiary activity she might be interested in pursuing. She could even become an engineer, a scientist, a lawyer, an astronaut, a plumber, or a prime minister, as long as she did not ignore her roles as wife and mother.

I grew up in an orthodox family but, carried by the changing tides, became an engineer in the mid-1960s. It was the decade when women had just begun to venture into engineering institutes in India. Soon afterward I followed cultural dictates and became a wife and eventually a mother.

By the time I moved to the United States in January 1980, my life had blossomed into something that came close to being "as happy as you hope your neighbors think you are." I was a family woman with a husband and two lovely children, and a workingwoman with a job as an engineer in the high-technology field of microprocessors. I came to this country with everything I ever owned, including my wifely-motherly culture, and a vague notion of what America would be like. The images of America glowed in my mind with the glitz and glamour of Hollywood, with dashing men and women living care free in brightly lit skyscrapers, smoking, drinking, working, and playing as equals in every way. I was entering a fantasyland, where women and men would be equal and progressive partners, working together as engineers, doctors, and lawyers, holding hands in every endeavor and sharing every responsibility. For once I would be recognized and admired for my intelligence as an engineer, rather than for my cooking credentials.

"So you are the new engineer?" a male colleague asked on my first day on the job, raising his eyebrows slightly, emphasizing his surprise and revealing a curious disbelief. The glint of amusement in his eyes, prompting my retreat deeper into the engineering lab's corner as a coil of his cigarette smoke moved menacingly towards my throat, was sufficient to plant a tiny seed of self-doubt inside me, as if my credibility were in question, my credentials not good enough. Was it this man's personality or something in me that provoked such a remark? Did I lack the necessary arrogance, perhaps? Did I look pathetically frail in my 100-pound frame? Not willing to bruise my pride by revealing any doubts, I swallowed my questions one by one and smiled nonchalantly, as if content with the affairs of this new world.

A month later I was half-kneeling on the floor of the engineering lab, beaming in confidence at my expertise, thinking how wonderfully adaptable I was that I could manage to spread out my diagram without a table, when the man with the raised eyebrows filled the door frame and said, "Aha! The right place for a woman is at the feet of a man!" Instantly, my worldview changed. Something turbulent began to rise up within me, changing me for eternity. I was shivering, unable to retort, my blood chilling, my extremities slowly shriveling inward, and my eyes sharpening to a cold stare. In a deeply hidden part of being, I was turning into a dog.

He was obviously referring to my boss sitting on a chair, engaged in some work of his own, and I was seated on the floor. I remember wondering, should I laugh off his remark as a tasteless joke, or cry, or be offended? I remember the sinking mood, the fumbling vulnerability, the embarrassing silence, as the linguistic part of my brain went blank and stupid and I could not speak.

In the world I had naïvely constructed as my new American homeland, men would never speak like this to professional women at

work. Why was I being forced to travel back in time, back to an earlier century when the first women's colleges in the country were sprouting and women were choosing "feminine professions" like nursing, teaching, and social work? To a period when women could not vote, and Elizabeth Cady Stanton and Susan B. Anthony were igniting the fires of the woman's suffrage movement across America?

As my body melted in sweat, I wondered who would be my mentor now? Who would show me the rules of the game, teach me to survive, show me the way to fulfill my dharma here in this new world?

Many American feminists had hoped women would gain confidence and self-esteem when they left their limited roles at home and went out into the working world, car keys in hand, and shared their equality with men. The workplace is where they envisioned a woman would develop her personality, shed her wifely-motherly apron-clad self-image, and become a full human being, paid, vacationed, happy. But perhaps they neglected to warn women that the office was not the nursery of humane culture, a place where kindness and compassion grew like potted plants, where *sexism* was a six-letter word never pronounced around coffee machines.

At an office birthday party one day, my worldview suffered another stunning blow when I saw the cake—shaped like a woman's naked torso. It was meant for the chairman of the company. Following what has become an American custom for these kinds of parties, a group of women in the office had taken the initiative, arranging the get-together in the conference room, inviting everyone to gather at a specified time, circulating a humorous birthday card for everyone to sign, and buying the cake. As everyone came to look at the cake and make wisecracks, this group of women stood aside, giggling and watching the scene. The chairman, through his reddening face, fell in with the joke and began

cutting the cake while everyone watched curiously to see which part of the woman's body he would cut first, and which part he would choose to eat. Amidst the jeers and cheers, he smiled as he cut just below the navel of the torso, taking a piece of her ovaries, leaving the breasts and other parts to his workers.

The ritualistic offering of a woman's body to the chairman as a gift on his birthday, its violation as the employees frolicked, did more than distract me—it nauseated me. The symbolism of sex and violence along with the fact that people were watching it in glee, and using it as a celebration, spoke more than I ever wanted to know about the culture of my office. It was perfectly legal and socially acceptable to do this. No one said a word of dissension, no one wondered why the cake was formed in the image of a woman. If the cake had depicted a puppy or a horse, wouldn't some animal rights activists have objected to eating it as symbolic of an inhumane and horrible act? But there we were, feasting on the body of a naked woman, laughing as we consumed her body parts in clear view of a lively group of people. The act was considered neither barbaric nor out-of-date.

I soon learned it was customary for women in the office to laugh off the many indelicate jokes some of the men shared about the mood changes and impaired reasoning that females were prone to each month. I secretly rejoiced on the rare occasions when one of us displayed an unexpected hint of assertiveness, transmuting from an "ordinary woman" into a "bitch." But ordinarily a woman in the office would simply cringe in silence when high-decibel curses bounced off the office walls, when a man's arm encircled her shoulders as she walked down the hall, when the laughter around the conference table was prompted by comments on her menstrual cramps and hot flashes.

The media showed me pictures of beautiful women with gorgeous bodies as the ultimate feminine goal. The mayor of a large city appeared on the front page of a major newspaper holding a lipstick in front of her mirror, implying that even for a mayor, being a woman meant physical beauty and lipstick. The media made bountiful harvest by giving Hillary Clinton's hairstyles more coverage than her intelligence or personality, making this brilliant woman the subject of trivial conversations in office cafeterias.

Television filled me to the brink with commercials showing curvaceous women hawking everything from hamburgers to Harleys, from diamonds to diet foods. Sex appeal, not health, was the focus of ads promising me I could lose six dress sizes in two weeks if I simply took three pills each day. A woman declared in absolute joy how the construction site workers whistled at her after she lost excess pounds. Another expressed her delight at having claimed her curves back and being able to wear a swimsuit again—as if swimsuits were taboo to the large-sized women.

Betty Friedan, American feminist and author, writes in her book *It Changed My Life: Writings on the Women's Movement:*[1]

> The essence of the denigration of women is our definition as sex object. To confront our inequality, therefore, we must confront both society's denigration of us in these terms and our own self-denigration as people.
>
> Am I saying that women must be liberated from sex? No, I am saying that sex will only be liberated to be a human dialog, sex will only cease to be a sniggering, dirty joke and an obsession in this society, when women become active self-determining people, liberated to a creativity beyond motherhood, to a full human creativity.

[1] Friedan, *It Changed My Life: Writings on the Women's Movement* (Cambridge, Mass.: Harvard University Press, 1998), 159.

I agree with Friedan to some extent. Every woman must be able to choose motherhood freely and consciously and not be defined only as someone's mother, not feel as if the only purpose in life is to give birth, not believe that motherhood requires her to forfeit all other functions as a human being. Only when she has the freedom to perform meaningful work beyond motherhood can a woman define herself as a fully functioning person, a person who chooses motherhood freely and happily. Motherhood then becomes one of the many ways she expresses herself.

But what if a woman is a full-time mother and housewife? What if she has no interest outside her home life and family? Does that justify sexual objectification?

In some countries motherhood is the essence of being a woman, but it is not all a woman can be. A woman's ultimate fulfillment comes from giving birth and nurturing her children, from that awesome responsibility, that fundamental privilege given to a woman by nature. When a woman makes the choice to become a mother, she is fully participating in life, not as a burden or a curse but as an opportunity for the full use of her faculties.

Elizabeth Cady Stanton, who bore and raised seven children while working for women's full participation in national affairs, said the following in a speech before the House and Senate judiciary committees in 1892:[2]

> But to manage a household, have a desirable influence in
> society, keep her friends and the affections of her
> husband, train her children and servants well, she must
> have rare common sense, wisdom, diplomacy, and a
> knowledge of human nature. To do all this, she needs the

[2] Geoffrey C. Ward, *Not for Ourselves Alone: The Story of Elizabeth Cady Stanton and Susan B. Anthony* (New York: Knopf, 1999), 191.

cardinal virtues and the strong points of character that
the most successful statesman possesses.

When I first saw a documentary film about two American women
a few years ago, I was stunned by the significance of their roles in
changing American society. Without the tenacious exertions of suffragists
Elizabeth Cady Stanton and Susan B. Anthony, women's lives would still
be controlled by the voting power of men. Yet I knew nothing about
them.

For me, an immigrant woman from a developing country ten
thousand miles away, ignorance of these nineteenth-century advocates of
women's rights is not particularly noteworthy. But in his introduction to
the book *Not for Ourselves Alone*, Paul Barnes writes:[3]

> I had never heard of Stanton, and I had always been a
> history buff. . . . my admiration for Stanton grew—along
> with my astonishment that this great American woman
> had never been mentioned in any of my history courses.
> I was not alone in my ignorance: none of my college-
> educated friends, female or male, knew anything at all
> about Stanton; nor did they know anything about her
> friend and partner, Susan B. Anthony, other than that
> she appeared on a rarely seen silver dollar.

I too attended an American university and received a graduate
degree. I worked with many educated American men and women closely,
consumed American books voraciously, went to Hollywood movies
frequently, watched television, read newspapers, and celebrated American
holidays. In all respects, I had lived a very normal American life for more
than two decades. Yet in that time the only thing I had heard about either
of these women was that the image of Susan B. Anthony was imprinted

[3] Ibid., x.

on a dollar coin that was no longer in circulation because it was too often mistaken for a quarter.

After seeing the documentary on public television, I learned that about 44 percent of mainstream history books do not mention the American women's suffrage movement. Many more do not record the names of Susan B. Anthony or Elizabeth Cady Stanton. For me, this appalling disrespect hung like a gigantic cloud of shame over the beauty and pageantry of the American landscape.

Eleanor Roosevelt's words of pure reason came to my rescue one day, spreading light across my consciousness. In a private letter to a friend, she wrote in 1941 words all women can look up to when they need inspiration:[4]

> Somewhere along the line of development we discover what we really are and then we make our real decision for which we are responsible. Make that decision primarily for yourself because you can never really live anyone's life, not even your child's. The influence you exert is through your own life and what you become yourself.

These words of American individualism expressed an exciting concept of egocentric self-reliance that I found both inspiring and perplexing. They called into question the ancient doctrines I grew up with, the philosophy that emphasized women's dependence on men—as a child on her father, as a wife on her husband, as an old woman on her sons. The idea of individualism is a difficult concept to grasp for the South Asian woman, who lives her entire life self-defining, growing, and flourishing on relationships with others.

I wondered how I could ever learn to recognize my individuality in a vacuum, outside the well-established roles of my relationships. To be

[4] June Sochen, *Herstory: A Woman's View of American History* (New York: Alfred, 1974), 328.

successful, do I have to learn to be independent and individualistic? Do I have to make decisions that would exclude my family? Is it necessary to nurture individuality to find happiness and lead a fulfilling life? Bringing into light an American perspective, authors Susan B. Evans and Joan P. Avis write:[5]

> There are two perspectives about the experiences of the baby-boomer generation. One is that their need to accommodate two antithetical models of womanhood—feminism and femininity—has made them schizophrenic. The other is that this is a very fortunate generation to have been born when they were.

If women feel schizophrenic, pulled between the two alternatives, how can we cherish our family roles and be feminine, yet be true to ourselves as individuals and discover our own paths? Can it be that individualism is strictly a masculine ideal, one that could never guarantee success for women? What is true for a woman who comes to America from a culture that encourages togetherness and bonding, even dependence?

Thousands of South Asian women immigrated to the U.S. starting from the first half of the twentieth century. I imagine they raised the same questions, searched for answers in the solitude of their domestic afternoons, in the hot dampness of their California farms, tilling, weeding, and fertilizing, laboring in noisy factories or on stuffed chairs of air-cooled offices.

The sighting of four Indian men in San Francisco made news just before the dawn of the twentieth century, when the *San Francisco Chronicle* of April 6, 1899, reported the story of their landing:

[5] Evans and Avis, *The Women Who Broke All the Rules* (Naprville, Ill.: Source Books, 1999), 184–185.

The four Sikhs who arrived on the *Nippon Maru* the other day were permitted yesterday to land by the immigration officials. The quartet formed the most picturesque group that has been seen on the Pacific Mall dock for many a day. One of them, Bakkshlied Singh,[6] speaks English with fluency, the others just a little. They are all fine-looking men, Bakkshlied Singh in particular being a marvel of physical beauty.

Having come from the farmlands of the Punjab region of India and generally known as the "Hindoos," the small number of Sikh farmers who arrived in California kept to themselves, going to work and returning home together as a group. Their traditional ways of living and dressing might have added to their isolation even more. This group, comprising mostly men, had left their families behind with the hope of returning to their homeland soon but found themselves trapped because the anti-immigrant laws that prevented them from reentering.

Bakhshish Singh Dhillon and his wife, Rattan Kaur, established their home in 1910, making their living in Oregon and California, raising their eight children. The Dhillons were the only Indian family in Simi Valley in 1915 when their fourth child, Kartar, was born. Now living in northern California, Kartar Dhillon is a published writer and an artist. In her autobiographical story "The Parrot's Beak"—an evocative tale of the tears, toil, and triumphs of an immigrant family living in America during the early part of the twentieth century—she writes:[7]

My father arrived at the port of San Francisco in 1899 as a matter of choice, an economic choice. He left his village in India of his own volition. Yet when my mother came to California, it was not her choice, but her husband's. My father had returned to India, and brought

[6] Bakhshish Singh misspelled.
[7] Dhillon, "The Parrot's Beak," in *Making Waves: An Anthology of Writings by and about Asian American Women*, edited by Asian Women United of California (Boston: Beacon Press, 1989), 222.

back to the United States the wife selected for him by his father. At the age of seventeen, she had been picked up virtually like a piece of baggage and taken off to a foreign land by a man whom she never saw before her marriage.

Over the course of more than one hundred years of immigration, many South Asian women like Rattan Kaur have struggled to make their homes, raise their children, create new dreams, find their own identities, and above all, become Americans. They have accepted this country as their children's home. They came here with new hopes, energy, and optimism and faced conflicts that were often impossible to resolve, too complex to comprehend.

The story of Quamrun Nessa is one of many that South Asian immigrant women have to tell. She was a physician in Bangladesh, treating women who were often so vulnerable that they could not understand how valuable their lives were. Seeing women die because they lacked proper heath education, Quamrun changed her career from clinical medicine to preventive medicine. It was a difficult decision; her friends thought she was making the wrong choice because she could have been wealthy if she practiced clinical medicine. Instead she decided to work in health programs operated by nongovernmental organizations, teaching the underprivileged women of Bangladesh, improving their access to health education and other health-related services. Quamrun traveled in rural areas of Bangladesh, trained hundreds of outreach health workers, and supervised the work at rural health clinics to ensure that women received the education they needed to prevent

pregnancy complications. She hoped her work would empower the village women.

Just over ten years ago, her life took a dramatic turn when circumstances brought her and her five-year-old daughter to the United States to join her brother and mother. She left behind her country and her career, which was also her passion. Initially, life in the United States was very depressing for Quamrun. She cried almost every day.

"I often thought I would have more peace if I went back," Quamrun says. Her medical education and expertise carried no value in this country. Often she was treated as thoroughly uneducated, and most people were surprised she could speak English. Like the dentist who became angry when Quamrun did not follow the instructions he gave her in Spanish, many Americans did not recognize her nationality.

Determined to make it work in the new country, Quamrun started volunteering with a nonprofit organization in San Francisco. She attended the California State University there and earned two master's degrees in health-related fields. Then she started working with a domestic violence shelter in the Bay Area. The work offered some solace to the service-minded physician. Quamrun spoke publicly about preventing violence in the South Asian community and in 1999 was honored with the World of Well Being Award for her work with South Asian victims of domestic violence.

For Quamrun, giving up her medical profession was the hardest part of her immigration experience. Currently working in a county public health department, she misses the old-fashioned medical care and education she used to provide in Bangladesh. Becoming a doctor was a dream Quamrun had nurtured even as a seven-year-old girl, and the dream was about service—helping others and being instrumental in bringing healthy changes to human lives. Her hope is to someday be a

physician again and to reach out to women in the developing countries, perhaps through the United Nations or the World Health Organization.

Any woman who comes to live in the United States as an immigrant goes through a process of relearning and a period of reevaluating her beliefs, values, and attitudes. She can never return to the previous life—the naïve, bound-by-tradition, perhaps unexamined life of the woman she left behind. For a time she exists in a vacuum, her societal support system taken out from under her, an unsavory reality staring at her from every mirror. There is nothing against which to measure herself, no way to examine her tracks. She alone has to decide how far she can go in search of herself. She needs to find the boundary where India or Bangladesh or Pakistan ends and America begins. She has to be brave enough, secure enough, to abandon her old safety net and leap right into the middle of America, where she may stand alone, in a whole new universe. Or she may create new boundaries to contain herself, risking failure and abandonment. It is up to her to draw a line she will never cross. It is up to her to find her new dharma.

So began my own search, starting with the uncanny welcome I received in the early years, for an understanding of my new role in a society that seemed to demand that women prove their worth at every step along the way. With their abilities undermined, their intelligence scoffed at, women had to wade through rough waters looking for approval and appreciation. I plodded into an American university to study human psychology and possibly figure out a way to unscramble my own personality. My fellow students, all with degrees in the social sciences, welcomed the solitary engineer—a brave student with weird ambitions. The experience turned out to be exhilarating and challenging, feeding every fiber of my body with a new vigor, unleashing a certain individuality, and affirming the "me" in me.

Self-knowledge is necessary, but it is not sufficient. Freedom is essential, but it is not enough. American feminism is useful as a concept, but it does not reach far enough to offer practical tools for women struggling to live full lives. Although the feminist movement has seen a new wave of change come and go, no doubt raising the nation's consciousness on women's issues a great deal, American women are still afraid our most private choices will be taken away from us, we are still fighting against glass ceilings and unequal salaries, we are still hoping to see a woman in the Oval Office, we are still measuring our success against a male yardstick. An alternative, feminine perspective is missing from the national subconscious.

With an audible sigh of relief, the average American woman has left behind her housewifely image of the 1950s. But she continues searching for a new image. She has developed an ambitious, confident, aggressive concept of who she ought to be, yet she is painfully aware that this image is not really what she is after. She cannot let the world define her only in terms of her newly acquired aggressive, self-confident personality, cannot let the world ignore the genuinely feminine, caring, sensitive qualities she has long valued. But she has yet to bring together the two mutually divergent principles.

She is looking to personal relationships for fulfillment, having resigned from the old model of a contented housewife who found satisfaction in laundering, cooking, housecleaning, and being an "ideal" wife. The modern woman demands equality at home. She may ask for shared responsibility from her partner but find the man less than willing. She may shun marriage and experiment with cohabitation, with single motherhood, with communal living—whatever arrangement gives her a feeling of worth and validation.

She searches for a spiritual connection to sustain her and ease the burden of her sorrows, a power that understands her feminine dilemmas. Perhaps she turns to a goddess, an archetypal image that brings forth a sense of benevolent strength and preeminent grace. She is willing to accept goddesses, queens, or princesses from other world civilizations, from the ancient Greeks, the Far East, the Indian subcontinent. Dianne Jenett, a professor of psychology from California, did her doctoral dissertation on an annual goddess ritual, called Attukal Pongala, performed in South India exclusively by women. Dianne goes back every year to participate in the ritual in which tens of thousands of women gather at a goddess temple. That the average American woman seeks spiritual fulfillment is evident from the plethora of recent literature, women's spiritual groups, and Web sites[8] devoted to the subject.

What does an immigrant woman do when she joins this milieu, bringing her own cultural aesthetics, images, and goddesses? I am not sure if I would like to be absorbed in the new nameless soup, losing my original flavor. Nor do I want to resist assimilation and live in an island of my own.

Perhaps the American woman, immigrant or native born, needs a new model. The new woman will be confident, ambitious, and driven yet calm, sensitive, and radiating with feminine charm. She will somehow, magically, combine the best of what America has to offer—its freedom, individualism, and material wealth—with a satisfying feeling of domestic bliss. She will retain her feeling of connectedness to all that is around her—her family, other women, her community, the Earth. She will become the modern American enigma by being true to who she is, with her roots reaching deep from wherever she has come, while living a

[8] One of the best I have seen is: http://www.serpentina.com/.

meaningful life in this bubbling amalgam of world cultures. She will find personal success in her choices, in her every role as a woman, emanating a different color from every angle, strong, luminous, and solidly feminine.

Dreaming aside, I was eager to find South Asian immigrant women who have, at the very least, rediscovered themselves and integrated their many selves. I wanted to know if, and how, they have been able to build new and meaningful lives for themselves. I was not looking for well-known or celebrated women, not only because writing about them would be redundant but also because fame is not a necessary ingredient in an "exceptional" life. Through some of my friends and other contacts, I became acquainted with several women who seemed to have done extraordinary things, things most immigrant women would consider too complicated and demanding. I found their achievements and the whole philosophy of living so fascinating that I soon realized their stories needed telling. Among them are entrepreneurs, executives, artists, performers, writers, lawyers, engineers, doctors, aviators, politicians, professors, homemakers, and community activists. They have made an impact on the American economy and culture, created jobs, tended to the homeless, taken care of the sick and the dying, entertained, inspired, emancipated, educated, offered spiritual guidance. They have assigned themselves places in the society, inspiring other women who will come afterward to claim their own places of honor and respect, bringing their unique zeal and zest to America.

Chapter 2

HONORING YOUR SELF

Celebrate Being a Woman

 Safia Khalil Rizvi was born and raised in Pakistan, the fifth of seven children. Even as a child, she knew in every fiber of her being that she and her sisters would never be equal to their brother. The way her parents and the whole society viewed a girl was fundamentally different from the way they viewed a boy.

"I grew up apologizing for being a woman, not always verbally, but always knowing that somehow I was less than my brother and not ever questioning that premise, not ever thinking that it could be wrong, but believing it to be the truth. My parents made the decisions for me; they never had to force their decisions on me, because I always accepted them. Now I look back and see how different it was for my brother. We

both went to college. I had a scholarship, he did not. When we came into the house at the same time in the late afternoon, I used to serve lunch for my brother, but I never had my lunch prepared by my brother. I don't remember ever asking my brother for a glass of water. It was completely OK for me to serve the dinner for my father and brother. If the food got cold, I would reheat it and serve them again. I love my brother, and I would certainly do it out of love. But to do it because he was a boy and I a girl was something else."

An excellent student in school, Safia was the first woman in her family to go to a university and graduate. Her professors from Karachi University urged her to pursue graduate studies in chemistry, preferably in the United States. With the dream planted in her mind, she secretly applied for graduate school in the U.S., although she doubted she would ever be allowed to go to a foreign country. When she was accepted with a full scholarship by the University of Oklahoma, she was overjoyed. But there was the task of convincing her parents. After much pleading and begging, she was finally allowed to go. For someone who had never been permitted to leave her home alone, not even to go to school or a friend's house, moving across the oceans to a foreign country was as big a deal as it could be.

But there was a catch. Her brother was strongly opposed to sending her abroad as a single woman. So a few months after Safia arrived in America in 1989, her parents arranged her marriage. Soon after, she got married—over the phone. She is probably the only woman in the world in recent times not to have attended her own wedding.

"The marriage was arranged in Pakistan," Safia explains. "It was the middle of the semester, but I still wanted to go home, get married, and be a traditional bride. But my parents and my in-laws decided to execute the marriage without me. Apparently, my husband was coming to the U.S.

They sent me my marriage license, which I signed and sent back. They had a big ceremony there. I got a phone call during the ceremony, when the priest asked me if I would accept him as my husband. I had seen him when I was very young and had vague memories of him. When I met him and spoke to him again, I was already married to him.

"I was programmed from a young age to accept that I would marry the man my parents would pick for me. I never dated; my horizon was very small. I wanted to get married, I wanted to be a bride. I was probably too young to understand more about the marriage aspect."

Her husband joined her soon, as he was about to start his own graduate studies in architecture. In about a year Safia became the mother of a baby girl. As a young graduate student, she had to deal with living in a new country, having a new husband she hardly knew, and above all taking care of a new baby. Her life was becoming increasingly stressful each day, although she was not able to recognize it as stress. Instead, she viewed it as her incompetence. Immediately after the baby was born, her husband asked her to send the baby back home to Pakistan. He complained of not being able to sleep with the baby crying at night. Having come from a wealthy family, he was used to being surrounded by many physical comforts and luxuries and people to do household chores.

Safia recalls, "In the culture in which I was raised, women didn't feel entitled to feel overwhelmed. I didn't think I was overwhelmed. But now as I look back, I know I was. I didn't have support or any family around. It seemed like so many things were happening at the same time. Some things went well, some didn't work out.

"Finally, I had to take the baby home for a while. When I came back, after leaving the baby, my husband had gone to California to be with friends. We had many separations after that first one. Living without

my baby was hard for me, and after a while I returned to Pakistan and brought my child back with me."

As time passed, Safia became aware of the extremely traditional views of her husband, who demanded that she return to Pakistan with him and be a "proper wife." The last warning came when he threatened to marry someone else if she didn't quit her education and go back to live with him in Pakistan.

"I thought he was bluffing," she says. "I thought if I finished my studies I'd be in a much stronger position. Six months later I found out he had married another woman in Pakistan. I came to know about it through somebody else. According to the law, he needed my consent. But I didn't even know. In fact, he never told me. Whenever I called, the servants would say he was not there. Finally, I came to know. It was a shock. It was hard. But in a way it was good that he did it, because if he hadn't done that, I wouldn't have had the courage to even think of divorce, and to do all this. After that I had to be strong. I had to give my daughter a good education. I felt responsible that she didn't have a father, and I had to be her father and mother. I focused on my career and my daughter. Then it was just me and the kid."

It was time for Safia to look at her life with fresh eyes. She was now a divorced woman and a single mother. In Pakistan she would have been a social outcast.

"If I were the one who had done it, if I, while being married to him, had gone ahead and married some other man, I would have been literally killed. That would have been the end of the story," Safia says.

Her parents disowned her because she was divorced. Her father did not speak with her. In their minds the divorce was her fault because if she had quit her education, had gone to her husband as he had asked her to, she wouldn't have been divorced. Her relationship with her parents is

still strained. They have not forgiven her for the shame she brought to them, and she has not forgiven them for not standing by her when she needed their support the most.

But she credits them for the encouragement they gave her to do well in school. Safia finished her Ph.D. while raising her child alone and, at the same time, working for a pharmaceutical company. She realized she had to stand up and do what she believed in, instead of feeling scared.

"I now look back and see trauma. We don't acknowledge trauma in our culture, particularly for women. We just do whatever it is we need to do."

Safia was fortunate to have friends, classmates, and roommates who helped in many tangible ways by baby-sitting and giving her emotional and moral support during those days when she was doing her Ph.D. work and bringing up her daughter. An older couple she was friends with, Mr. and Mrs. Moak, adopted her daughter, Sheherzad, as their granddaughter. They would take Sheherzad to their house and do things just for her—small things that added much to the little girl's life, and to Safia's life as well.

"They gave me a sense of family, which I very much needed at the time," she says. "In our culture the children are used to having family all the time. So it was good for me to have my friends and my roommates. Here in the U.S. I also had my cousin, whom I actually think of as my "real" brother. He was very instrumental in my making the changes I have made. He has always encouraged and supported me to exploit my potential, to pursue every opportunity, to have a good career. Now, after all these years, he is also very close to my daughter. We don't see him very often because we live far away from each other. But I feel very lucky to have him."

A significant event happened in Safia's life in 1997, when she heard a talk sponsored by the Asia Society. The speaker was Asma Jehangir, a Pakistani attorney and one of the most well known human rights activists in Pakistan. She spoke about the latest cases of blatant abuse and injustice happening in her country in the name of culture and religion, and how she chose to fight them. What she said struck close to home for Safia.

"I found myself crying," says Safia in describing the encounter with Asma. "But I felt relieved and privileged that I was so lucky to have come out the other end, instead of enduring what I had heard from her about other women. That was a decisive moment in my life. I felt fortunate that I had finished my Ph.D. and had a good job that I enjoyed and a beautiful daughter whom I could raise with values I believed in. I was free. I decided that I had to stop feeling sorry for myself and stop the negative thinking. I did come out the other side, I did land on my feet. So many women don't. That day I was able to compare myself with the women living under different circumstances. I had choices. So many women didn't have and didn't know they could make choices."

There was a time when she felt ashamed of her divorce. When other Pakistani families stopped inviting her to their homes, she believed it to be her own fault. But now she accepts her divorce with no feelings of guilt or shame. And she is proud of Sheherzad, a bright and talented thirteen-year-old who is also a caring human being. Safia is proud that her daughter is a well-balanced child who has made many friends on her own and has beautifully adjusted to her mother's hectic routine.

"I don't know if I can take the credit for it or not," Safia admits, "because it may not be my accomplishment at all. It may not be what I have done, but my daughter may very well be that way by nature."

Living in Philadelphia, Safia is a full-time scientist at GlaxoSmithKline, a leading pharmaceutical company, and a full-time mother. She is also a full-time student again, pursuing an MBA from the Wharton School. Specializing in oncology research and market analysis, she plans to move to the business side of her company. *Working Mother* magazine, which honored Safia with the Working Mother of the Year Award in 2001, wrote this about her:[1]

> Ivy Gilbert, an admissions officer for Wharton's MBA program who says she reads hundreds of applications each year, was struck by Safia's intellectual curiosity. "What tremendous inner strength and energy she must have in order to have done so much without a support system," says Gilbert. "Nothing has dampened her zeal for life or her hopes for her daughter or for other Pakistani women. Reading her application, I thought, Here's a woman we want associated with our school."

Having received many awards during her graduate studies for excellence in education, Safia is the only non-American-born woman to receive the Working Mother of the Year award. In addition, she was interviewed by Diane Sawyer for ABC's *Good Morning America* as well as by CNN, NBC, and many other television and radio stations.

One of her greatest wishes is to educate and empower women from South Asia, who still have no choices before them and believe that being a woman means having no control over their destiny.

"When I think of my country, I think of India, Pakistan, and Bangladesh, even though I have not lived in Bangladesh. I think of women from there as women of my world. Besides being here and giving a good life for my daughter, I want to help these women, but not in a condescending way. These women are very capable of helping themselves.

[1] *Working Mother* 24, no. 5 (May 2001): 46.

They just need little support. I didn't know there was a way, and that a choice existed for me. But most women don't know of their choices.

"A person who has the ability to make informed choices is an empowered person. So the first thing is to provide them with information. They also need the tools to decide how best to use the information. Only then would they have the ability to exercise choices, pursue an education, and gain economic independence. To that end I want to empower the women of Pakistan and other developing countries, so they can make their own choices."

With this in mind Safia, who discovered the power of computers as a student and researcher, founded an organization called eLIT, which stands for Empowerment through Learning Information Technology.[2]

eLIT takes computer literacy to economically disadvantaged women and children in Pakistan, India, and the United States. They are given the skills necessary to use computers and explore the world of ideas and information through Internet access. The organization works on the belief that educated and fulfilled women are essential to bringing up children in the twenty-first century. Currently, the organization relies on donated time and equipment to provide computers at eLIT training centers in the cities of Hyderabad in India, Karachi and Mansehra in Pakistan, and West Philadelphia.

Unfortunately, India prohibits visitors from bringing electronic devices worth more than 4,000 rupees ($80) into the country without taking them back out again. One eLIT volunteer, Helen i-lin Hwang, writes about her experience of literally smuggling a used notebook computer to one of the eLIT centers in Hyderabad, India:[3]

[2] http://www.elitonline.org.
[3] http://citypaper.net/articles/2002-12-19/slant.shtml.

The center is housed in a pink cinderblock building equipped with three new desktop computers, and now the laptop we brought. Several women crowd around each computer to learn the hands-on skills.

Since its start nine months ago, 106 women have completed three-month computer courses in Microsoft Word, Excel, Access, and PowerPoint. Many of them hope to find jobs after they're done, but the reality is that many of them are still looking.

One of the first graduates, T. Surya Nagamani, was one of the lucky ones. She now makes 3,000 rupees ($60) a month typing newspaper articles from *The Times of India* into a database. The average monthly income in India is 1,800 rupees ($36), according to the World Bank. "We are very happy now," says Nagamani. "Better life, better Diwali." She never attended college, only receiving the required basic education that finishes at the age of fifteen. At thirty-five years old, this is her first job.

Safia's next goal is to start a training center in Afghanistan. In 2002 the organization held an event to raise money for establishing a technology training center for the women and children of Afghanistan who are eager to learn how to use computers, and the Kabul center is set to begin operating soon.

The training is free for the women and children at the eLIT centers, which have paid and volunteer staff. Each center has a director and two teachers who train the students in computer skills and help with general literacy. Since many women either are not allowed or do not feel comfortable learning from male instructors, all the teachers in Asia are women. eLIT also provides advocacy groups and shelters for abused and disadvantaged women and children.

"I have a room in my house filled with donated computers," says Safia. "I ask individuals and corporations to donate computers. The University of Pennsylvania has donated their equipment, and so has my company, GlaxoSmithKline. When I heard that in one of the centers in

Pakistan, a cleaning woman saw what was going on and bought a used computer for herself, I was so happy. I want to help young women grow up liking themselves, find out who they are, and celebrate their lives— celebrate being women."

Today Safia feels strongly attached to her South Asian culture, its food, its clothes, and, especially its music. She says no other music touches her as Indian music does. It allows her to relax and experience a great sense of nostalgia.

"As a child I loved my culture, but I didn't know anything else. Now I have a conscious love for my heritage. Now I love all the positive things about it, and everything seems more deeply meaningful. I have a sense of joy that I am from that part of the world. I like the color of my skin, I like the way I look. I feel very anchored as to my identity as a person of my cultural heritage, and I am becoming comfortable with the world. Last year I was in South Africa for three weeks doing a consulting project with the public health system of Cape Town. I felt very loved there, and I felt connected with the people of South Africa. I have become a citizen of the world."

§§§§

Fly Solo

"My mother wanted me to become a typical woman, marry, have children and all that good stuff. She said I could also become a doctor and give free services to the poor. My father wanted me to be a lawyer, because he thought I could argue better than most people. But there are lady lawyers, and there are lady doctors. I wanted to do something totally different. I wanted to go for aviation," says Chanda Budhabhatti of her growing-up years in India.

"I was fortunate because when I asked my dad if I could become a pilot, he said, why not? He was the first person to give me that self-confidence. My dad had spoiled me. I have two brothers, and I was brought up like a boy by my father. So I learned horse riding and swimming, which was unusual in India for girls in my days."

Unfortunately, Chanda's father died before he could initiate her into flying. Her mother had a much more traditional outlook and very different ambitions for her. Chanda protested—by fasting.

"Eventually, after three days of my fasting, Mom agreed, because I wouldn't give up. After that she began to support me. She said, OK, if that is what you want, that is what you are going to do."

But the flying-school instructor ignored her. Chanda sat at the flying club every day for six months before the instructor agreed to teach her. She learned firsthand that aviation is an extremely difficult field to pursue, whether in India or in the U.S. Only women who are determined, disciplined, and patient can succeed. Chanda remembers the early years of

her flying in India in the 1960s, when people used to call her crazy and a freak.

"I remember I had many disappointing situations," recalls Chanda. "I was often depressed, because aviation was very challenging. My mom would say, don't feel depressed, and then she told me a very nice thing, which I often share with my friends here. She said, when you are depressed and think everything is going wrong, then that is like nighttime. It is totally dark. But you know there is going to be morning, you wait for it, and the sun rises. You have to have that patience to wait. Once you wait, there is the knowledge. Believe me, a thousand times I felt dejected, but I tried to remember those words, that there was going to be morning. So I continued. When people ask me how the hell do you do this, I say, wait till the morning! I don't give up.

"*Patience* and *perseverance* are the two words I learned from my mom. And I think they are good qualities to have. My mother was the main person to give me strength and determination. If you know what you are doing, and if you continue to believe in what you are doing and know it is right, then you shouldn't change the path. You will succeed. But if you try to please everyone, eventually nobody gets pleased, and you are most miserable. The best thing is to please yourself. Just go and do it. You will be surprised how many people would agree and encourage you."

Chanda had already been flying by the time she was seventeen years old.

"Women pilots have struggled really hard here in the U.S., too," Chanda says. "I admire them because they don't just take no for an answer, they keep on going. I think men are more arrogant here than in India, and women have to fight their way."

Ayn Rand, the American woman who inspired readers with her ideas of individualism and self-esteem, was Chanda's favorite author.

"Then I read *Jonathan Livingston Seagull*," Chanda says. "The story is of a bird wanting to fly—in a way it is the story of what I am doing. It tells you, even if you don't have wings or your legs are broken, there are things you can do. I like those kinds of inspirational stories.

"Then, of course, there was Amelia Earhart, the pioneer woman pilot, who set many records and encouraged women to fly—a role model for all women aviators. Amelia Earhart was in every way my aviation role model. She not only set records but also encouraged other women. That is something I like. I have seen a lot of pilots here; they want to do their flying; they want to break records; but they are not interested in whether somebody else is flying or not. But while breaking records, if they try to help other women achieve something too, then that is a great thing. I feel that if I had not taken the cause of promoting, and if I had just concentrated on myself, I would be breaking records and getting my name in history books. But that was not for me.

"I knew Sheila Scott, who went around the world three times. The British aviatrix, who became a good friend of mine, was a most prominent figure in aviation, with astonishing world records. She did encourage others in her own way. My goal is to provide aviation awareness to all, aviation education and opportunities to the young. The support I get wherever I go with my projects is encouraging."

Women pilots in the U.S. realized that they needed to stick together and support each other for recognition because they were not welcome in aviation clubs run by men. So they decided to have their own club. Thus was born the Ninety-Nines, an organization of women pilots formed in 1929 in Long Island, New York, under the leadership of Amelia Earhart.

The Ninety-Nines is an international organization of licensed women pilots from 35 countries, currently with more than 6,500 members

throughout the world. The organization came into existence to give mutual support, promote women in aviation, and contribute toward aviation education and safety all over the world. Amelia Earhart was elected its first president, and the group was named after its ninety-nine charter members.

It has been pointed out that the Ninety-Nines have sponsored more than 75 percent of the Federal Aviation Administration's pilot safety programs in the United States annually.[4] They also organize air races, the most famous being the Powder Puff Derby, an all-women air race across the U.S. They encourage women aspiring to be pilots all across the world by giving scholarships and mutual support.

As a member-at-large of the Ninety-Nines, Chanda first came to the U.S. to attend an international convention organized by the group. When she arrived in 1967 as an invitee of the Ninety-Nines, she already had her private pilot's license in India. It was through the encouragement and help of the Ninety-Nines that she received a scholarship to attend flying school and receive further training in this country.

"I got 97 percent marks in my commercial license and instrument rating," recalls Chanda. "I then became the third commercial woman pilot in India. I went back and formed the Ninety-Nines section in India. When I learned how devoted these women pilots in America were to aviation, I tried to do the same in India. And five of us pilots formed the India section. A significant part of my own confidence came through my association with the Ninety-Nines. They have helped many people like me. They take young girls with flying ambitions into their houses, sit with them, and talk to them about what they want to achieve. They are a fantastic bunch of women pilots.

[4] http://www.ninety-nines.org/99s.html.

"The Ninety-Nines taught me to be in touch with other women. They taught me the camaraderie, the mutual support."

What she learns from the Ninety-Nines in the U.S. Chanda takes to South Asian countries—to India, Nepal, Pakistan, and Bangladesh, encouraging women in all those countries to go and fly. Chanda is proud that in some way she is helping people of those countries change their attitudes about women and what they can do. Elected international director of the Ninety-Nines more than once, Chanda was the first non-U.S.-born candidate for its presidency. She is well known in aviation circles all over the world for her work in the area of aviation education and safety.

She recalls those early days when the major domestic airline in India, the Indian Airlines, would refuse to have a woman pilot, saying, "No, we don't want a crying woman in the cockpit."

"You just give a girl the same tests you are giving the boys," Chanda would tell them. "And if she doesn't pass, fine, we are not going to cry discrimination, because it is a high-tech field and we understand your concern.

"For two years they threw away every qualified woman's application, but after two years, they decided to take a chance. The girl passed with flying colors, and they couldn't send her away. They thought she would fail in training, but she didn't. She became the most outstanding woman pilot of Indian Airlines, and she is a commander now. They know we are serious and we understand the importance of being competent."

An ardent advocate of women pilots all over the world, Chanda is the first Asian woman to receive the Chuck Yeager Aerospace Education Award for her outstanding efforts to promote aerospace education.

"We women pilots don't demand respect, but we command it," Chanda says. "Women have to work twice as hard as men to be considered half as good! Fortunately, it is not that difficult. The fact is, the plane doesn't know if the pilot is a man or a woman."

Living in Tucson, Arizona, Chanda holds the current speed record for single-engine planes in the U.S. In 1997 Chanda started a conference called Women in Flight, for which every March she invites speakers to come and talk about aviation. Called admiringly the Ambassador of Aviation, she has received numerous awards and honors, including the Spirit of Amelia Earhart Role Model Award for 2001, presented by the Amelia Earhart Birthplace Museum.

"In America I attend a lot of conferences and meetings and let them know what other women are doing, and whatever I learn here, I take it back to other countries. Because I am a commercial and instrument pilot, they know I have knowledge. I promote aviation not only to women pilots but also to the young people.

"I think there is a vacuum in aviation education, and I am trying to fill it as much as I can—by having aviation museums, by conducting aviation safety seminars."

Chanda says she is married to aviation.

"There are fantastic wives and mothers, and I admire them. But I have made my choice that I don't want to be one, because I want the freedom. Twenty years of my life would go for the child, if I wanted to be a good mother. I didn't want that. There are enough people in the world, and that is my own consolation in life. I convince myself that I am not doing anything wrong. I am not depriving anybody, because from the beginning I was open about it. If you are open about it, you don't feel guilty. My pilot girlfriends have kids and they are managing very well. It depends on each individual.

"I admire women who can do both. I think women can do both. Women are very strong, stronger than men, frankly.

"My dream is to see that women can fly, women can join aviation, women can do anything they want. I get the most satisfaction from seeing these young women in captain's uniforms, walking around proudly."

Like Amelia Earhart, Chanda thinks of flying as not only a great achievement but also a metaphor for freedom. Soaring high in the sky, with no one in control but herself, is her greatest freedom. Her dream is to fly solo around the world.

"You shouldn't fear fear," Chanda says. "You can't live your life if you fear fear. We still have a lot to accomplish. We still have to search—what we are, who we are, why we are here."

§§§§

"I Am My Kind of Woman"

Raised in a Catholic tradition, Manuela Albuquerque comes from Goa, an old Portuguese colony on the west coast of India. When Portuguese missionaries converted the local Hindus to Catholicism, all the converts were given Portuguese names, like the Spanish names in the Philippines. Thus Manuela came to inherit a Latin name and a liking for Latin music.

Her father was interested in the broad spectrum of religious philosophies, and Manuela grew up reading some of his collections, from Pierre de Chardin to various translations of the *Bhagavad Gita*. She also read a wide range of Buddhist books—books on Zen and many books by the Dalai Lama reflecting Tibetan Buddhist traditions. The religion struck her as both highly analytical and deeply spiritual. Manuela later became a Buddhist.

"I found that the Buddhist explanation of how we operate in the universe is more like a psychology than a religion," Manuela says. "It seems very persuasive to me, and it has a unifying theme that seems to incorporate my notions of feminism, and my belief in an inclusive justice for people of all socioeconomic and ethnic backgrounds.

"I think my mother was also an important influence, in the sense that she is an articulate, intelligent, independent sort of woman. Her belief that one should contribute to the community, that each person can make a difference, and that one must stand up for what is right has influenced me the most. But she had to leave medical school to marry my father.

And because my father was posted all over India, she couldn't carry on a career. But she did a huge amount of volunteer work her whole life, as though it were her career. As a child I had always seen my mother as very active, contributing to the community. I remember, when Mother Teresa came the first time to Delhi, my mother did volunteer work for her. I would go with my mother, make medicine packages, feed the homeless at the shelter, go look into the crippled children's homes, and so I got the sense of the importance of public service at an early age. I feel fortunate for that.

"My father was a doctor, and he established a whole system of social security, as compensation for the workers when they were injured, all around the country, known as the Employees' State Insurance Corporation. So I saw him really committed to public service in that way.

"I grew up with parents who contributed in some way to public life. So I had much more of a sense of that being more important than making money. But my parents did not push me into any kind of profession."

After finishing her undergraduate degree, Manuela moved to the U.S. in 1970 with her American husband, a lawyer, whom she had met and married in India.

"My husband was representing the poor in civil cases. He was what we call a legal aid lawyer while we lived in San Joaquin Valley, where he represented farm workers. It was a very isolated life actually, and I found that quite difficult when I first got there, because I had left all my family and friends in India. My husband went off to work, and I was stuck in this little town of about 15,000, in the middle of the San Joaquin Valley. I had read about Caesar Chavez, who was a farm workers' union leader, and I started doing volunteer work with the farm workers' union in Delano. This experience inspired me to go to law school."

Manuela received her law degree from the Hastings College of the Law in San Francisco.

"There were not many women role models in the school," Manuela says, "or even in the public interest bar, and generally speaking, people were sexist in their attitudes toward women lawyers and held stereotyped opinions of minorities. When I decided to go to law school, it occurred to me that I wanted to do some sort of community service. So I became a government legal aid lawyer representing the poor. That is what I did for six years."

It was a time of major changes in the United States—an exciting time to be around. It was a time when the civil rights movement, antiwar movement, the women's movement were at their heyday, a great time to read provocative books and discuss revolutionary ideas.

"I read a lot of books, before and after I came," Manuela says. "In the early seventies I read all the feminist books. I read *Soul on Ice* by Eldridge Cleaver, Gloria Steinem, Angela Davis, *The Autobiography of Malcolm X*. So the notion of being able to do something that would change the society and bring about a just society was what made me excited, and that is what I did for six years as a legal aid lawyer. My heroes were people like Caesar Chavez of the United Farm Workers and Angela Davis of the Black Panthers.

"For me, having an ideological understanding of the status of women, women's roles, the systematic way women were repressed, all that really came after coming to the United States. I think I was far more familiar with the civil rights movement before I came here, and it seemed to be evocative of the anticolonial movement. I think there was a continuum there because after all, Gandhi was challenging the repressive laws of South Africa and was promoting civil rights.

"I think I have a strong sense of justice and how the society should be just, and I have made choices in my life based on that. I used to think, these are the good guys and these are the bad guys. Now I see that oppression can be manifested in a variety of contexts. And there aren't merely people with the white hats and people with black hats. I think all human beings carry around prejudices. Society sometimes reinforces these prejudices and provides a vehicle to oppress a particular group, saying OK, this is the group we should pick on now. But nobody is immune from being the oppressor—it is not like certain groups are always the victims and the other groups are always the oppressors. The roles are reversible."

Following her work as a legal aid lawyer, Manuela went to work in the city attorney's office in Berkeley. She is the first Asian-born to become a city attorney in California. She might also be the only lawyer in the United States who goes to court wearing a sari. The official attire of an American attorney is a dark blue suit.

"The Supreme Court relaxed its dress code for me!" she beams.

"When I go to work I usually wear Indian saris, mainly because it is very difficult to find clothes that fit me, look nice, and I like. It is also difficult to keep track of the fashions. So I started wearing saris more and more when I have to be in formal settings. It is one of the things I love about India. Unlike so many cultures, India has retained its cultural traditions of how people dress. The sari is a beautiful dress. Why would we ever give that up? I hope we would never give that up—lovely textiles, beautiful clothes. It is such a cultural advantage. Why would we relinquish this advantage in favor of wearing a kind of worldwide uniform? For men having to wear suits and women having to wear dresses is like we submit to a tyrannical fashion. Wearing a sari is a kind of liberation. I don't have to have some designers design the kind of clothes I wear. I can be my

own kind of woman. There is also the influence of my mother who thought the sari as the perfect way for us to dress, since it is beautiful and elegant. I never felt that I had to give it up in order to function in a Western world."

The Supreme Court required lawyers with cases before the court to wear dark blue suits. On hearing that Manuela normally wore a sari to court, the Supreme Court paused to ponder and finally decided to permit it. Now it is part of the legal dress code of America, thanks to Manuela.

"What I find is, when you do things your way, people take you on your terms," Manuela says. "Now people don't see the sari, they are oblivious of it; they just see me. They may observe that I am wearing something nice. I could be wearing a nice suit. By the fact that somebody like me in a visible position wears a sari, I hope I have made it more acceptable for other people to feel that they don't have to fit into some mould."

Because of the way she is dressed, occasionally she is mistaken for the client rather than the lawyer, but Manuela is not offended. Once she was singled out by a court bailiff, who asked her for identification while letting in other more conventionally dressed lawyers, as if to imply that someone dressed in a sari could not possibly be a lawyer. And at a sexual harassment workshop for city employees that she had attended, a male employee approached her and made an off-color sexist joke. The workshop had been organized based on Manuela's legal advice. She pointed out to the man that his joke could constitute sexual harassment. The male employee, unaware that Manuela was the city attorney, arrogantly handed her his card and asked her to "have your lawyer contact my lawyer." Manuela quipped, "Well, actually, I am your lawyer."

Manuela has been the Berkeley city attorney for more than nineteen years, which is four times the tenure of previous city attorneys.

Since the sixties the job has been very turbulent and difficult. Manuela finds she is always in the middle of the cross fire, not necessarily because she is doing anything right or wrong but because the issues are politically charged and people are so intensely involved.

"In my role as the city attorney, I have a duty to the public. So when I issue opinions I try to figure out what the law is and conscientiously tell the people. Our role inside the city is to make sure that the city follows the constraints, and that is not just being the policeman but keeping the government operating in an ethical way."

The city of Berkeley, in a proclamation honoring Manuela for her remarkable career and for other contributions, described her as "one of a select group of women who have served as role models for young people through courage, compassion and commitment in helping to shape American life, and who are an inspiration for building our future."

Manuela was honored as one of twelve Asian American Women of Hope by the Bread and Roses Cultural project of New York, through a poster campaign to honor women for their contributions to society. The first person of color to serve as the president of the City Attorney's Department of the League of California Cities, Manuela has received several prestigious awards.

A "real" person in every sense of the word, Manuela is refreshingly forthright, having no pretenses, no deceptive façade to hide behind. One can see her passion brighten her eyes when the topic is feminism, or civil rights, or equal justice for all, or sexism in America.

"There is the whole objectification of women—women as sex objects—and reduction of that objectivity into some sort of very harmful ideal of body type," Manuela argues. "Feminism has been challenging these norms for a very long time, and celebrating the divinity of women's bodies and styles. There are so many different ways to be attractive. I

think it is very unfortunate that sex has become a commodity, which debases American culture. There are so many wonderful things about American culture, but constantly focusing on sexuality has cheapened it a great deal and makes sexuality less sensual than it actually is."

Manuela is a cofounder of Narika, a nonprofit organization helping South Asian women victims of domestic violence—one of the first of its kind in California. The organization was started on a shoestring budget, using the founders' own homes as venues for fund-raising events and their phones as the help line, and depending on contributions from friends and families. Today Narika has become a well-recognized information and referral service, with a toll-free hot line, helping abused South Asian women, who generally are less likely than women from other cultures to go for mainstream help. Manuela also established a hot line for South Asian victims of hate crime.

As an attorney and a believer in civil rights, she spearheaded a voter education and registration campaign for the 2000 presidential election, putting together a voters' handbook and registering people at various gatherings.

"I wanted to make sure that all immigrants are participating in the society," she says. "They need to know what their rights are, and not just let some few people go to the polls and make laws that might be discriminatory against the new immigrants. So, in the sense of empowering the community, educating the community, bringing them into the mainstream, that was very exciting to me. I might do it again for the future elections."

Manuela worries about our highly materialistic approach to success, which she considers harmful to children, too, because they feel pushed in that direction. When her daughter chose to be a teacher in a public school—not exactly a lucrative job—her initial reaction was dismay

because her daughter is smart and good at math and science. Also, Manuela's feminist notion of "we have broken down the barriers, and now women can be anything, not just secretaries and teachers" came to the surface. But it only took her a few seconds to realize what a silly reaction that was, because she saw the picture from another perspective. Her daughter has *chosen* to be a teacher.

"We didn't break down all the barriers in order to force all women to become scientists or lawyers or doctors," Manuela says. "We wanted women to have a range of choices, and what contribution is more important than raising our children to be full human beings?"

§§§§

Love Your Math

There was a long period in the United States when the term *woman mathematician* was an oxymoron. Lenore Blum, a research mathematician currently working at Carnegie Mellon University, writes:[5]

Now, if you were a female graduate student at the time, there were certain departments where you probably were not. For example, Princeton did not start admitting women to their graduate program in mathematics until the fall of 1968. Marjorie Stein (Princeton Ph.D., 1972) was the first woman to complete her degree requirements there, although a Japanese woman had been admitted some years earlier by mistake.

[5] Blum, "A Brief History of the Association for Women in Mathematics: The Presidents' Perspectives," *American Mathematical Society Notices* 38, no. 7 (September 1991): 738–774.

Apparently the admissions committee, unfamiliar with
Japanese first names, did not recognize hers as female.

But wherever you were, you may very well have
been told the following "joke" by the head of your
department or your thesis advisor:

"There have only been two women
mathematicians in the history of mathematics. One
wasn't a woman and one wasn't a mathematician.'"

Before the 1970s people seldom mentioned mathematics and
women in the same sentence. Girls were discouraged from taking math
courses in schools, perhaps with the underlying belief that they were not
biologically endowed with the brains to do math.

Bhama Srinivasan was fortunate to have come from a family of
learned men and women in India. Her maternal grandfather was an
amateur mathematician. Her great-grandfather was the administrative
chief of a province in the British regime, her aunt was a professor at
Queen Mary's Women's College in Madras, and her cousin was a
professor at Cambridge University in England.

All these factors may not count as credentials for a woman to
have a career in mathematics. However, growing up in such eminent
company in the South Indian city of Madras, Bhama showed an interest in
mathematics while still in school. The oldest of three children—all girls—
Bhama was the only one drawn to math. Her parents were enthusiastic
about their children's education, and it was more or less assumed that they
could study whatever field they found appealing.

"My father was an avid reader, and his love of books was passed
on to his children," she says. "I think this was an important influence in
our lives. My mother was a housewife. She was more outgoing than my
father, and this also was a good influence as it helped us to learn to
socialize with people. My mother had a wide circle of friends with whom

she went to the movies, theater, and so forth, while my father stayed home with a book.

"Our parents wanted to give all of us a good education. Beyond that they didn't have any special aspirations for us. They definitely wanted all of us to get married and have families, though."

Bhama remembers her high school years when she was fortunate to have a good mathematics teacher. The teacher introduced her to Euclidean geometry, and she learned to write proofs for geometrical theorems. However, her college education at a coeducational institution turned out to be an uninspiring experience because of its ancient curriculum. She received her bachelor's degree in math and went on to more stimulating graduate studies at the University of Madras. A course in abstract algebra, based on lectures given by Emmy Noether, the renowned German-born mathematician, would prove to have a profound effect on Bhama's life.

"I did not have any ambitions to be a researcher in mathematics at this time nor, for that matter, to pursue any career at all," recalls Bhama. "I knew I was expected to get married rather than worry about a career. So I got married to a mechanical engineer who went to Manchester, England, to receive practical training. Following my husband to England, I was able to start my Ph.D. program at the University of Manchester, which led to major changes in my life."

The experience in England opened her eyes to a new way of life—women's role in particular—including having a career for herself. She stayed in Manchester to finish her Ph.D. after her husband had returned to India. On her return to Madras later, Bhama tried for an academic job at her alma mater. But in the 1960s women were not expected to have independent careers, and the society was uncomfortable

with the notion of women leaving their domestic roles. Bhama confronted many unfriendly questions:

"Your husband has a good job, so why should you work?"

"Aren't you taking away a job from a breadwinner?"

"It is a pity you don't have children, but isn't it wonderful that you have something to keep you occupied?"

Women were just barely beginning to explore their other options outside the home, much like the scene in the United States at the time. During this period Bhama happened to meet Professor Armand Borel, an American mathematician, who invited her to come to the U.S. for a one-year study at the Institute for Advanced Study at Princeton. Bhama accepted the invitation and attended Princeton.

Eventually, she wanted to leave India and emigrate to the U.S. to become a professional mathematician here. By the time she decided to leave India and start teaching at Clark University in Massachusetts, she had separated from her husband. She came to this country in 1970—the beginning of a decade when American women started participating in many professions, including mathematics. Bhama was one of the few women at that time who studied and taught mathematics.

She and a group of women mathematicians and students began meeting regularly to discuss problems and issues they faced. In 1971 the group became the Association for Women in Mathematics (AWM), dedicated to encouraging more women and girls to enter the field of mathematical sciences.[6]

[6] The Association for Women in Mathematics was founded in the U.S. The main office is in the University of Maryland, and many members are in foreign countries. The president of the AWM coordinates the organization's activities and represents the organization to the public. The organization discusses problems like women's pay, promotion, recruitment, and retention of women faculty in mathematics departments.

In 1981 Bhama became the president of AWM, and one year later she organized the group's first major mathematical symposium in celebration of the hundredth anniversary of Emmy Noether's birth. The symposium, held at Bryn Mawr College, was charged with mathematical energy and overflowed with enthusiasm and scholarship. Subsequently, the Association for Women in Mathematics has been presenting the Emmy Noether Lectures annually to honor women who have made fundamental and sustained contributions to the mathematical sciences. These one-hour expository lectures are presented at the Joint Mathematics Meetings each January.

Emmy Noether, born in Germany, received a doctorate degree in mathematics in 1909 and taught without pay because women were not allowed to work as professors anywhere in Germany at the time. Later she came to the United States and became a professor of mathematics at Bryn Mawr College for Women. She taught a branch of mathematics called abstract algebra and in doing fundamental research became a founder of modern algebra. Emmy Noether became a prominent figure in her field, inspiring future women mathematicians, including Bhama.

Since 1980 Bhama has been a professor of mathematics at the University of Illinois in Chicago. Her specialty is abstract algebra and, more specifically, representation theory of finite groups.

"My experience as a student in England did help me to adjust quickly to life in the U.S.," recalls Bhama. "Naturally, my family was not happy when I decided to live in the U.S. permanently, but after some years they realized I was happier here than I would be in India and accepted it. They were also proud of the fact that I was doing well in the U.S.

"The major adjustment I had to make was to learn to teach in an American university. The experience was somewhat different than that of

England, because more students go to college in the United States than in Europe. So one gives a lot more homework, tests, quizzes, and so on, here than one would in England where students are expected to learn on their own. After a few years I got used to this system."

Happily accepting her responsibility to future mathematicians, Bhama specializes in group theory. Her work in the early eighties, in collaboration with colleague Paul Fong, led to new directions in the modular representation theory of finite groups. Bhama provides direction and guidance to Ph.D. students in her field, helping them achieve their goals.

"The situation for women mathematicians in America has changed for the better," says Bhama. "There are more professional organizations for women now than in the sixties and seventies. Now more women are going to professional careers. In the 1970s only 7 percent of Ph.D. degrees in mathematics went to women; now the figure is 25 percent.

"I would tell any young woman or girl who liked math to go ahead and excel in it. There are many careers open to young men and women with a mathematical background. I would emphasize, however, that it is important to have a liking for the subject if you are going to be seriously involved in it all your life."

Getting a Ph.D. in mathematics is a lengthy, difficult process that can take six or seven years, Bhama warns, and ultimately, it might not be easy for a pure mathematician to get an academic job. For a woman wanting to have a family, pursuing mathematics can be very challenging. But those women who decide to work toward a career in mathematics have several options today because it provides a tool for solving complex practical problems, besides offering opportunities to be creative. Mathematics is logical, intuitive, and precise. It helps one to identify and

explain patterns of all kinds. Its applications are quite varied and may range from studying the patterns of nervous systems to stock market fluctuations, from astronomical variations to ecological analysis. The Association for Women in Mathematics publishes stories of women who use their math education to work in various fields—oil recovery and exploration, robotics, research on nature, cryptology, health science research, and, of course, teaching, are just a few.

Besides serving as the president of the Association for Women in Mathematics for two years, Bhama was also a member of the Institute for Advanced Study in 1977 and the Mathematical Sciences Research Institute in 1990. She has held visiting professorships at the École Normale Superieure in Paris, the University of Essen in the Federal Republic of Germany, Sydney University in Australia, and Science University of Tokyo in Japan. She served as an editor of the *Proceedings of the AMS*, *Communications in Algebra*, and *Mathematical Surveys and Monographs*. Bhama was also a member of the Editorial Boards Committee of the American Mathematics Society.

The international aspect of mathematics excites Bhama—her students come from all over the world—and she hopes this tradition will remain alive. Having lived more than thirty-two years in the United States, however, she believes immigrants should assimilate into the society in which they live.

"I don't like the insular life that many immigrants lead," she says. "So I have tried to make friends with many English people in England and with Americans here. This way I have come to be comfortable and at peace with my environment. Mathematicians form an international community of their own. It is possible to go to a completely strange country, like Japan for instance, meet a mathematician working in your

field, and start a conversation right away. This is a very important reason why mathematicians are able to adjust quickly to new environments.

"But sometimes people have misconceptions about Indians. Once a colleague introduced me to a woman in a restaurant. This woman immediately asked, 'Are you a yoga teacher?'

"My colleague replied, 'Maybe one day your children will be her students at the university, learning mathematics.'"

When not in her classroom, or figuring out the solution to a new problem, Bhama likes to read, especially biographies of interesting people. One might also find her in museums, probably the famous Art Institute of Chicago. A recent enthusiast of yoga, she looks forward to a healthy and productive life as she gets older.

A quiet and unpretentious woman, Bhama's love for mathematics is obvious to anyone visiting her office, where mathematical symbols of all shapes and sizes appear in every available space—bookshelves, blackboard, desktops, computer screens, walls, windowsills.

Bhama likes to communicate to her students the great beauty and applicability of mathematics. In answer to the age-old question, "What is mathematics for?" she is apt to respond, "What is the Grand Canyon for?" Just as the Grand Canyon is one the wonders of the world, mathematics is one of the wonders of the human mind. If its mysteries make you nervous, you might joke about it, but Bhama would say it is nothing to laugh away.

"My own view of mathematics through the years has been that truth and beauty are enough," she remarks. "In fact, I have often

reminded my students that the best mathematical achievements took place when the question, 'What is it for?' was never asked."[7]

Living single and childless, Bhama comments about her American life.

"In Western society one can lead an 'eccentric life' and not be part of the mainstream. A woman can be single and live alone, be married and childless (or child free, as some would call it), be a single parent and so on. When people ask me, 'Do you have children?' the answer, which is no, is accepted as a fact. In India, on the other hand, it is a loaded question, where not to have children is the worst fate that can befall a woman, except perhaps not to have a husband!"

§§§§

From My Perspective

I grew up listening to the stories my grandmother told of many strong women in mythology. The power of mythology was such that it could open your imagination, allow you to travel with any particular character, assume their superhuman capacity, and then, unknown to everyone, return home with an expansive feeling of potency. It all depended on the acumen of the storyteller.

My grandmother allowed us to imagine, to fling open our artistic windows. So the mesmerizing story of Draupadi in the *Mahabharata*, instead of frightening me, captured my fantasy, raising me to a realm of personal euphoria mingled with a sense of sovereignty. Americans may

[7] From *Profiles of Women in Mathematics The Emmy Noether Lectures*, http://www.awm-math.org/noetherbrochure/Srinivasan90.html.

like to call her Dru for convenience. Dru had to please many people, be this and that to her five husbands, accept many roles unquestioningly, and finally face extreme humiliation through no fault of her own. She was born a princess, the only daughter of a king, beautiful and blameless. Although she married the most valiant prince of the time, she ended up marrying her husband's four brothers as well because of a strangely ironic wordplay. She carried out the awesome responsibility of being the wife of five men, one at a time. Single-mindedly, she lived with one husband for one year, bearing his child if necessary, then moving on to the next husband, never disapproving of any, never favoring one husband over another. She followed the husbands to the forest on a long exile, surviving on meager accommodation, still pleasing them, and being the hostess to random visitors to her jungle abode. Finally, on returning from exile, she was pawned as collateral, as a piece of property, in a chess game played by her gambler husband. When he lost the game, Dru lost her identity, even her dignity. The lowest moment of her life came when the villain, the winner of the chess game, dragged her by the hair before the royal court filled with men and disrobed her while her five husbands watched in despair, paralyzed, too afraid to protect her. While the last strand of self-respect was to be yanked away from her, while she saw in horror that not one man dared to rescue her, she turned inward to the one spot she had held sacred, powerful, self-determining, and divine. Anchoring her faith to that part of her uncorrupt self, believing that a universal force beyond her fearful existence would protect her, she stopped begging for mercy, began to let go, and prayed. Miraculously, as the villain struggled to reveal her nakedness, the long piece of cloth she had wrapped herself in seemed to become endless, unrolling forever. The more he pulled, the more clothing appeared on her. Dru returned to her chamber victorious, as her violator fell exhausted.

Dru could never have beaten her oppressor by physical force. There was nobody she could rely on at the moment, not even her five husbands, who had pawned themselves on the chess game. Not only did she recover from her humiliation, she made a solemn vow that the assault would be avenged, that her hair would remain untied until one of her husbands would tie it back with hands stained by the assaulter's blood. It was a vow that had to be fulfilled, and it was a significant trigger leading to the *Mahabharata* war between the two opposing factions.

It is easy to dismiss her as a pliable woman who bent backward and sideways as her husbands demanded of her. But we can also see Dru as an extraordinary woman who had built her strength through years of practice, focusing on her inner spirit, affirming her vitality. How could she even believe she would be able to bring the brothers together and not lead them to fight each other over her? How could she survive her multiple roles, which, if she were not centered in herself, would have hurled her into many emotional typhoons? This drama of a powerless, solitary woman, battling against the mean, uncaring world of a vociferous court, was one of the most empowering stories I heard in my childhood.

Coming from a stronghold of patriarchic culture, the story beautifully and imaginatively tells us that a woman is not all that helpless, that she has immense power within her if she cares to grasp it and nurture it. Of course, the story is not about the rightness or wrongness of a woman having five husbands at one time. Instead, her story can be seen as a metaphor for a modern woman exerting herself to meet the thousand expectations of her family, her job, and society. She is striving to be simultaneously a breadwinner, the nurturer of her family's needs, a model homemaker, a perfect wife, a supermom. She has a husband and a boss to please while being the accomplished daughter of her parents' aspirations. Society demands her to look a certain way, dress a certain way, and be

forever young, attractive, and worthwhile. She is asked to be gentle and soft-spoken and yet assertive. Her worth is measured higher if she is with-a-man.

In the midst of it all, the pressure builds to be accommodating to everyone around her, and she forgets to discover her inner vision, hear the voice of her soul. Should she go along with the popular intentions and the dictates of her culture? Or should she become the sculptor of her idyllic self-image, be self-respecting and attentive to her own desires, and live authentically, purposefully? Because at the moment of truth, when all else fails, when the rest of the world turns away, she would have to look inward, to the depth of her own essential nature to find her answers.

Chapter 3

LIVING BEYOND WIFEHOOD

Honor Your Creativity

 "Mine was an arranged marriage," Ramaa Bharadvaj describes. "There was this matrimonial ad that mentioned, 'Girl should be either a singer or dancer.' It wasn't romance or love at first sight or any such thing. I knew I would never be fulfilled playing the traditional roles of a wife and mother. I married my husband for my dance. First and foremost I am a dancer. I belong to the world, too! That is part of my destiny. No human has the right to artificially alter anyone's destiny."

Twenty-two years later, when *Dance* magazine, regarded the most authoritative and respected dance publication in America, put Ramaa and her daughter Swetha on the cover of their June 2000 issue, Ramaa knew she had come full circle by being recognized for her dance around the

globe, beginning with the dance stages of Madras, India, where she grew up. Those who remember the little dancing girl of the 1960s are now witnessing a brilliant woman, a world-class dancer, who has stepped into the hearts of the American public. She has brought the Indian classical dance of Bharata Natyam to a place right beside the Bolshoi Ballet, which was featured in the same issue of *Dance* magazine.

"That is the first time in forty-five years that Indian dance has made the cover of the *Dance* magazine," beams Ramaa.

"Indian classical dances are very different from Western dances, like Flamenco, jazz, modern, or ballet. The differences are not only in the movement and style but in the very attitude itself.

"First of all, Indian dance cannot be categorized simply as a concert dance form, performed for the sake of entertainment. I once read a quote that said, 'The purpose of dance is to educate the illiterate, to enlighten the literate, and to entertain the enlightened.' So the purpose of all art in India is to educate and elevate the spirit. There is a lot of spirituality in the dance, and a sense of humility that goes with it before you begin to dance, as you dance, as you finish your dancing. The Western dance form started as an entertainment art form and it stayed as an entertainment art form."

Bharata Natyam, one of the seven major classical dance forms of India, is representative specifically of the culture of Tamil Nadu, South India. It is an evolved form of an ancient dance, which has been known in India for more than three thousand years. It was practiced as part of a worship ritual within the sacred confines of the temples by temple women, the so-called Devadasis.[1] It draws its inspiration from Bharata's *Natya Shastra* (Bharata's treatise on dance), dated at least 2000 years ago. The

[1] *Devadasi* means "servant of the gods."

dance later acquired a reputation of being associated with women of "questionable character." As a result, most women of the upper castes, especially the Brahmin women, did not perform it.

Ramaa's mother, born in an orthodox Brahmin family, dreamed of becoming a dancer, but she could only dream, never practice. Her twin daughters, Ramaa and Uma, endowed with their mother's gift, began displaying their talent even as toddlers. Watching performances in which their neighbor danced, the children picked up many of the gestures and steps and would enthrall the audience during intermissions. At one such performance, a well-known dance teacher of the time, Vazhuvoor Ramaiah Pillai, happened to see the sisters on stage. He was amazed at the innate grace they displayed and offered to give them training. Ramaa's parents struggled with the decision to send the children to dancing school; her father, an accountant, didn't think he could afford it. But Ramaiah Pillai was so sure of the twins' talent that he started a program of training that culminated in the girls' Arangetram, their debut concert on stage, when they were only six-and-a-half years old. The sisters were later trained by dancer Kamala, the legendary Bharata Natyam dancer of international fame.

"It was under her that I really blossomed," Ramaa says. "My creativity grew, and I owe a lot of my growth as a dancer and a choreographer to her. My teaching is now structured by the way she taught us. So I owe it all to her."

Ramaa also learned Kuchipudi, another form of South Indian classical dance, from Dr. Chinna Satyam, a well-recognized master in India. Known as Uma and Ramaa Dancing Duo in India, the twins performed together for many years until 1978, when they parted ways as Ramaa married and left for the United States.

Ramaa lives with her husband, Bala, who has a Ph.D. in aerospace engineering and works at Boeing. Bala is a very good cook, Ramaa says, makes the best masala tea in the world, and is a great housekeeper. They both take care of the home in each other's absence. He is also her photographer.

They have two children. Their daughter, Swetha, started dancing with her mother when she was four years old. She has become a Bharata Natyam and Kuchipudi dancer in her own right, having received extensive exposure and training from her mom. She is a university student, studying biochemistry and business management, but dance is still an important part of her life. Ramaa's son, Siva, a sixth-grader, is as proud of his heritage as his sister.

An ardent devotee of Lord Shiva, the Hindu God of Dance, Ramaa once had a miraculous cure from a disease. When her daughter was three months old, Ramaa contracted a spinal infection that left her paralyzed. The family was living in Boston at the time, and she went to various doctors and neurologists who predicted that she would never dance again.

A year later they went to India and visited Ramaa's favorite Shiva temple at Chidambaram. She stood in the temple with tears rolling down her cheeks, asking Shiva what she would do, how she would dance without her legs. Then hearing a commotion all around, Ramaa looked up to see her daughter, seated on her husband's shoulder, who had never seen a dance before, show three of the most important hand gestures of Bharata Natyam.

"'Thank you God,' I said to Shiva," Ramaa recalls. "If she has to dance, that means I have to dance, because I have to teach her. When I came back to the United States, within three months I was dancing! I even invited my neurologist for my concert, the one who told me I would

never dance again. And I taught my daughter, and even now I tell her, you have no choice, your first lesson came from Nataraja (the Dancing Shiva) Himself, and so whether it is frustrating or whatever, until He takes your legs away from you, you have no choice, you just have to dance."

The experience was so moving for Ramaa that she began to see her art as "not a privilege but a sacred gift that I have to handle with much respect and a lot of sanctity, because what He gives, He can take away."

She established a dance academy in Orange County called Angahara Ensemble where she trains future dancers in the traditions that have brought so much meaning and direction to her life.

"If I have left my country and come here," Ramaa says, "there has to be a purpose, because God has brought me to this country instead of leaving me back in India, where I would be most comfortable. That means the art that was given to me has to be shown in a beautiful way to an audience outside of my Indian community. I have done that quite successfully and the recognition is coming from that arena as well.

"When I hit my fortieth year, I went through this big turmoil of trying to understand what it is I am doing with my life, what my art is supposed to mean to me. What am I supposed to do with my dance? That quest became my struggle."

In 1996 Ramaa was asked to teach Bharata Natyam at the Los Angeles County High School for the Arts. Many of the students came from low-income families of different races and backgrounds.

She had to teach them for six months. Maybe it was the confusion of religiosity with spirituality, or maybe it was just a fear of the unknown, but the first few weeks with those students were extremely difficult. Even though the students were artistically gifted and focused, they were unmotivated about taking the class. Most of them dreamed of

becoming professional ballet or modern dancers and wondered why they should learn this "weird" Bharata Natyam dance, which was of no immediate use to them. Every time Ramaa initiated a specific dance movement, the students would resist learning or even attempting it. They were convinced that Indian dance would surely give them physical injuries.

"Taking the project as a challenge to transcend the cultural barriers, I persisted," Ramaa says. "A turning point came in October 1996 when I decided to organize a Vijayadasami Festival for the students.[2] I designed a ritual for them to be part of the class in the dance studio. All the teachers from the dance department were invited. The students enthusiastically helped me create an altar with objects they brought from home: their favorite musical instruments, ballet slippers, costumes, books, even a sewing kit. The invited teachers were seated at this altar.

"My students came forward in pairs and recited the English translation of *Gurustotra* couplets.[3] With bells on their ankles and colorful scarves covering their bosoms, each of them worshipped the teachers by waving ghee lamps. For the first time, they were looking at their teachers as 'givers of knowledge' and they were fascinated by the idea of respecting that 'light of wisdom' in their teachers. I even had Indian snacks for them at the end. The event was so successful that one of the teachers suggested doing it every year.

"The following classes became more manageable. The students asked questions, participated with enthusiasm."

[2] Vijayadasami is a ten-day festival of Goddess Saraswati, during which adults and children surrender their tools, books, and other objects of importance to them to the goddess for blessing and rejuvenation.

[3] The *Gurustotra* is part of the *Taitreeya Upanishad* and used as a student-teacher peace prayer.

At the end of the six months Ramaa taught them a brief Thillana, using the movement patterns that they had worked on.

The students were soon getting ready for a stage performance, as part of the school's spring concert at the California State University, Los Angeles. Ramaa and her husband made costumes for all of them because the school's budget was tight. The students, along with Ramaa, did three performances. Ramaa admits the students were amazing, and after the event the girls went up to her with tear-filled eyes, saying how beautiful and touching the entire experience had been for them.

"When you create a ritual for them," Ramaa points out, "you create meaning for them, and they open up. India is full of meanings, full of rituals, full of symbolism."

The project was so successful that the teachers claimed that the students Ramaa taught were the most well behaved group in the whole school. After a break of four years, a grant from the Parsons Foundation enabled the Los Angeles County High School for the Arts to invite Ramaa back again to teach for an entire semester in the fall of 2001.

According to Ramaa, a teacher comes closest to achieving immortality when she or he passes on knowledge and traditions. Whether it is art or science, by giving students that living, breathing, intellectual thing called knowledge, the teacher becomes immortal.

"A student once wrote me a very beautiful note that I have treasured," Ramaa relates. The note reads:

> Ramaa has been one of the best teachers I have ever had. I am not a dancer, but she was so able to pull talent out of me, and make me feel proud of what I have learned so far. . . . I have never been an athletic, or even graceful person, but Ramaa has truly made me feel more coordinated, and she makes me feel that I am beautiful. I appreciate her time in the classroom and her caring attitude. I wish every teacher did for me and my

educational process what Ramaa has done—make me
feel excited about learning and achieving.

Ramaa's dance career, which started with teaching a few Indian
immigrant children, has grown beyond ethnic boundaries. Even her
teaching style has evolved over the years. When she teaches children
growing up in this country, whether or not they are Indian, they have a lot
of questions in their minds, and dance becomes a vehicle for her to help
the children find the answers to those questions. She also makes good use
of her great sense of humor, because humor always gets people's attention
and opens them to receiving the messages she wants to pass on. In a
feature story in July 2000, the *Los Angeles Times* described her as " a
woman with a vivacious spirit, dry wit and warm laugh. . . . She has
emerged as an important voice in the mix, an unorthodox blend of the old
and the new."

A tireless advocate of multicultural education, Ramaa has taught
at U. C. Berkeley, Loyola Marymount University, Inner City Arts, Mt. San
Antonio College, Riverside Community College, Pomona College, Mt. San
Jacinto College, the California Institute of Arts, California State University
at Long Beach, the American College Dance Festival, the Southern
California Tap Festival, the Twenty-seventh Annual California Dance and
Movement Conference, the Art Center College of Design in Pasadena,
and the California Arts Council's statewide arts conference in Asilomar,
California.

In the summer of 2000 she was invited for a weeklong workshop
at the Ballet San Jose, a high-profile ballet school in the city of San Jose.

"I just had a magnificent experience there," says Ramaa of her
experience. "The students there are so disciplined. This is a serious ballet
school where students dance from morning till evening, going from

technique class to music class to acting class. So the artistic director wanted to give them a different kind of body experience."

The emphasis of the body alignment is similar in ballet and Bharata Natyam, she explains. There are differences in movement, though. In ballet, whenever the dancers lift their legs, there is a point and a kick to it, and there is an airborne feeling. Bharata Natyam has more earthiness, with power coming from the earth and directed back to the earth. The other difference is that Indian dance emphasizes eye and neck movement and facial expressions.

Ramaa's teaching style may have a lot to do with the enthusiasm of the students to learn a dance style entirely dissimilar to their own. Her high spirit when she is on the dance floor ignites students' excitement to learn. She doesn't simply stand there as an "Indian dance teacher" but often becomes a clown, gets them to move, teaches them a certain walk, for example, by showing the movement in an exaggerated way, using humor and breaking down the movement. She keeps them motivated, keeps them laughing and happy.

With older students in colleges, Ramaa is not shy about discussing the eroticism and sexuality of the human body.

"In fact, the first gesture I teach when I go to colleges is how we show sexual intercourse in Indian dance. 'Do you know we have a gesture for that?' I ask. They say, 'Wow,' and I show them, and everybody is practicing separately. I teach my whole class like that, and now they sit down, now they want to listen to Indian dance, because they know that this is interesting, it is not stupid or sobering, and I am not going to teach religion to them.

"Why is there a negative connotation attached to human sexuality? I am a dancer, and my body is my temple in which I invoke God every time I dance. We trained our bodies to look elegant, to look

beautiful, to look graceful. We were taught that our bodies became the instrument of worship every time we danced. We were taught that the erotic content of the divine love poetry, used abundantly by dancers, was a metaphor for spiritual yearning. Why? Why did the poets use that as a metaphor? It is because the actual physical union of two people in love is probably the most beautiful and the closest feeling to bliss."

Ramaa became the first Indian dancer to receive the prestigious Lester Horton Award, not once but twice in 1993 and 2001, for outstanding achievement in staging traditional dance. The award was established by the Dance Resource Center of Greater Los Angeles to honor Los Angeles dance community, and the recipient is picked by a peer panel of prominent dancers and choreographers from Southern California. As a special tribute to Ramaa's contributions, she was selected to host the award ceremony in 2000.

Ramaa is a regular advisor for the California Arts Council, working on several dance panels for them, and also on a panel for the National Endowments for the Arts. The honors came to her not because she is an Indian dancer within an Indian crowd but because she accepts a bigger responsibility.

Judy Mitoma, the director of the Center for Intercultural Performances at UCLA described Ramaa as follows in the July 2000 article in the *Los Angeles Times*:

> Just as Twyla Tharp shocked people by combining ballet and pop culture, Ramaa is courageous in not restricting herself to pre-determined categories. She is dedicated to tradition and respectful of what it represents. Still she is also a contemporary soul engaged creatively and politically with what's happening in the world.

"Today I see myself not just as a dancer narrating the stories of the gods but as a mentor as well," says Ramaa. "I also see myself as a

leader capable of creating change in the society through my art. I realize that every time I dance, teach, or create, I have the capacity to make a change in the life of someone. I feel drawn toward social causes such as dancers suffering from AIDS, violence against children and women, and causes that afflict the society in which we live.

"I also believe in the basic freedom of an artist to create. No one has the right to deny or take away that freedom. Recently, at a conference in Chicago, I was saddened by the uproar that was created after a performance by Chandralekha's presentation of Sarira—an exploration of the erotic power of the human body. It was OK to watch stories of Krishna's adulterous relationships enacted through gestures in a classical dance presentation, but it was not OK to watch Chandralekha's presentation because it made the traditionalists too uncomfortable. I was on the review panel and spoke up for Chandralekha because I believe in the artist's basic freedom to create. Otherwise, there is a danger of us repeating the horrors of the Khmer Rouge and Cambodia.

"It is censorship, and I am against it. I am reminded of Archibald MacLeish's quote, 'What humanity needs is not the creation of new worlds but the re-creation in terms of human comprehension of the world we have, and it is for this reason that arts go on from generation to generation.' For the same reason, artists have the obligation to fiercely guard their freedom."

For a tradition to continue, she believes, new energy must constantly offer the nourishment of new experience and small revelations. She hopes to be continually energized and inspired by life around her to create new collaborations, explore new artistic possibilities, and keep her tradition alive through growth and change.

"I have different roles: I am a wife—we have been married for twenty-four years, and he is someone I look up to—I am a mother, and I

am also a daughter. But finally, I strip all those roles out of me and try to explore who am I, what I am doing that is meaningful to me. If the kids leave, will I become meaningless? If my husband leaves me, will I become useless? Those are some questions I go through. I then realize that I have to first understand whatever I create, whatever I give, has to give great personal satisfaction to me, whether I am creating art, or whether I am living my life as a human being. But once I get that, then all of a sudden everybody goes into shock: What is the matter with you, you have changed. But the truth of the matter is that I have not changed, I just have not exhibited that part of me that was suppressed so far. And then I realize, oh, this is me, this is who I am, and please try to understand this part of me."

§§§§

Discover Your Art

Mercy Metherate knew at an early age what her role in life would be. Her two older sisters were married at sixteen years of age, on finishing high school, so Mercy never questioned what she would be doing when she finished school. Born and raised in an upper-middle-class Christian family in the southern state of Kerala, India, she grew up in a large family—the third of eight daughters, with aunts, uncles, sisters, cousins, and grandparents as well as servants, maids, cooks, neighbors, old family

friends, companions. *Loneliness* was a foreign word. Her father, G. P. Paul, was the general manager of a well-known cloth mill in Kerala.

Getting married was the most natural thing for girls to do when they graduated from high school in those days. Parents would be looking for a "boy" the day a daughter was born—a boy from a good family, with similar religious beliefs and matching financial status. For Mercy, the choice was clear when they found Joseph Metherate, a young man of great promise doing graduate studies in the United States. Joseph married Mercy when she was sixteen.

"I stayed home in India," Mercy remembers, "while he traveled back and forth between the U.S. and India. Our two children were born in India. Only after finishing his graduate studies and accepting a job in the World Bank did he ask that our children and I join him. It would be my first trip outside of my home, away from my family."

Mercy still remembers the warm August day she landed in New York, about forty-three years ago. For a young woman, barely out of her adolescent years, who had lived her entire life with parents or other family members, it was a long journey to America with her two infant children, the youngest only three months old. But thoughts of any hardships were far from her mind, her youthful exuberance only aware that she was going to be reunited with her husband. Yet she missed home, and in her mind she often flew back to the field of coconut palms she left behind, and the green expanse of paddy fledgling rippling in the wind.

While settling into her new surroundings in Washington, D.C., Mercy knew what her role was going to be. She knew she was expected to care for the family, be a housewife—nothing more, nothing less. At first the aloneness was shocking, almost tormenting, as all day long she took care of the children alone, cooked, cleaned, and washed. But she became a

contended housewife, a happy mother whose thoughts stayed home with the family.

They lived in an apartment for three years before buying their own house. Mercy was very excited about decorating her new home, and because she was interested in sewing, she made drapes, curtains, upholstery, cushion covers, and other domestic paraphernalia.

"One day, someone saw my work in the house, and said, 'Why don't you take up painting, because you have such a good sense of color,'" Mercy recalls. "But I didn't know anything about painting. I had never done it, not even in school. Then I had a new awareness that changed everything. When someone recognized a talent in me and suggested that I might be a good candidate for a painting class, my life changed."

Mercy had never heard of Welcome to Washington Club, never knew they offered classes in painting, among other things, as a way of keeping foreign wives engaged in interesting leisure. She never knew she could paint—her leisure hours were used for crafts like embroidery on pillow covers. But she decided to join the painting classes offered by the Welcome to Washington Club and give it a try.

To her surprise, the painting classes turned out to be easy, enjoyable, and exciting.

"That was when I thought, may be there is an innate talent, which had been there but would have remained unknown. So I am very grateful to Welcome to Washington and Helen Gaudin, the art teacher. The revelation was thrilling. We would go on weekends to the beaches and to the nearby Ocean City to paint. I could easily paint all night. I loved to paint moonlights, sunsets, and sunrises. To paint all those scenes I had to stay up late nights, early mornings. I became pretty engrossed in the artwork.

"That really made a dramatic change in my outlook, in my life itself, as every Thursday I would go to the class sometimes with friends, other times by myself. Our teacher, Helen Gaudin, and her husband were in the diplomatic service, and had traveled all over the world, and experienced what it was like being in a foreign country. They knew the feeling of lonesomeness and separation the wives felt being away from their families and culture. That was how she decided to teach the class, and I just took to art like a fish to water."

Eventually, Mercy held solo art exhibitions, participated in group art shows and juried shows, and received awards and commendations. Television shows used her paintings and sculpture for their programs on national TV. News media covered her exhibits. Mercy became the artist in residence at Wesley Theological Seminary in Washington, and a member of the Smithsonian Resident Associate Program.

"Metherate's water color studies reflect the artist's response to the beauty of nature," wrote *Potomac Almanac*.

"Spirituality and sensitivity are reflected in unique interpretations that delight the senses. Extraordinary use of vibrant color and powerful simplicity predominate the lively water colors," reported *Advance*.

"The influence of Western culture is noticeable in Mercy's use of color, yet the spiritual feeling her works convey is the thoughtful introspection of the East," described the *Wesley Journal*.

"That was a little excitement, a feather on my cap," says Mercy. "I was also interested in sculpture, and I found that if I were ready to put the time and effort into it, I could sculpt. As my talent blossomed and expressed itself in watercolors, acrylics, oil, and fired clay, my paintings and sculpture became exhibits in numerous art shows.

"This, of course, goes along with taking care of my family's needs, because I come from a fairly traditional family background. So

caring for the home, cooking for the children and family was my first duty. I don't think I ever questioned that."

But through her art she had a glimpse of herself, her own truth. Gradually, Mercy saw that painting was more than art for her. It became a form of meditation.

"Painting is the conveying of an inspired moment through color and form," says Mercy. "That moment could be our openness to the beauty that is around us and in us. This openness is inspired by the spirit within us, and thus what is expressed as art is a form of prayer. In the awakening of my talent, a spiritual side of me was also awakened. They generally go side by side. In my case I was able to pay attention to it and even encouraged to take that path when I met Sister Claire Sullivan."

Encouraged by Sister Sullivan, Mercy went to a meditation center called the Anchorhold Center, named for the life of a spiritual counselor who, in ancient Europe, lived a solitary life in a room adjacent to a church. That room had two windows, one facing the sacrament and the other facing the town where people could come for advice and help. The concept was that the counselor literally was serving God as an instrument, by receiving guidance from God and using it to help the townspeople.

The Anchorhold Center was established by Sister Claire Sullivan, who believed in the value of contemplative prayer and became Mercy's mentor for spiritual pursuit. Inspired by the desire for a deeper spiritual experience, Mercy went to India and stayed in ashrams and hermitages. One such experience was at Shantivanam (Abode of Peace) of Father Bede Griffiths in Tamil Nadu.[4] Father Griffiths, an English priest, was

[4] Father Bede Griffiths wrote many books, including *The Marriage of East and West* (1952), *Christ in India: Essays towards a Hindu-Christian Dialogue* (1966), *Vedanta and Christian Faith* (1973), *Return to the Center* (1976), and *A New Vision of Reality: Western Science, Eastern Mysticism and Christian Faith* (1989).

educated in Oxford, traveled to India in his search for spiritual meaning, and settled in Shantivanam in 1968.

Mercy eventually became a meditation facilitator at the Anchorhold Center, offering introductory classes in meditation as well as training students to lead groups. She has continued this work for the last twenty-three years.

Art and meditation, like two tributaries of a river, came together in her, gaining force from each other, and merging as one.

"When you have a creative mind you have to unload many things that normally keep your mind active, so you can focus," Mercy says. "This focusing helps one to become aware of the flow of energy within yourself and in all things, communing with the creator.

"The beauty of the majestic mountains, the depth of the blue ocean, the swiftness of the flowing river, the strength of the deep-rooted trees, the tender growth in the paddy fields, the wild flowers in the meadows, all express the glory of the creator. In meditation, when I let go and let God be, I am open to the divine union. This letting go, openness, and union soon found an expression as watercolor paintings entitled *The Meditation Series.*"

When Mother Teresa and the order she founded, the Missionaries of Charity, opened homes for the needy in southeast Washington, D.C., Mercy visited their first home in Anacostia. She saw that the sisters' caring response resonated with God's love. From then on she set aside her Saturday mornings to work in the sisters' soup kitchen. It was here that her desire to work with Mother Teresa in Calcutta grew, and she began to wait for an opportunity. Finally, it came during one of her trips to India. She spent two weeks at Kalighat, Calcutta, at the home of the dying and the destitute with Mother Teresa and the Missionaries of Charity.

She later transformed the mental images she brought back with her into sculpture in clay. The agony and the despair emanating from the whiteness of the clay hold viewers transfixed.

Art and meditation became her tools to reach out to people in despair. One of the places she went to help was the unwed mothers' home founded by the Missionaries of Charity in Anacostia. The home, called the Queen of Peace, offers a place for pregnant women and girls to stay until delivery and sometimes a month or so after. Often the girls were very young, even thirteen or fourteen years old. Mercy volunteered to teach the girls art, meditation, and yoga. Her dedication has continued for more than seventeen years.

"It was difficult to understand the inner-city, mostly African American people who came to the soup kitchens and the unwed mothers' home. We were—they and I—in very different ways of life; my cultural background and the culture of the young blacks were vastly different. So I think one needs to have tremendous compassion and openness to be able to enter into their world and accept them. Interacting with them on a one-to-one level taught me their sociocultural background. This openness helped me understand rather than be judgmental of them.

"I hope that with this kind of support and with the grace of God, they can find themselves and live productive lives. I cannot say every day has been rewarding. Sometimes there was total rejection of me or the planned activity. Whatever happened, I had to accept where they were."

The Gift of Peace, a center for people suffering from AIDS and other incurable diseases, is another place where Mercy volunteers. Mercy teaches them to draw, paint, read scriptures, and share life's journey with her.

"These people rarely go anywhere else from here," Mercy relates. "Most of them don't have anyone to take care of them. For many this will be their last home."

Joseph, her husband, goes with her to offer his support and help. He has been a volunteer at the soup kitchen and the Gift of Peace for many years. The couple live in their beautifully furnished home, where the walls are adorned with Mercy's paintings and sculpture. A daily practitioner of yoga and meditation, Mercy keeps a special room for this purpose in her home, where her grandchildren, thirteen and ten years old, come to learn meditation. They recognize the quiet energy in the room and respect its silence. She considers it her valuable accomplishment to be able to give the children a gift they can use as they grow, especially at times of stress, to turn inward for strength, balance, and peace.

Mercy reminds herself that whatever role we play in life, it can be filled with challenges that are unknown to us. Greeting each day with courage and hope, accepting each day with gratitude, brings us peace and joy.

"I have often experienced God's peace and joy in my life, and I hope that is my contribution. Whatever you have done, if you have done it sincerely, with your whole heart, body, and soul—whether the outcome was to your expectations or not—it gives you peace of mind to have done that."

§§§

Step Out and Say Hello

It was 1958. A young woman left her small town for the first time in her life. She flew out of her country over thousands of miles to join her husband in America. She was alone, spoke very little English, had an eighth-grade education. It took her three days to get to her destination, with long halts, delays, and multiple flights. The food in the flight made her nauseous; she had never eaten any food other than home-cooked, spicy vegetarian meals. Finally she reached Chicago, hungry and exhausted, not knowing a soul except her husband—and he was nowhere in sight. Chicago International airport was bustling around her; huge, six-foot-tall men and women walked back and forth. No one seemed to care who she was or why she stood alone and anxious. When her husband finally arrived, she could utter only one word in greeting—"Food."

Snehlata Shah, also known as Lata Shah, remembers that day as if it was yesterday. Lata had come here, leaving behind her parents, grandparents, brothers, numerous in-laws, dozens of other family members, and the steaming hot town of Nandurbar on the west coast of India. She had come as a young wife, who had married her husband a year and a half before. It was an arranged marriage, following the normal custom.

She started her new life in a small apartment on the University of Illinois campus, at Urbana Champagne, where her husband, Shantilal Shah, was a Ph.D. student. It was a solitary life for the most part, from the

time her husband left for his classes until his return. She learned how to heat the apartment by adding charcoal to the central stove kept in the middle of the room. She began her daily cooking routine, realizing that she had to manage with whatever items were available—yellow split peas, wheat flour, and Mahatma long grain rice. The small kitchen became a workshop and laboratory for the expert cook, who would use her creativity to produce authentic, home-cooked meals for her husband.

She had mastered the art of cooking precisely for this purpose. Her mother had insisted that she become good at this essential aspect of wifely duties at an early age. Although Lata was instructed, like most girls in South Asia, on domestic chores from the day she was able to walk, the serious lessons began after she quit her schooling, on entering adolescence.

"My grandfather was very orthodox and old-fashioned," says Lata. "He didn't approve of me attending school with boys. I went up to eighth grade. Boys and girls going together was frowned upon. Then my father agreed to employ a tutor at home. But the tutor was male, and when my grandfather came to know, I had to stop that, too. So I couldn't finish my education. My father had an ambition to send me to college, but grandfather wouldn't allow it. So I learned the domestic things—cooking and managing the house."

Lata's domestic skills came in handy in those early years in the little apartment of Urbana Champagne, military barracks converted to one-bedroom dwellings, where she became cook, cleaner, mother, nurse, friend, and hostess. While living in the apartment, she gave birth to two sons. No one came from her home to help out because they could not afford the expense.

Growing up in an extended family where pregnancies and childbirths were routine matters, where childbirths happened in the home

and children were regularly exposed to infant care and breast-feeding, Lata had learned the basics even as a girl.

"My brothers and my cousins were born at home. When you grow up in that atmosphere, you learn many things. For instance, I gave my babies baths, just like I saw them do in India. I breast-fed them even though the doctors didn't support it. The doctors encouraged using formula instead. But I had seen the women in my country breast-feed, and I wanted to do that. Now the doctors here know of the benefits of breast-feeding babies. We had known it all along."

When Lata and her husband went to live in Santa Rosa, in Northern California, in the late 1960s with their three children, there were no other Indian women in the area raising a family. She was the novelty rather than the norm. Some people had only a vague idea of where India was or who Indians were. When she walked to the neighborhood store wearing her colorful sari, people were fascinated. When they saw her long hair flowing down to the back of her knees, they were speechless. When they saw her making intricate designs on her doorstep with rice flour, they were curious. She explained she was drawing a Rangoli design in front of her house, as she had done in her home in India. It was meant to bring good fortune to her home. It was an auspicious symbol. She did not want to give it up just because she was living in America.

The town accepted her just the way she was. Her neighbors found it exciting and extraordinary to have someone from another culture in their midst. When she started to drive she decided to forego wearing her sari and replaced it with modern clothes. The first time they saw her in pants and shirt, her neighbors said, "Mrs. Shah, we don't want you to change. Why aren't you wearing your sari?" She would agree with them, but she told them she had to drive, she had to go for walks, she couldn't do everything in a sari. Besides, in the cold weather she was not

comfortable in a sari. The townspeople conceded but said, "We don't want you to forget how to wear it."

She knew wearing Western clothes would not make her less Indian, because deep inside, she could never be anything else but an Indian woman. Lata loves to keep her old traditions, but she is not someone who lives in the past. She is well aware of the complexities of modern life. She is as welcoming of computers, for instance, as she is of new philosophies of living in America.

Realizing the advantage of being able to speak English well, she decided to go to the community college in Santa Rosa to take classes in English. She was not shy about talking with people, but her inadequacy in the English language had become an impediment. She started with classes for foreigners offered by the city of Santa Rosa and then went on to enroll in the community college. She learned to speak well, an achievement of which she is proud. When the computer era dawned, Lata decided to learn the basics of computers and again enrolled in the community college. She was most fascinated by a device called the mouse.

Lata became a ready volunteer at school and community events—PTA activities, Brownie and Girl Scout meetings, bake sales, classroom activities—you name it, Lata was eager to help. The first time she gave a speech about India was at a junior high school. A girl from her neighborhood, Paula, was going to make a presentation about India in her history class. Paula's mother asked Lata if she would help Paula cook some Indian dishes. When Paula's teacher suggested Lata come to the class and give a talk, at first Lata was terrified because she had never given a talk anywhere. But the teacher and Paula were able to persuade her to give it a try. So on the day of the presentation, she made some vegetable pilaf for Paula's class, helped drape a sari on Paula, and then went to the

eighth grade class to speak about India. It turned out to be a great experience.

Thus began Lata's talks on India, its cultural specialties, foods, vegetarian dishes, religions. Her speeches were not scholarly but based on her day-to-day practice, the rituals she used to do, her favorite festivals, and other interesting aspects of Indian life. The children became fascinated by what they heard. Sometimes she talked to younger children in elementary schools, where they asked her about trains and cobras in India. Slowly Lata began to enjoy the talks and feel more comfortable about giving them.

Then she started teaching cooking classes at the community college. Students thronged to her class to learn the exotic cooking methods. They learned to make the deep-fried Indian bread called puri and dishes spiced with curry. At the end of each semester she would give a cooking demonstration, where she would bring the ingredients and make the dishes she had taught them. She made sure she wore a sari to make the atmosphere more authentic.

It delighted Lata to speak to American audiences. Lata happily taught her neighboring communities the basics of India and its culture, helping them widen their perspectives. She has been invited to demonstrate sari draping, ritual floor decoration, and cooking at many places.

As a participant in programs on South Asians in America sponsored by the Oakland Museum and Sonoma State University, Lata drew attention by making the ritualistic floor patterns made from rice flour. The morning ritual of creating Rangoli on doorsteps, an age-old Indian tradition practiced by women even today, was originally meant as a ceremony to invoke plentiful harvest, prosperity, and the community's health. It is also believed that the intricate drawing, done in meditative

mood, will bring a woman inner peace and harmony. Using her bare fingers, she grabs a little rice flour, which can be white or of different colors, and let the flour flow through her fingers to create the pattern. The secret lies in being absorbed in the act of creating the Rangoli, not thinking of the day's activities.

Another facet of life in India is the draping of a six-yard sari, which the women wear every day. Lata would teach the technique at cultural exhibitions, schools, and colleges. Women loved to learn this intricate art.

Lata, the contended wife, the happy mother, and the grandmother of six children, loves her community. She has a smile and a hello for her neighbors, and always a few minutes for a neighborly chat. Her husband, Shantilal Shah, retired now, worked as a biochemistry research scientist at the University of California for many years. Their three children, brought up with Indian values, were the only Indian children in town. They went on to attend Cal Tech, Stanford, and the University of California and became successful professionals.

Lata has been the inspiration for many South Asian housewives and professionals who have settled in the neighboring counties of Northern California since the 1960s. She has shown them that one need not give up one's traditions to live and be useful in a new community, but on the contrary, one has the obligation to participate in the lives and education of the community. Lata recently celebrated her sixty-fifth birthday, surrounded by her extended family in her hometown of Santa Rosa. Where is home, if not America, after forty-five years of living in it? What is her heritage, if not Indian, which she honors even after spending more than four decades in another country?

India lives in her, although she lives an American life, a voting citizen and a full participant in American festivities. She has embraced

both countries with equal fervor and equal sincerity. Through her unconditional acceptance of who she is and where she comes from, she has given others who followed her a fresh perspective on life as an immigrant.

She has treasured the values she brought with her, but she has also reevaluated them, polished them, and made the best use of them in her adopted homeland. She has lit a new path of understanding between two distinctly different cultures and lifestyles.

§§§§

From My Perspective

Where I come from, getting married used to be similar to taking a dream trip, like going to the Bahamas, except you never knew your destination, if its inhabitants would be man-eating tigers or piranhas, or if the climate resembled the interior of a volcano or the frozen tundra or perhaps, through your blissful good karma, a gentle, breezy seashore. A girl grew up optimistic that tigers would be tamed and climatic conditions altered in a manner as dramatic as her entrance to the bridal chamber, a glass of sweetened milk in hand, where a total stranger would devour her partly or wholly. Preparations for the trip would begin at the precise moment when the nurse or the midwife would announce the arrival of a brand new girl. She would receive extensive training for the role of her life, with assumptions made about the hard-to-please mother-in-law and the short-tempered husband, who, with the demanding father-in-law, would squeeze the last drop of faithful composure from her. She would declare victory in the end—this being the promise of all the hard training—for

she would earn the admiration and love of the entire household and community through personal sacrifices and unerring commitment to the husband's cause.

We were taught the stories of such illustrious women from mythology as Sita, the central embodiment of all that was virtuous and feminine, whose sorrows strengthened her character, whose renunciation of worldly pleasures for her husband made her the ideal wife we all aspired to be. Sita became the ever-glowing presence in our hearts. Our imaginations were electrified by the image of her victorious, though subdued, emergence from the roaring fire her brother-in-law lit for her so she could, before the accusing finger of her husband, prove her innocence once and for all. We could forget the rest of the story but not her, not her joy in following her husband, Prince Rama, to his fourteen-year exile in the forest, leaving her luxurious princely bed behind. We could not forget that all-consuming torrent of love that tormented her. Every suffering purified her, sanctified her soul, even her chilling abduction by the demon king, the subsequent confinement in his palatial garden, and his amorous approaches when the palace guards slept. Sita, of course, declined the king's invitation to his royal lap. She steadfastly held to her faith that, like the hero of a Hollywood movie, Rama would rescue her in the end, shower her with tears of unabashed passion, and take her home to be crowned the most admired queen of all times. But such an ending was not to be. Although her princely husband did come to her rescue, he proved to be very unlike the Hollywood hero, rejecting her because she had lived in her abductor's palace and had, perhaps, been touched by him. Through her despair, Sita did not blame her husband for his harshness but endured the humiliation, making us tremble in awe of her strength. She performed the ultimate lie detector test by entering a fire and arising from it unscarred.

The symbol of fire holds great meaning for women in India as it signifies both personal suffering and purification—as if both are one and the same. A woman's life revolves around fire, be it the kitchen fire she is responsible for igniting so her family does not starve, or the ceremonial fire she goes around with her husband at the time of their wedding, or the fire that burns within her while she struggles to give warmth to her husband and family, or the final funeral pyre that burns her remains back into the earth. The age-old custom of letting her burn alive in her husband's funeral pyre disappeared from reality a long time ago, but the concept, the idea of a widow becoming sanctified through the process—the power of self-sacrifice—continues to enliven people's imaginations.

Later in the story, Sita suffered even more when, pregnant with Rama's children, she was abandoned again. But she remained heroic in our thoughts, sometimes even allowing us to compare our own pain with hers. Our pain dimmed in comparison, always, as she showed us the image of the perfect queen of tragedy.

There was also a strength in her not visible to the casual eye, the fortitude to live through the inevitable, the faith to prevail as she raised her twin children alone, teaching them to love and admire their father, despite his shortcomings, because he was their father and, above all, a just king.

A woman who lived her childhood among such incredible women, exerting their mythological powers, cannot leave them behind as she walks away to America. The images linger. Sita never leaves her. If Sita becomes her vulnerability, her blazing self-admiration brought on by the sacrifices she would happily endure for the sake of her husband might make her a weakling, a doormat. She might question the strength she once believed she possessed through her association with Sita. She might willingly take on suffering after suffering without complaint. How could

she accept divorce as a solution when it would be interpreted as failure on her part? All her training showed her that a successful marriage was her responsibility, that the husband's defects were her burden to bear.

How can a woman overcome this dilemma and erase this source of conflict? Sita becomes her conflict. Sita lives through women all over the world for generations. She exists as this strife. Her presence becomes the source of internal contention in the modern woman who loves nothing more than to merge with the man she loves, and come through unscathed from fire after fire to affirm her adoration.

But she, the modern woman, also has a desire to fulfill her destiny and to authenticate her self-worth. She wants to blossom, be who she wants to be, and yet allow her traditions the power to shape her, to fill her rather than empty her into vacuum. The women whose stories filled this chapter show us that she can.

Chapter 4

EMPOWERING OTHER WOMEN

Engineering Is Empowerment

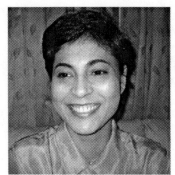

Risa Altaf remembers a discussion she helped arrange in a short time after September 11, 2001, when suddenly many people regarded Muslims, or anyone that appeared to be from a Muslim country, with suspicion. A city councilwoman from Mountain View, California, arranged the meeting in which many people spoke. Risa was the president of the International Organization of Pakistani Women Engineers (IOPWE).

"Our position was that we wanted to bring our communities together," Risa recalls. "We are here, we live in the Bay Area, we are part of the community. We want the people to know more about us. Basically, we are their neighbors, and we want them to know that some women and men are more progressive, they believe in education and independence.

But if you take any country in the world, there are some traditions that are repressing to women. We are here to help alleviate those problems, and I think in America we should continue to do that. We want to become spokespersons from different cultures."

Risa Altaf was a college student in the United States in the early 1990s when, for the first time in her life, she was exposed to different countries and cultures. She found it exciting to meet people from other parts of the world, be they from countries like Brazil or China, far from anything to which she had been exposed, or from India, just across the border from her home in Pakistan. On the neutral territory of the university campus, she delighted in talking with people from vastly different countries, getting to know them as people not all that different from herself.

Risa had started her engineering education in Pakistan, where she grew up. Her main motivating force was her father, who went to a Pakistani university in the 1960s.

"He is a very open-minded person," says Risa. "And I believe he is a feminist, because he believes that a woman should get the best education she can get. My father is an engineer. He was the one who suggested engineering to me when I was young. Pakistan has very few universities, and there you have to be very good to get into a university. They are very competitive. I went to the University of Engineering and Technology in Lahore."

She spent a year studying engineering in Pakistan but felt that a lot of time was being wasted because of strikes and the students' political activities. After discussing with her family the possibility of continuing her studies somewhere else, she decided to come to the United States.

Although the decision was her own, her parents insisted she spend the first year with her aunt in Florida, allowing her to get familiar

with American society and culture. At the University of Florida, she was surprised by how helpful the professors were.

But her education about the world, its numerous cultures, peoples, customs, and habits, came later when she began her graduate work at Cornell. Dormitory life at the university's International Living Center was an experience far beyond anything she had imagined, because it was the first time she had lived in an international dorm where she came into contact on a daily basis with people from every corner of the globe.

"Those things have made me a little more mature," Risa recalls. "Coming to the U.S. has itself changed my life. I look at things differently now than before. I remember the day before I left for the U.S., my father told me, 'No matter where you are, make sure you give back to the society where you live.' I really have taken that to heart. You shouldn't just give back to the society or the people you yourself associate with. You have to open up to and give back to the society in general. I really appreciate that from my father. We have got to live our lives now, and we have to help out other people.

"My association with the International Organization of Pakistani Women Engineers has been a big influence in my life. It has been a real training ground. This change was triggered when I met its founder, Farhana, and we agreed on many things, that we needed women to come together, that we needed to support each other. There was not enough support for women to study engineering. We initially had a network of support for professional single women here in the Bay Area, because many of us were young women who had just started our careers. We were here by ourselves, with no families nearby. So we wanted to have a support structure. That was how IOPWE came into existence. Through IOPWE, I am able to do some of the things I want to do and I believe in."

As the president of IOPWE, Risa was able to pull together many professional women engineers and reach out to help other less fortunate women.

"Whatever I have done, probably my work with the IOPWE is what makes me most proud," Risa states. "But I would never take personal credit for it. All the other women have worked with me and contributed to it also. It would be very difficult to do anything without their help.

"Before IOPWE there were no organizations like this to inspire and motivate women engineers in Pakistan. I am amazed that this organization that we started in Berkeley, originally for networking purposes for women, is doing a lot to help women. We are inspiring engineering students and young girls. We have very little resources, mainly just a Web site and whatever hours we spend at night. Every time someone among us visits Pakistan, we see some important people for support, visit a school and talk to the teachers and students, and get them to believe that professional education is good for women. We are getting a lot of memberships from Pakistan. We are also raising questions with the government of Pakistan. Whenever a government official visits the U.S., we make sure we talk to them. We want them to know what can be done. When we visit Pakistan, we work with the Ministry of Science and Technology and urge them to encourage women.

"There are things we do here in the U.S. that are also important. We are trying to arrange a regular program with the YMCA to inspire girls to go for engineering. Once we develop it, we will talk to young girls about engineering. There are a few other things also we have done—not engineering related. Talking about ourselves as Muslim women and how we are part of the community because we contribute to the society—we do that at every opportunity.

"I think it is very important for young girls growing up here to have good role models. I think some of the American media, especially the mainstream media, portray women as objects, sexual objects, which is very bad for young girls. We older women, we can look away because we know better. But for young girls it is important to have good role models, good teachers. That is one of the things we do when we go to the YMCA, where we talk to young girls about careers. I don't really care if those young girls go into engineering. Even if they decide otherwise, it is fine. But they should know there are women who are doing it, and there is more to life than looking pretty. We see there are women in Congress and the Supreme Court. Perhaps those women had male role models. There are male role models in my life, too—my father, a college advisor, my husband—who inspired me. A role model is somebody who believes in you and says you *can* do more and you *should* do more."

One of Risa's aspirations has been to use the IOPWE to offer scholarships to women who cannot afford an engineering education. The idea is now a reality—so is her vision for starting a mentoring program.

Risa has been working full time for almost nine years as a member of the technical staff at Altera Corporation in Silicon Valley, designing semiconductor chips. She is also a new mother of a little girl. Risa's husband, Abrar Hussain, is a lawyer. He helps her and supports her commitment to IOPWE, not only with some of the legal work for the organization but also, and more importantly, with his moral support. She is happy that he is there to push her to do better and to give her the confidence. She encourages men to take active roles in the organization.

"Our membership is open to men also, and we make sure we involve them," Risa says. "We want men to participate, whether in terms of affecting their wives, daughters, and mothers or for creating a better society. It is difficult to do women's work without that kind of support.

The issues we face are not really just women's issues. The men are equal partners with us."

§§§§

Speak Out, Girls!

An honor Prema Mathai-Davis remembers fondly came from the people of Staten Island, where she went to establish an independent nonprofit agency in 1981. She was responsible for the development and management of social services such as home care, transportation, entitlements, counseling, and victim services for older residents. Initially, several people reacted negatively to her appointment. They called her an illegal alien and other derogatory names. If she had reacted with cynicism and despair to the comments, life would have been very different for her. By not labeling everyone racist because of the beliefs of a few, and not holding a grudge against anyone, she was able to change people's attitudes. In a couple of years the community not only recognized her contributions but gave her a medal of honor.

Prema is an immigrant woman from India living in New York. She is passionate about the "American alloy" being tested in New York and California, as millions of new immigrants enter every year. The country gets revitalized because of this, she says. What we have is the "American mosaic," in which each piece keeps its identity, and all come together to create harmonious patterns. She eschews the use of prefixes—

Italian American, African American, Indian American—that sharply define our differences rather than emphasize our commonness. "Let our children not be defined as anything other than American," she says.

In 1995 everyone in California was talking about Proposition 209, also known as the California Civil Rights Initiative, which was to be on the ballot the following year. The initiative, if it had passed, would have ended the state's affirmative action programs and funding for minorities and women to participate in the state's universities and job market. It was a hotly debated issue.

"The California Civil Rights Initiative is a misnomer," Prema said in a speech opposing the proposition. In the speech, which she delivered in 1995 in her capacity as the national executive director of the YWCA of the U.S.A., she said, "It is neither Californian, nor civil, nor right. The initiative is a disaster for women and girls. This will make it more difficult to get legal protection from sexual harassment and job discrimination." The voters passed the proposition, but her words continued to echo across the country.

Prema was the first Asian and foreign-born woman to hold the position of the national executive director of the YWCA of the U.S.A. in its 140-year history. It is the guiding, overseeing, and policy-making position of the more than 364 YWCA organizations in the U.S.

Prema was born and raised in a family where public service was like a common gene. "I grew up as a YWCA baby," she recalls. In her household YWCA was a name that not only brought fond memories of old times but also created an unbreakable bond among the women of the family. Starting with her great-grandmother, who helped establish the YWCA in southern India, women in her household had served the organization in many capacities. Her grandmother was involved in its management, followed by her mother, who became a member of the

national board of the YWCA in India. Her aunt followed the same path and became the president of the YWCA of India, and another aunt—her father's sister—became the president of the YWCA in Pakistan.

As an outstanding student from Delhi University, Prema came to the U.S. in 1974 to earn her doctorate in human development at Harvard.

Her first project after graduating was to set up a long-term-care gerontology center at Hunter College in collaboration with the Mount Sinai School of Medicine in New York, and to become its first project director. Later, New York City Mayor David Dinkins appointed her the commissioner for the city's Department for the Aging, which was the largest agency in the country focusing on caring for the elderly.

Growing up in an extended family in India, with parents and grandparents living together, gave Prema a multigenerational perspective on the problems of aging. During her tenure as the commissioner of the New York City Department for the Aging—a position she held from 1990 to 1994—Prema organized and led the first United Senior Action Day in Washington, D.C. It was the first grassroots mobilization of senior citizens representing diverse groups from across the country, involving more than 10,000 senior citizens. This resulted in the development of a national agenda to focus public attention on issues facing older Americans. The agenda on aging was presented to leaders of the House and Senate and was incorporated into both the Democratic and Republican party platforms.

The first immigrant from South Asia to head the Department for the Aging, Prema convened the first National Conference on Intergenerational Programming for At-Risk Children and Youth in an effort to bring old and young generations together to address the growing phenomenon of children being raised by their grandparents.

"There are a lot of issues, and there is of course the issue of plain old fatigue," says Prema, on the problems of grandparenting. "They are of different generations, different values. We were looking at that and creating a set of programs to provide support and services."

Following the conference Prema helped establish the first public-sector Intergenerational Resource Center for New York City to assist older relatives who become the primary caregivers of young children. Prema also established the country's first computer technology center for elderly workers in New York City, called Age Works.

"My grandfather was very gutsy and courageous in what he did as a young man, when he left his homeland and went to faraway places as one of the first Indian missionaries," reminisces Prema. "Growing up in a family with all of them—my grandfather, my grandmother, my father, and my mother—giving a lot of time doing public service, it was seen as a way of life for me."

Following the family tradition, Prema continues to live in an intergenerational family in America. Prema and her husband, Wallace, have three children. Her parents came to live with her and her family in Manhattan more than sixteen years ago, when her twin daughters were born.

"If you ask my parents, they would say they came here to help with taking care of the twins," Prema says. "But I had child care and other help to take care of the twins. We wanted them to come and live with us while they were still young and mobile and able to make their own friends, and enable us to take care of them when they grew older and frailer."

When Prema became the head of the YWCA of the U.S.A. in 1994, she represented more than two million women and girls in America. The New York City–based organization is the largest provider of shelter services for women and their families in the country, with affiliates in

thousands of communities in all fifty states, seeking to empower women and girls and to eliminate racism, sexism, and all other forms of discrimination. In line with the mission of the YWCA, one of Prema's major efforts was to coordinate the drive to have Congress maintain Title IX, Education Amendments of 1972, which promoted gender equity in sports and athletics. Title IX is the landmark legislation that bans sex discrimination in schools, in both academics and athletics.

Like education, women's health has been a major issue requiring political intervention and legislative support. One such legislative effort was the Women's Choice and Reproductive Health Protection Act of 1996, which includes a provision related to preventive health measures regarding breast and cervical cancer. On recognizing its significance, Prema played a leadership role in advocating with Congress for increased funding for the National Breast and Cervical Cancer Detection Program administered by the Centers for Disease Control and Prevention.

In 1995 Prema organized a national YWCA child-care petition and rally against child-care reforms sought by the Congress as part of a welfare reform legislation. The rally was against allowing state governments to fund unregulated child-care providers without regard to even minimal standards. The YWCA is the largest nonprofit child-care provider in the nation.

A passionate believer in the intellectual equity of women, Prema initiated a YWCA program to expose girls to technology at an early age. Launched as TechGYRLS Day in 1997, YWCA made the event an annual affair and soon established TechGYRLS Clubs in many parts of the country. Meeting twice a week, each club offers twelve girls aged nine to thirteen years the opportunity to gain confidence and competence in interacting with modern technology. The girls are also encouraged to

develop problem-solving skills and to understand the importance of using technology in every career choice they might face in the future.

"I think we have made some progress over the last several decades on issues of equity," Prema says. "But we still have a long way to go, and in addition to legislation, there is also education. If you start from kindergarten onward not creating different conditions for boys and girls, because intellectually and in every way, other than physically, they are the same, then we begin to create a generation that sees no real difference. Unfortunately, that is not what happens currently. We are all conditioned from an early age to see boys and girls as being different. For instance, in schools the girls are encouraged to take certain subjects like arts, as opposed to the physical sciences. So subconsciously we pick up those values that become part of our lives, and it becomes harder to change later."

As a university student in India, Prema was the first president of the Model University Student Parliament, an organization in which young students from all over India participated. That position gave her the opportunity to speak at the Indian Parliament House in New Delhi and had a tremendous confidence-building effect on her.

"That was an important learning experience," Prema recalls. "Even though I didn't think I had the ability, others thought I did—that I could come up to it. So little things like that have been very important."

Giving girls and young women a platform to speak out, Prema, as the YWCA national executive director, was one of the conveners of the first Girls Speak Out events at the United Nations building in 1995. This was done in preparation for the U.N. Fourth World Conference on Women held in Beijing. Following the conference in Beijing, Prema organized the First National Girls Conference, which focused on developing a national girls' agenda based on the UN platform for action.

"The girls had developed a platform of action that discussed issues of sexual assault, violence, and how the media portrayed girls," explains Prema. "Girls came together to have regional summits where they were addressing issues that concerned them."

Many regional girls' summits mushroomed all over the country, organized by schools, the YWCA, and other organizations, giving girls a chance to be heard.

Another area in which Prema has made a significant difference is violence prevention. Under her leadership, the YWCA launched a national public education campaign to increase awareness about alternatives to the violence in our lives.

"Every day each one of us gets caught up with it," Prema says. "You may not necessarily be a victim of violence, but you are telling your kids, 'Don't go there, don't go here, be careful.' When you go out, for instance, when you are walking down the street in New York City, you are holding your handbag tight and close to your body. You don't leave your doors open, you don't leave your cars unlocked. So violence is all around you. When your kids go to school today, with the violence that happens in school, you are not sure whether they will come back home."

Prema launched the YWCA Week Without Violence program in 1995. Observed in the third week of October, each day of the week focuses on a different aspect of the whole spectrum of violence.

The first day is one of remembrance of all individuals who have died as victims of violence. The second day focuses on how to prevent violence against children. It addresses the issues of child abuse and other forms of violence against children. The third day draws attention to the issue of violence in our schools and the importance of educating our children to express their anger in nonviolent, socially acceptable ways. The

fourth day examines issues of violence against girls and women and how to make the world safer for them.

The fifth day focuses on violence against men and alternatives that can be created. On the sixth day attention is brought to issues of hate and race-related violence, including those that are gender based. And the seventh day examines the role of sports as an alternative to violence and how it enables aggression to be released in positive ways.

By focusing public awareness on issues of nonviolence for one week, the Week Without Violence enables people to see that nonviolence can become a pattern, a habit. The United Nations, taking the example of the YWCA campaign, declared the fourth week of October as the Week of World Peace, looking at what countries can do to reduce violence on a global scale.

Following the success of the Week Without Violence campaign, Prema chaired and convened the First World Conference on Family Violence in Singapore in 1998. The purpose of this international conference was to bring together all kinds of professionals who deal with domestic violence—medical practitioners, lawyers, community activists, social workers, educators—to talk about it. All aspects of family violence, child abuse, spouse battering, and elder abuse were discussed. The U.S. government, taking a leading role in the conference, sent a high-level team of senior staff from the Department of Justice's Violence Against Women Office and the Office for Victims of Crime to lead a workshop. Practitioners from many different countries also participated in this global conference.

To crown her achievement in the area of stopping violence, in 1995 Prema was named the Woman of the Year by *Ms. Magazine* for "reminding the nation that violence need not be a way of life."

Best of all, the Week Without Violence educational campaign that she started has been implemented in about forty countries all over the world.

If one way to measure success is by counting the awards and honors a person has received, then Prema has several reasons to feel successful. Perhaps it is more satisfying for her to know that in a hundred different ways her decisions and actions have touched the lives of millions of Americans, and made our burdens just a bit lighter—awards or not.

Currently retired from her travel-intensive YWCA stewardship, Prema spends more time taking care of her parents. She also serves as a board member in several corporations and nonprofits.

"I am a person very passionate about causes, about injustice and unfairness, and always pushing to change that," Prema says. "When I started out I was taking advantage of the opportunities presented. And I needed to. I thought the time was short, and I needed to make a difference and would go all out to do that.

"My approach is changing now, because I realize that it doesn't have to be such a fight. One doesn't have to go all out to create change but rather be more optimistic that the change will happen with less effort on one's part. I can stop and smell the roses, and at the same time make a difference. Each one of us is born with a purpose, and the purpose is unfolding anyway. So the end result is going to be the same."

§§§§

Give Your Community a Voice

Born and raised in a Parsee family in the city of Lahore, Bapsi Sidhwa grew up at a time when Lahore was transforming from a preindependence Indian city to a postindependence Pakistani city. It was a period of unrest and turmoil in the Indian Subcontinent, with conflicts between Hindus and Muslims intensified by the partition into India and Pakistan. Bapsi's family, being Parsee, neither Hindu nor Muslim, was relatively undisturbed by the conflicts. As a young girl, she was afflicted with polio and spent most of the time at home with servants or reading books and taking classes from her tutor. On her tenth birthday she received a gift from her tutor—Louisa May Alcott's *Little Women*—that marked the beginning of a lifelong relationship with books and her entrance into a world that excited her more than anything else. She could escape from boredom anytime through the numerous books she received as gifts from family members and others.

"Starting from childhood I read a lot because I didn't go to school," Bapsi recalls. "And all these fictional characters became role models. I used to get classics as birthday presents. So books became my best friends. I lived in a world of fantasy. As I look back on it, I am quite amazed I had such a fantasy life."

While attending Kinnaird College for Women in Lahore, she read even more. However, she did not consider writing as an occupation, as her life followed the normal course of getting married as soon as she graduated from college at nineteen and settling down as a housewife. She

lived in Bombay those days, where she could mingle and socialize with other Parsee families. She moved back to Pakistan after her divorce about five years later.

Later she married a Parsee businessman, Noshir Sidhwa, and led a contented life as a housewife. One day, when she was about twenty-six, she met a lady from Afghanistan, and as they were chatting, the woman revealed that she was a writer. That meeting sparked an ambition in Bapsi to write. The inspiration for her first novel came a little later, when she and her husband were vacationing at a remote construction camp in the Karakorum mountain range in northern Pakistan. While staying there she heard the story of a young girl being brought to the mountainous tribal territory by a man. She was to be married to his nephew. A month later Bapsi heard that the girl had run away from the tribal home. She also heard of the terrible fate that awaited the girl when she was inevitably caught by the highly skilled hunters in the mountains. For the tribesmen, a runaway wife was an insult they had to revenge with nothing less than the young girl's death, possibly by decapitation.

The girl's saga so touched her heart that Bapsi decided to sit down and write about it. The short story later became her first novel, *The Bride,* which took her four years to complete. Her love of writing thus discovered, Bapsi began an exciting occupation that she continues to enjoy today.

Although Bapsi's subsequent novels deal with the lives of women in more sophisticated cultures, they all give us vivid pictures of women's lives, their silent pain and dilemmas. Immediately following *The Bride* came *The Crow Eaters,* both written in secret because for a woman to write novels was considered odd in Pakistan. She feared people would laugh at her. Besides, there were no English-language publishers in Pakistan. She ended up publishing *The Crow Eaters* herself in 1978.

"My books have been pirated all these years because there was no publishing in English in Pakistan," Bapsi says. "Now that Oxford University Press has come up, there is at least one press that publishes in English. There was nobody to help me. There were no writers. It was a miracle that I was in Pakistan and I was published in England."

It was only after Britisher Jonathan Cape published *The Crow Eaters* in 1980 that Bapsi began to see herself as a writer. *The Crow Eaters*, her favorite book, was the first novel ever published about the little-known minority community of Parsee Zoroastrians. The book, poking gentle fun at her own community, proclaiming the nickname given to Parsees because of their loud talkative habits, brings out the culture and the camaraderie of the Parsee community.

Being a tiny minority in India and Pakistan, Parsees had never been written about in any significant fiction before. Through *The Crow Eaters* and its sequel, *An American Brat*, Bapsi introduces us to the life of this marginalized community and its culture. Having migrated to the Indian Subcontinent from Persia around the eighth century, Parsees are the followers of Zarathustra, the Persian prophet born about 1500 BC, and their religion is known as Zoroastrianism. Bapsi's books give us a glimpse into the life and philosophy of this relatively small group of people. We come to know of their sense of humor, the ancient traditions, the practice of endogamy, the rituals, the fire worship, their love of nature, and the Tower of Silence, where the bodies of the dead are left for the vultures to feed on. Parsees habitually merge with the country of their residence, and yet they keep their traditions alive as much as possible.

Bapsi Sidhwa moved to the U.S., accompanying her husband, in 1984. *The Crow Eaters* had already been published in America, and *The Bride* was at that moment being published.

"It was extremely exhilarating to move out of my domestic circumstances. I was reluctant to move, though, because it was a big change and frightening to me. I hadn't been abroad really, but once I did move and started setting up the apartment we had rented, then I felt very exhilarated by the sense of freedom I got in America."

America welcomed her and showered her with many awards. She was beginning to become internationally famous. Accepting the welcome America gave her in the 1980s, Bapsi was encouraged to write two more books, *Cracking India* (1991) and *An American Brat* (1993). In *Cracking India*, the story, depicted through the eyes of an eight-year-old polio-ridden Parsee girl, unravels in the northern India city of Lahore during India's struggle for independence. The girl watches the country being torn apart and the horrid crimes, killings, and atrocities against women being committed. One small scene stands out for its simplicity and profundity—and its wry humor[1]:

> "What's a fallen woman?" I ask Godmother.
> "A woman who falls off an airplane."
> Godmother can be like that sometimes. Exasperating. She can't help it.
> "Wouldn't she break her head and die?" I say patiently.
> "May be."
> "But Hamida didn't break her head . . . She says she is a fallen woman."
> "Oh?" Godmother's expression changes.

The scene, like the rest of the story, unfolds from the viewpoint of Lenny as she grows to become a worldly nine-year-old. Lenny's personal story gets interwoven imaginatively and skillfully with the story of a nation. Lenny, the Godmother, and the Ayah are all unforgettably

[1] Sidhwa, *Cracking India*. (Minneapolis, Minnesota: Milkweed Editions, 1991), 227.

lively characters. We smile at the Slavesister, the Electric-aunt, and the Oldhusband. The novel was later made into a movie called *Earth (1947)*.

"I was actually surprised that so little has been written about the partition. Look at the Holocaust," Bapsi says. "There are over a thousand books about it, whereas the books on India's partition, and the bloodshed, can be counted on the fingers of your hand. After reading *Cracking India*, many young people said to me that they didn't know about all this. Why didn't they know of the violent history? It is important that young people know their history; you can't brush it under the rug. I think history reflects people to themselves, and I feel gratified to hear people say, 'You are showing us ourselves.'"

Bapsi's next novel, *An American Brat*, was published in America in 1993. It tells the story of a Parsee teenage girl who leaves her childhood home in Pakistan and becomes a young woman in America, surviving confusions, conflicts, and heartaches to finally emerge strong and emancipated. In this book Bapsi gives us a glimpse into a humorous family scene, trying to iron out a plan to dissuade the Americanized Parsee girl, Feroza, from marrying a Jewish man she met at school[2]:

> Now the formidable think tank of uncles, aunts, parents, and friends, talking vociferously, settled down to the solemn business of thrashing out a strategy.
> All opinions were considered, angles analyzed, opinions aired.
> "If this David fellow says this, you say that! If Feroza says that, you say this!"
> Zareen was alternately instructed, "Be firm. Exercise your authority as her mother!" and "If you can't knock him out with sugar, slug him with honey."
> They further confused her by directing, "Don't melt if she cries. If Feroza throws a tantrum, throw one

[2] Sidhwa, *The American Brat*. (Minneapolis, Minnesota: Milkweed Editions, 1993), 272.

twice as fierce!" and "But be careful; if you're too harsh, she'll rebel."

Now residing in Houston, Texas, with her husband, after living in Charleston, North Carolina, and Atlanta, Georgia, for short periods, Bapsi enjoys the company of her extended family of at least six hundred Parsees in the area. One daughter lives in the relatively close city of Tucson, Arizona.

"I found that Houston energized everything for us," she says. "It is a big city, and it opened to us all sorts of possibilities. I started reviewing books for the *Houston Chronicle*. The *Chronicle* interviewed me with great fanfare when I received the Lila Wallace–Reader's Digest Writer's Award. In Houston my husband and I made friends with the Parsee community. I also started teaching."

She has taught creative writing at Brandeis University, Mount Holyoke College, Columbia University, Rice University, and the University of Houston. She was a Bunting Fellow at Radcliff-Harvard University, and a Fellow of the National Endowment of the Arts. Bapsi was recognized by the Rockefeller Foundation Study Center in Italy and by the Pakistani government with the Sitara-Imtiaz (The Star of Excellence) award. Her books have been translated into many languages and published in several countries, including Germany, France, Italy, and Russia.

Always voicing her concerns about the suppression of women and minorities, Bapsi was on the Advisory Committee on Women's Development under Pakistan's Prime Minister Benazir Bhutto. She also worked as the voluntary secretary in the Destitute Women's and Children's Home in Lahore for many years.

"Helping women is an urgent need in Pakistan, and so I was very active," Bapsi says. "My books are also from the woman's point of view.

All my books are steeped in women's issues without it being obvious, and without lecturing. I was brought up in a life of seclusion. America got rid of some of my inhibitions. America also opened the person, making me more comfortable, more aware of the world. Of course, one of the landmarks was my vision of myself as a writer, a woman and a mother.

"I hope my books are worthy. I also hope that I have given Pakistan and the Parsees of the world a voice and the sense of a shared humanity."

§§§§

Women Need Better Role Models

"It takes incredible will power and determination, self-confidence, and faith in yourself for a woman to succeed in this society," says Sarita Sarvate. "I am infuriated by the obsession of the American media to show women as sex objects. Is this what feminism all about? American women are so brainwashed by the media that their idea of sensuality is completely perverted.

"They don't know what beauty is. They think Ali McBeal is beautiful—this woman who is anorexic. Women are reduced to sex symbols here, and because there is dating, women can't get away from it. In India when we were growing up, we could get away from that because we didn't have to date. We were liberated, in that sense. Here there is no

escaping it. Even at work, women put on the makeup and stuff. They have to lose weight, and they have to diet."

Sarita is a freelance columnist and commentator for several California media. Writing is her passion and hobby. In a recent column published in *India Currents*, she gives this critical comment on American feminism today:[3]

> When I first came to America in the late '70s as a student at U.C. Berkeley, I thought I had arrived in the land of fast foods, freeways, and feminists. I soon discovered, however, that while the first two were available in abundant measure, feminism was as scarce as a flying fortress in America. Over the next two decades, I was to become even more disenchanted with the status of women here, so much so that I began to wonder if I, with my fiery passion and avowed independence, was an anomaly in the world of men. . . . Watching a tape of the acclaimed HBO series *Sex and the City* after my return I couldn't help noticing how one female character obsessed about losing her orgasm, while a second one agonized over inviting an ex-boyfriend to her birthday, and a third one worried about her husband's soft penis.
>
> And I couldn't help thinking, "Is this what American feminism amounts to today; the freedom to sleep with whomever you want and the ability to talk dirty like the boys?"

"We need better role models for women," Sarita says passionately. "We need another feminist movement for the younger women. I don't know who is going to start it. I don't see any leadership in the society doing that for the younger women, because the feminists have declared success and gone home. Their job is done, and they are retired.

"How many women's voices did you hear during the recent terrorist crisis as expert commentators? Zero. I think the American

[3] *India Currents*, March 2002, "Last Word."

feminist movement has basically abandoned women, given up on them and declared success, prematurely, and said we made it because a few women have been appointed into professional positions.

"I don't think that is enough. I mean, look at the CEOs of professional corporations. Look at the major politicians. Whom do we have? Have we ever had a woman president? How many media outlets do we have with women at the top or women as anchors? I think there is no hope, I don't think in my lifetime it is going to change. It makes me very upset that in my lifetime I am not going to see the kind of life I want to have."

Sarita Sarvate grew up in the town of Nagpur in central India. She recalls her childhood as unusually hard and full of adult responsibilities, because her mother had a nervous breakdown when Sarita was twelve years old.

"I am still trying to figure out why she had a nervous breakdown," Sarita says. "She was a highly intelligent woman. She worked in Bombay before she was married to my father. For women of that time, in the 1950s, it was pretty unusual to work, and so I think there was a part of her that was very independent, wanting to do more than be a housewife. When we were little she was studying for her BA. She had almost finished it when she had this nervous breakdown. My uncles and aunts and her sisters-in-law were very orthodox, and they kind of undermined her. My father was a domineering husband, wanted to suppress her, and perhaps as a result of all these forces, her life ended at that point. Then she never did anything.

"My father and I would run the household. I had to cook, I had to do the grocery shopping, I had to pay the bills. It was hard on me, but it was also positive in the sense that I realized that this was not the life I wanted; I wanted to get out of India, I wanted to get out of all this."

The tough childhood events might have helped her to be gutsy and daring, capable of looking squarely at life, being responsible for her actions.

She had bigger aspirations than other girls. She wanted to have adventure, wanted to see the world and do what they do in America and Europe. There were professors and teachers who influenced her as far as academics went. The teachers liked her for being open and outspoken and smart. She was encouraged to give speeches at school gatherings. Later in college there was a woman professor in the Government Science College in Nagpur who was a math lecturer. As a single woman who never got married, she was a big influence on Sarita. In the physics department at the university, there were professors who encouraged her because, besides her intelligence and good grades, they could see that Sarita wanted something more. The teachers never discounted her for being a woman.

"It is interesting, because they talk about how women are treated very well in this country in the educational institutions. But in India, after independence, there was an environment that encouraged women to study and, particularly, it came out of the independence movement, where women played a big role. Gandhi and Nehru really wanted women to be educated. Parents of that generation, my parents' generation, wanted their daughters to be educated, at least among the middle class. So I lived in this community where all of my friends grew up to be professionals, and they were all very gutsy girls and young women."

She earned her degree in physics and attended the Indian Institute of Technology, the prestigious school for science and technology. She became a researcher in physics at Nagpur University. She was playing with the idea of advanced studies in the U.S. when her father arranged her marriage.

Having been influenced by Western writers like Mary McCarthy, Simone de Beauvoir, and the Brontë sisters, Sarita began to dream about what life could be. She looked at the Indian life and thought how limited it was, particularly for women. She used to think she wanted not to get married but to live alone. But she couldn't visualize a life like that in India, and then she would imagine herself being in England or somewhere, living alone.

Sarita first came to the U.S. in 1976 as a graduate student at the University of California, Berkeley, where she had a fellowship to study energy and resources. She came to the U.S. with her husband, who was to enter the master's degree program at Georgia Tech.

Berkeley at that time had very few minorities. Sarita was considered exotic rather than a threat. Her friends introduced her to life in California. During the first summer after coming to Berkeley she drove across the country with a woman friend. It was exciting to go on the trip, although looking back she feels she probably should not have gone on such a "crazy" trip. During their trip the other woman told her about her life as a girl, her summer vacations, holidays, boyfriends, and so on.

"I was working at the Berkeley Lawrence Laboratory as graduate research assistant. Two American women I worked with kind of embraced me, took me to downtown department stores, and helped me buy my clothes. I had to rely on somebody because I was alone.

"After the first nine months I moved to a nice house near Telegraph Avenue. I was still very conservative. I wouldn't share a house with men because I came from India, I was married, and I didn't want to fool around with anybody. I was worried and scared. I didn't want to screw up my studies and ruin my chances of doing well in Berkeley. So we were four women who shared a house and did a lot of things together. We went on trips together, we had big get-togethers and parties, and I used to

cook Indian food for them. They loved that. When it was my turn to cook, they would invite all their friends. Overall, it was a great experience in Berkeley, and I always say it was the best time of my life.

"I had to make friends and survive on my own. My husband was over there, very far from me. So it was a difficult but also interesting experience because I realized I could do all this on my own. By the time I graduated, we had been separated for two years, and I really grew apart from him. We were divorced soon after."

Divorce was a major decision for her because of the wrath of her family for the rest of her life. Sarita has written openly about the consequences she faced and the "fallen woman" label she acquired as a result. She wrote in 1999 in *India Currents* magazine:[4]

> I have always been the black sheep of the family. During my college years, when my female cousins were learning embroidery, I was winning debates and dreaming of a job at NASA. I was the only one in the family to acquire a National Merit Scholarship, the first one to obtain a graduate degree, the only one to go abroad. Had I been a boy, these distinctions might have brought me acclaim, but for a girl, they brought resentment and scorn from my male peers in the family.
>
> Later, my divorce from my first husband, with whom I had been coerced into an arranged marriage, only worsened my status as a pariah. Nothing, not even the fact of obtaining a prestigious graduate degree from U.C. Berkeley, or the acquisition of a green card, or my standing in my profession, could remove the stigma that now accompanied me whenever I went back to India. I was shunned by my relatives. Many of them prevented me from entering their kitchens and polluting the Gods. And no one ever asked me the reasons for my divorce. Because they knew. It had to be "my fault." Unfortunately, no one would have believed my tale, had I possessed the words to tell it.

[4] *India Currents*, July 1997, "Last Word."

So I became a fallen woman, an object of innuendo and rumor. Even today, twenty years later, their perception of me as an impure woman has not changed. My subsequent cohabitation with and eventual marriage to an Englishman only exacerbated the taboo they attached to me.

"Some women wrote to me personally and said they were very happy I wrote it," Sarita recalls. "They thanked me for revealing my personal story and making it possible for women to see what is happening, and acknowledge it."

One reader wrote:[5]

By sharing her own story, I believe that the author has made a tremendous contribution towards positive change. Such inspiration can only help others to at least begin to rattle the conventional shackles of patriarchal thought. Thank you, Sarita Sarvate, for making the political personal and for aiding the crusade against domestic violence.

In a severe criticism of the arranged marriage and dowry system prevailing in India, Sarita once wrote:[6]

At least we have had the chance to lead lives, even though it has come at a hefty price. In my case, it meant a painful divorce from a husband arranged by my father. . . .

In my case, that was how it was. I was not an illiterate villager but a middle-class girl who had been a National Merit Scholar, an Atomic Energy Commission Fellow, and a physics researcher.

But as a young woman in India, I had to submit to an arranged marriage. The alternative of finding a job, moving out of my parent's home, and living on my own would make me a pariah, cut me off from the only world I had ever known.

[5] *India Currents*, August 1999, "Last Word."
[6] http://www.pacificnews.org/jinn/stories/6.12/000616-dowries.html.

Not that I was without stigma. I made the mistake of falling in love with a fellow student, a man who ditched me for a girl with a big dowry. If the romance were to be discovered, I would be branded a fallen woman, however innocent the liaison.

"I think, my kind of writing, especially when I first started it, was unusual because I wrote much more about controversial topics," Sarita acknowledges. Her topics are wide and varied, covering all aspects of life.

"*Oakland Tribune* or *San Jose Mercury News*, *Pacific News Service* or *India Currents*, *Salon* or KQED Public Radio—wherever I write, I write more openly about arranged marriage or whatever. The article about female infanticide in India I wrote from the point of view of the dowry system. I don't think very many people do that. Whether in political writing or in fiction writing, I don't think very many South Asian women do that."

She gets e-mails from women all the time, women who are divorced, who are victims of domestic violence, or who had done something that made them "fallen women" in the eyes of a society that sometimes is very judgmental and mean toward people who don't fit the usual pattern. She sees it as an important service because it opens up a place for other people where they can have a dialogue. That is why she keeps doing it, because people are getting something out of it. And she is happy about this contribution.

Although Sarita comes from a controversial position, she doesn't cater to any particular culture or community.

"I feel like I have transcended communities," she says. "I am a unique individual, and I want to be that way. Look at California, for instance. The latest census shows that the so-called minority is now the majority. We are in this unique time and space where we have this opportunity to interact with people from all over the world, learn

something from other cultures, and get the best from each, whether it is white culture, or black culture, or Asian—Chinese or Japanese, or Middle Eastern—and yet most people are living in their own little cocoon.

"I am comfortable with who I am, and I don't want to be anybody else. I feel that I was really privileged, having the experience I had in India. I feel very fortunate about who I am, and I am very proud of my Indian heritage. I have written many articles critical of India, but I have also written articles explaining India and Indian culture to Americans."

Sarita, who is separated from her second husband, takes a strong stance against the American dating scene.

"I am going to be continuously reduced to this female thing; I mean, I have given up on dating," she says. "I am not going to date, forget it. Actually, men insult you. They try to evaluate me on the scale of 1 to 10, and I feel like telling them, 'You are a 1 or 0. What about that?' I get into big run-ins, and I am told I should be more conciliatory. But no, I don't want to be conciliatory to these people. I want to live by my principles even if I end up being alone. That is fine because I don't want to make myself so cheap in this demeaning way. I don't want to be so humiliated in the whole social encounter. That is why originally when I was single I didn't marry an American guy, because even when I was younger, I found American society not as liberated as it pretends to be."

Currently working as a physicist at the California Public Utilities Commission, Sarita divides the rest of her time between her two children and writing her columns.

In some ways she feels the American society is too alienating. In 1976, when she first came to the Bay Area, she found the people were genuinely friendly and helpful. But during the eighties and even the nineties, the "me" generation was in control. Even now, Sarita finds that,

driving on the road, people are not as courteous as they were. So perhaps the area has lost its charm and life is not as great in the Bay Area anymore. But then, Sarita cautions, having children makes one change, too. One doesn't want to be negative, one wants to look at the positive side in the American life.

"I get pleasure from sitting in a garden, from a hike, from talking to a friend, listening to beautiful music, riding a bike, writing, talking to other writers, reading beautiful books, and listening to the radio—and none of these costs any money at all. The things that give me the most happiness, divine happiness, don't cost a penny.

"I continue my journey as a global villager. I continue to be involved with the Pacific News Service and the California media, and I meet with journalists from all over the world and from all cultures."

In the end, this society may not recognize she has achieved something, but she feels good about what she has done, and that is a reward in itself.

"If I feel like I have to stick with my principles, then that is all I can expect. I don't expect the society to appreciate what I have done; I think the society is not there yet."

§§§§

Believe in Your Strengths

One day a volunteer working at a domestic violence hotline took a call from a South Asian woman with three children, living in a very violent relationship for twelve years. Luckily for her, the volunteer who took the call realized the extent of help the woman needed and called for a case manager. One of the people who responded immediately was a Sri Lankan woman named Shrimalie Perera.

"I was working for Alameda County Social Services Agency," says Shrimalie. "I responded immediately and started working with this woman. The woman had left the relationship once before but later returned to the batterer because she could not survive alone with three young children. As the violence in her relationship escalated, she left again for a second time. She needed a great deal of support, advocacy, and case management. I helped her with the application process to get public assistance, food stamps, cash aid, medical assistance, and I was with her every step of the way as she learned to navigate the county welfare system. She was also in need of counseling, crisis intervention, emotional support, childcare, and employment training. She had to be trained in a suitable employment field so she could make a living. I didn't do all this alone, a team of us worked with her closely, and so it was a multidisciplinary group of people helping her.

"I arranged parenting classes for the woman, psychotherapy for the older kids, and a South Asian therapist for her. The woman needed emergency cash, car repairs, car payments, clothes, and linens—many of

the things someone else would take for granted, and everything a woman needs to get back on her feet again."

The work to empower a battered woman who decides to leave the abusive partner is long term. Shrimalie knows the whole process inside out because she has been a veteran in the area, working with battered women, both as a domestic violence specialist and as someone who knows the system, for more than fifteen years.

As a young woman living in Sri Lanka, she was interested in helping women lead better lives. She went to Indonesia as a U.N. volunteer and worked in a village in Java, helping with health and sanitation for the village families. She was intent on going abroad for advanced studies and had applied for a student visa to the U.S. While she was in Indonesia, the visa came. She was sponsored by an Irish American family whose daughter had participated in an American high school exchange program—the American Field Service Program—and had stayed as an exchange student with Shrimalie's family in Sri Lanka in 1973. The two families had maintained a relationship with each other, and the U.S. family sponsored Shrimalie's visa to come to the United States and helped her to adjust to a new life in this country.

"Otherwise I wouldn't have been able to come," she recalls. "I came in January 1982 and went to college for seven years for my bachelor's in sociology and master's in women's studies, focusing on feminist, political and sociological issues. For my master's internship I worked at the Greenhouse shelter for women and children in Chicago. Perhaps I would have come to the U.S. anyway because I was determined to come. Also my mother was a source of inspiration in my life and she encouraged me to follow my dreams. I wanted to take an alternative path from the traditional role expected of women from my socio-economic background. I didn't want to get married. I didn't want to have children. I

wanted to be adventurous and travel the world; I also wanted to make a contribution—that was sort of my vision, even as a child. My father was a planter of tea, rubber, rice, and other crops, and as we were driving around, I used to notice the shacks of the laborers, the horrible conditions. I think I developed a social conscience at a young age. The people I used to admire were Florence Nightingale and Mother Teresa. I chose to be in a profession where I could make a contribution to humankind."

Shrimalie decided to get married later, after meeting her husband in San Francisco.

In 1988 she moved to San Francisco and worked for a battered women's shelter—the Rosalie House and the Riley Center. San Francisco had four domestic violence organizations.

"Domestic violence work, and ending all forms of violence against women and children is the major focus of my career," says Shrimalie. "First I worked at the women's shelter in Chicago. I was trained to work as a women's advocate, to work at the hot line, meet clients, manage cases, support women to leave their violent relationships and rebuild their lives and the lives of their children. I learned everything from emergency shelter and crisis counseling to vocational training and housing."

Professionally, Shrimalie has been the county domestic violence specialist for some time, working on intervention from the moment the woman walked in. She would hook up with the initial intake worker and identify all the woman's needs, whether it was immigration, counseling, family law, child care, support, job training, housing, or other types of resources she might need. Sometimes a woman would be at home, choosing to stay with her husband but needing support, somebody to talk

to. Other times the woman would need counseling until she decided to leave the relationship.

Shrimalie worked at La Casa de Las Madres in San Francisco, where she was the community education and outreach director. At that time she conducted numerous presentations on familial and societal violence and its impact on women and children and she went to the jail to facilitate discussions on domestic violence. Then there was work at the drop-in center as a backup worker, seeing clients. Sometimes she would go to the shelter and speak about racism, homophobia, classism, working with immigrant women, the need to provide culturally competent and linguistically appropriate advocacy and support services to enable women to live with dignity and respect. She was also in charge of the volunteers—interviewing, recruiting, and training sometimes as many as 60 volunteers at a time.

Shrimalie also does a good deal of volunteer work. She has volunteered on the board of the Asian Women's Shelter in San Francisco and at Narika, a South Asian organization that works with battered women and children. She also volunteered with California Alliance Against Domestic Violence in a program advocating on behalf of underserved and marginalized communities of color in California.

The abuse itself does not have to be life threatening; it can be verbal, emotional, or sexual abuse, and many women actually do end up in the hospital. Shrimalie has not worked with men, although she recognizes that side of the domestic violence problem. She knows there are men who are victims, too. Recently, the Office of Criminal Justice Planning calculated that 85 percent of abuse victims are women and 15 percent men, with the gap narrowing in recent years.

Working in the domestic violence field does not always give rewards, because many times the women stay with the abuser, or they do

not access the services available. So Shrimalie has to face the failures and the successes. And, of course, the job is not for everyone.

"I think, it takes a certain kind of person to do it, someone who has a lot of inner strength and passion to continue amidst many obstacles encountered along the way," Shrimalie admits. "I know a lot of women who do it for a short time, quit completely and go on to other jobs. Many of them don't stay long term. What has worked for me is the ability to work on domestic violence, violence against women and women's rights from a local as well as a global perspective. I feel privileged to have had the opportunity to conduct Violence Against Women/Domestic Violence Intervention and Prevention trainings to non-governmental and governmental organizations in the Philippines and in Uzbekistan.

"The stress is enormous. It is also emotionally hard to work with victims/survivors of domestic violence. It takes a lot of strength to do what I do. I go to Siddha yoga meditation in Oakland to renew my spirit. I learned Vipasana meditation in Sri Lanka. I find meditation very helpful. True, when I was doing public speaking, there was stress too, but it was a different kind of pressure—being able to perform well, to speak in public. But now, in direct services with clients, I deal with multiple issues including life-and-death situations with battered women—they could get killed by their batterers."

Social services tend to draw a lot of immigrants from many parts of the world. Majority of people think working for the government provides job security. Shrimalie knows that not all social workers come from activist backgrounds as she does. Some people work for the government because their families have a history in public service.

Before she left Sri Lanka, Shrimalie was aware of women's oppression and saw that there was gender discrimination that led to her second-class status in Sri Lankan society. Here, in the U.S., she was

exposed to feminist philosophy and women's rights and was better able to express herself and speak of her feminist outlook. Even though primarily she serves women and children, she looks at all oppressed people equally.

"Men, especially men of color, are oppressed too. Although my focus is on domestic violence and violence against women, I recognize there is also violence against men, lesbians, gays, elders, youth, and children." she says.

She observes that the country has gone more to the right, especially under the Bush administration. She is finding the current welfare reform program very controversial because many say it does not really empower poor people to get off welfare. It is a vicious cycle. There are various studies showing the downside of welfare reform. For women fleeing from domestic violence, welfare is a lifeline to survival because without the money from social services, they can't leave the violent relationship. When Shrimalie works with women who are on welfare and fleeing violent relationships, she sees clearly that the cash aid and food stamps they get are crucial for them to live decently. So she feels that people do get public assistance to survive and help their families. Shrimalie believes some sort of welfare reform is needed, but it must be well planned. Some people need assistance for much longer periods; they may be physically disabled, or homeless, or be victims of domestic violence. So some aspects of welfare don't seem to be working well. The people who are for welfare always talk of its successes, but millions of people are off welfare. What is happening to them? Are they homeless, are they starving? What living conditions do they have? Those problems are not really addressed, Shrimalie points out.

Economic welfare is one element of the domestic violence argument. Equally, if not more, important is the issue of inner strength and self-esteem.

"It takes inner strength to be who you want to be," Shrimalie says. "With all the pressure in this country that women experience to look attractive in a certain way, for instance, I have managed to live here many years without ever bothering to use any makeup. But many women feel societal pressure and get caught up in supporting this billion dollar cosmetic industry."

Women, Shrimalie asserts, need to believe in their strengths. They should also develop confidence and not let a negative personal, economic or socio-political environment, get in the way of their physical, mental, and spiritual development. Generally speaking, girls and boys are raised and socialized differently from birth onwards. If we raise children in a more gender neutral environment, studies have shown that there is more equality between the sexes. Parents should try to develop these abilities from the beginning, and so should the society at large, the teachers, the school system. There are many negative cultural, political, religious and social forces towards women, and some women find it very difficult to overcome these barriers. Working with immigrant women from South Asia, one cannot use the western model where women are addressed as women in isolation. In the South Asian culture, it is more appropriate to address the family with an emphasis on the women and try to lift women within the family setup as women often return to their batterers.

"I would like to echo the mission statement of the Asian Women's Shelter," says this eighteen-year professional of social service. "Their mission is to eliminate domestic violence by promoting the social, economic, and political self-determination of women.

"I do believe people receiving public assistance prefer to get out of the welfare system. I know, working with survivors of domestic violence, they have always wanted to be economically independent and not dependent on public assistance. They want to be able to get jobs and

support their families. Their circumstances inhibit them. They don't have family and community support, transportation, childcare, and the kind of jobs that give them a good income.

"To me, this job is very humbling and has great rewards. The most rewarding experience for me is when a woman tells me that without my help she would have gone back to a violent relationship because she couldn't have managed on her own to re-build her life and the lives of her children. In my opinion to win a place in the hearts of the women whom I work with is the biggest achievement and reward of doing this work and I am proud to say that I value this honor. Lastly, I am honored to be a source of inspiration for younger South Asian women who choose this career path."

After working with victims/survivors of domestic violence for a number of years, Shrimalie has recently moved on to join the Institute of International Education as the manager of a global leadership development program focusing on women's rights, gender-based violence, reproductive health and population issues. Shrimalie will be conducting Violence Against Women/Domestic Violence Intervention and Prevention trainings in the Philippines, India, Sri Lanka and Pakistan next year. She will also be providing technical assistance and support to organizations working on gender-based violence in these countries. She continues to work with domestic violence victims in a voluntary capacity.

§§§§

From My Perspective

Here we have the stories of five women who, through their jobs, writing, and community activism, have taken the reins to lead and empower other

women and girls. I feel empowered just listening to their stories, because they refuse to stand back and let things be what they are.

"A woman's strength comes from other women," my aunt said to me once, a long time ago, when the word *feminism* or any of its themes were unheard of in India. Come to think of it now, this aunt was the only woman I knew who would express such notions in this way, and agitate my thoughts a little, beyond the conventional attitudes that always connected a woman with the kitchen. No one talked about a woman's strength in those days, although at a subliminal level women were aware of their strengths, their potency as home builders, wives, and mothers, as the movers and shapers of the future generation of great men and women. No one belittled their occupation or downplayed their purpose. Perhaps my aunt meant another kind of strength, the type that would sustain her beyond the kitchen walls and outside the home periphery. Her words slipped through my young mind, down the layers of disarray, like dry seeds falling into a pile of odd-shaped pebbles. It would be years before they would get a bit of moisture and sunshine and begin to stir.

She was the first woman in my family who had traveled beyond our visible horizon and brought back stories of distant lands where people dressed and spoke differently from us. She was a housewife, accompanying her husband to wherever he was posted, her days beginning and ending in her kitchen. But somehow, unknown to us, perhaps through her visits to the market or listening from behind the window curtains, she experienced a different world and danced with refreshing new thoughts. I remember waiting for her arrival sometimes during summer, when she would bring beautifully tailored dresses and fancy parasols with floral prints in her suitcase. I would expect her to present me with one of those foreign-smelling gifts. She always had a gift to delight each of her nieces and nephews.

But it was her talk, looking straight into my eyes, that grabbed my attention more, and the way she conducted herself. She was sensitive, for instance, not to embarrass a young girl in front of a large family gathering. She asked questions of a personal nature discretely, as if she held a secret instrument inside to measure the sensitivity of a question. It was easy to trust her because she would understand our situations, read our thoughts, and even mop up our fears with a single glance. There were times, I confess, when I wished she were my mother.

I grew up in my extended family, routinely watching women help each other in all matters of life.

Sometimes it began with the bathing ponds. We had our own ponds in my father's large family enclave—one pond for men, two for women. The ponds were huge, with built-up rooms for changing, oiling, and relaxing. We had our first swimming lessons in the ponds, watched the older women swim underwater like turtles, do the butterfly and back strokes, and make a big splash under the deep blue sky. It was a playground for the women and girls of the extended family, where we were free to undress and get wet, to swim, to dive, to submerge and hide.

The bathing ponds were more than places to bathe. They were part of the "centers of life" for women, where life was lived in its magnificent fullness; there life's moments became times of transformation and rejuvenation; its goal came within our grasp, and its name was joy; our awareness opened like the water lily at the touch of the first morning rays; our bodies awakened to a new sacredness by the water enveloping us, embracing us. A full-body dip in the water symbolized purification, and nothing else was necessary to bring us to our original wholeness. In the morning our day started with a refreshing immersion in the water to cleanse, purify, and restore. The ponds were at the center of life, a place for the female members of our family to come together each day and at

times of transition. The water was our medium of expression; we would swim across the breadth of the pools when energy bubbled up inside, or we would lie on our backs and float, watching the clouds, meditating. We would dissolve our depression in the water and wash away our tears. The pools were a place to share gossip and secrets or to sit alone for a few minutes as the water rippled away to the far corners.

As girls we took our first lessons of swimming at the ponds and learned to trust each other as well. The bathing ponds witnessed our growing up from girls to women to wives and mothers. The water safeguarded our privacy and renewed our vitality. The pools, too, were reenergized with fresh water during monsoon rains and sometimes overflowed their outer banks onto the surrounding coconut groves. Every summer, just before the arrival of the rains, we emptied the ponds, a hundred hands working in unison, dozens of people standing in tandem, moving buckets of water from the ponds down a channel to the canal nearby. Neighboring children would come with nets to catch the fish and turtles thrown away with the water. It was a whole afternoon of fun and fanfare for us. At the end of the day we would stand around the ponds, mesmerized by their nakedness, their vastness and depth, and then we would depart, leaving them alone to relax, to take in fresh breaths.

Most ancient cultures of the world created occasions for the womenfolk to get together and share news and expertise, for which the men invented the term *girl talk*. The women needed intimate talk, they thrived on it, and they grew from it. The quilting circles of Africa, Europe, and the Americas were examples of women getting together, offering mutual support and aid while they each created a part of the quilt. Quilts are perfect metaphors for the relationships women nurtured with each other, creating harmony from colorful, individualistic pieces sewn together. Women traveled from far and near to participate in quilting

circles. In India women had knitting groups, in sunny autumn afternoons, when they would sit outside in the courtyard, knit scarves and stockings for their dear ones, and share bits of family news and friendships.

All this happened before the habit of television. Today the age-old women's circles have been replaced by "Oprah's circle." Popular talk shows like that hosted by Ms. Winfrey have become such an accepted form of "gathering" that we forget they are made-for-television entertainment, where the participants have to pause for commercial interruptions. They are not real get-togethers or support groups in the same sense of a quilting circle. But the prevalence of talk shows and the predominance of women in them tell us something important—how we miss the old-fashioned sharing, connection, personal contact, and mentoring. We want to know how others have handled their ordeals, met their challenges and hurdles, overcome their disappointments. We want to be inspired, we want to have role models, we want to be validated.

The connecting instinct of the cave-dwelling women who collected food and water, carrying the babies on their backs, while the men hunted has survived. We have a future. We can reach out to each other for comfort, for consolation and inspiration. The television has become our extended family.

We also reach out through written words and computer networks. We do not need to be in the same room, or even in the same country, to offer a helping suggestion, to bring a new awareness. Global networks of women are being formed all over the country to inform, to educate, and to empower each other. We are realizing the power of communication and, as my aunt so eloquently stated, women realize they cannot live in isolation but need to strengthen each other for survival and sustenance.

Chapter 5

BEING AT THE HELM

Modesty May Not Be Your Best Asset

 When Dr. Kalpalatha K. Guntupalli, called Kay by her friends, first arrived in the United States in 1973, the secure young doctor from a family of five accomplished physicians suddenly became "a short, female, foreign, medical graduate with an accent." In fact, many universities did not even bother to send her the application forms for residency.

When she finally started her residency in the bitter cold month of January in northeastern United States, with no transportation available to get her to work at 6:00 in the morning and the bank refusing to give her a loan to buy a car, facing an atmosphere of professional and social isolation, not to mention managing her vegetarian diet, she thought she had two choices before her: either go back to India's security or face

reality here. She chose the latter. She decided to ignore the professors' apprehensive looks, their obvious anxiety and tone of mistrust, their apparent focus on her height, her gender, her accent, her unfamiliar last name, and her ethnicity.

"It was a difficult and trying time," recalls Kalpalatha. "In those days, physicians were on call every other night, month after month. I lost 16 pounds in the first three months. The work was physically tiring and mentally taxing. It was difficult to make all the cultural and social adjustments. Besides, there was social isolation because of extreme work pressure and lack of time to take care of oneself and socialize. During the first year, I thought I was definitely going to go back by the end of the year. But by the time I had enough money for an airline ticket, I had made the adjustment. I told myself, 'It is much better to wear out, than rust out.'"

When Kalpalatha was growing up, the youngest of five children in a lower-middle-class family in India, she had two uncommon women to look up to. One was her maternal grandmother, a self-confident lady who did not let people push her around, and the other was her mother. Grandmother was widowed by age twenty-seven and had to raise her four children alone. She later devoted her whole life to helping her only daughter succeed in getting what she herself could not have—an education and a job.

Kalpalatha's mother went to school, got her degree, became a teacher while raising a family, and later retired as the principal of a school. It was possible because grandmother lived with the family to help out. It was unusual for a married woman to go to school in those days.

"My mother got her master's degree when we were in medical school," says Kalpalatha. "Mother's education changed the family's perspective on girls completely. The question raised about the four

daughters was not whether we should go to college or not, but it was which college and what profession. Studies and education became a cultural norm in the family. All four sisters became physicians and the brother a veterinarian. Once you have an educated mother, the family's perspective on social priorities change."

After graduating from medical school, Kalpalatha married her classmate, Dr. Guntupalli.

"I had only one criterion for choosing a life partner," she says. "He should be emotionally secure with himself. It was a bold decision."

Then they decided to immigrate to the United States for advanced studies. Eventually, her professors started to recognize Kalpalatha's capabilities, as she could outperform many of her colleagues. The professors recommended she take the internal medicine boards at the end of just one year of training instead of the traditional three years. Before long she was completing a fellowship in pulmonary medicine at Georgetown University in Washington, D.C., and beginning another in critical care medicine at the University of Pittsburgh.

There was no turning back, no time to give up. It was 1979, and the race was almost won. But life in America was not easy, even with her education and professional smarts.

"Sometimes, we are judged by our physical characteristics, making us believe that certain attributes are needed for success," she says. "Nothing could be further from truth. The world does not care whether we are short or tall, speak with an accent or without. The world judges us for our ability to contribute to a given cause. Every time I saw an initial hesitation when I walked in or spoke, I would affirm to myself and others that behind every accent there is a different language, and behind every language, another rich culture.

"About ten years ago, I made the decision to try to get what I need and what I want. I was not going to wait for somebody to take care of me or look after me," explains Kalpalatha. "And then things started to happen. In this age nobody takes the time to think what another person's needs are—this is especially true in the academic setting. My philosophy is to ask for what I want and not sulk and expect others to take care of me. If I get it, that is good; otherwise, I know at least I have tried."

She carries a curriculum vitae that runs nearly forty pages. Today she is a tenured professor of medicine at Baylor College of Medicine in Houston, Texas—one of only two or three women in the faculty—and the winner of Barbara and Corbin J. Robertson Award for teaching excellence. She is the chief of the pulmonary and critical care section, the associate chief of medical services, and the director of the medical intensive care unit at Ben Taub General Hospital in Houston. She has been in leadership positions in a number of mainstream organizations, with the endorsement of her American peers. She has been recently elected by the American board of internal medicine to the prestigious Critical Care Test and Policy Committee, which writes and evaluates the critical care specialty examination for the entire nation. She is also on the Critical Care Board, which writes, validates, and sets policies for the certification of the critical care specialists in this country.

"It is a recognition of the academic community for the significant contributions to the field of intensive care," Kalpalatha says. "It is wonderful to know that my signature appears on the board certificates of all those who successfully pass this examination."

Having served in various capacities in the Society of Critical Care Medicine (SCCM), Kalpalatha was elected to the board of regents of the American College of Critical Care Medicine, the highest academic body of the SCCM that formulates practice parameters and guidelines for critical

care specialists. The board of regents is formed by election, with nine people elected in the entire country. She is also a regent of the American College of Chest Physicians.

Kalpalatha's professional success is recognized by nearly a hundred scientific publications and numerous prestigious grants. She is a speaker at national and international scientific conferences and is a reviewer for many medical journals. She became the first woman president of the American Association of Physicians of Indian Origin (AAPI), a nonprofit organization representing 35,000 Indian American physicians, the largest ethnic medical organization in the country. She also worked as part of the Task Force on Minority Issues in the American Thoracic Society (ATS), which represents physicians, scientists, and health care professionals interested in preventing and controlling lung disease.

Perhaps she is most well known for her direct involvement in the international scene, as one of the founding directors of SHARE USA (Science, Health, Allied Research and Education)—a nonprofit philanthropic organization formed by expatriate Indian scientists and lay people in the United States to share technical knowledge with developing nations in the field of medicine, research, and scientific education.[1] One of SHARE's projects, called MediCiti, is a hospital-city complex located on 200 acres near Hyderabad, Kalpalatha's hometown in India, created to bring technology and expertise from developed to developing countries. The organization was able to raise about $2 million in donations in the U.S., with matching loans in India. Kalpalatha helped design the intensive care units and train the personnel at the hospital. MediCiti has adopted about twenty-five villages, giving 35,000 villagers free medical care from birth to death, including providing immunization to 96 percent of the

[1] http://www.mediciti.org/wwh.html.

villagers. She led a group of forty-two faculty to conduct medical courses, even before the hospital was opened. Now MediCiti has its own medical college. She returns year after year to teach courses and render patient care for one month out of the year. She also started the first School of Respiratory Therapy in India.

"That specialty was nonexistent in India before," Kalpalatha says. "Now they have several schools. I feel gratified that I could recognize the need for some of these unique programs and put them in place where there were none. I feel that my major contribution in the international scene is connecting my motherland to my adopted land. I feel somehow the debt of gratitude for my medical education is repaid in a small way.

"I have taken many leaders of the medical community to India. A lot of them would not have gone to India. I was not just taking them on a tour but educating them, showing them the faces and the people behind the scenes. A lot of good things have come out of those trips— unbelievable things."

A recent recipient of World Lung Health award from the American thoracic society for her antitobacco educational work in the U.S. and in India, Kalpalatha has been a trustee at the Surrey House, a cancer patient housing center in Houston, and also at Pratham, an organization that focuses on educating 80,000 preschool children in the slums of India. She is a featured speaker at the Happy Puffers Club and many other self-help asthma support groups, schools, organizations, and churches. She was also a contributing editor for the Asian Women magazine, writing on health care topics of relevance to women.

Through all her trials and triumphs, there is one person who, she says, has helped her at every step—her husband.

"He is truly my soul mate," she says. "He is my trusted advisor and my friend. When I started getting involved in many things outside the

home, he took the brunt of responsibility. When I travel, he takes care of the kids and the house."

Like many Hindus, Kalpalatha believes in reincarnation.

"I want to be born in India again," Kalpalatha says. "I think India puts the right perspectives on life. What America has given me is an opportunity. I think if you need to leave your country, this is the country you should come to, because America encourages your talent, recognizes your merit, and fosters and nurtures your growth. But, basically, you get your tools and whatever values in your hand, and then you come here. So if I am to be born again, I want to be born in India, and if I decide to emigrate again, I want to come to the U.S.

"My heritage keeps me well grounded and my priorities straight. I know my priority is my family, and then doing some good to the society and taking good care of my patients. It is most essential to get one's priorities straight and not get carried away by irrelevant issues. Most importantly, if the family is lost, everything is done in vain."

When people ask her about the secrets of her success, she says she has none. However, she has some paradigms within which she operates.

"We should surround ourselves with people who have positive attitudes and not those who throw cold water on everything. It is also important to have a team around you. You do that by showcasing junior colleagues' strengths, not their weaknesses. Such genuine caring builds strong loyalties. One should be there to help the younger aspirants, because many times they are looking for guidance. Encourage them, and bring out the best in them. Instead of apologizing for what you consider your weaknesses, make them your strengths.

"It is important to set goals, even minor ones, and accomplish them on schedule. What counts is not so much what one achieves but the

longing to achieve it and the effort one makes to get there. I also believe in prudent time management. Time is the most precious thing we have.

"One needs to make one's presence felt when talking, especially in formal meetings. Be precise, and be prepared. It is important not only to say the right thing but also to leave unsaid the wrong thing that might come up in a moment of temptation.

"Women who strive for leadership positions need to remember that modesty dubbed as fairness may not be your best asset. As the saying goes, men play to win, whereas women try to be fair. So women may have to reevaluate their strategy for success."

In the middle of it all, Kalpalatha raised two boys—Saketh and Bharat. Saketh graduated from Johns Hopkins University in 2001. As the president of the student body, he successfully introduced the Indian language of Hindi into the Johns Hopkins' language curriculum. The second son, Bharat, is a high school student and an Indian classical dancer. Mother glows with pride at how much her children appreciate their heritage.

"Do the right thing is my philosophy in life now," she says. "That is all I am responsible for. Opinions as to what is right and what is not may change. But the desire to change and the courage to accept the results provide a new perspective on life."

§§§§

You Have An Obligation to Society

In the summer of 1977 Talat Hasan was a young bride living in India. Her husband, Kamil Hasan, had earned his doctorate from the University of California at Berkeley and was taking a year off from his job with a company in California. He had promised Talat's father that after the wedding they would make their home in India, because Talat had been close to her father. She had lost her mother at age fifteen. While in India for his wedding, Dr. Hasan got a job as an associate professor at the Indian Institute of Technology in Delhi.

Before settling into his new job and the couple's home together in India, Kamil suggested they both go to California for a couple of months so he could finish up his work there. That trip to California, which was supposed to last only two months, became a life-changing experience for Talat and her husband. They never dreamed that the trip would have unexpected twists and turns and that destiny would hold them in the U.S. for the rest of their lives.

Shortly after their arrival, Talat visited a doctor who discovered she had breast cancer that had to be treated immediately. The shock of this news came with the realization that she knew no one in California and had no friends or family for support. Not knowing a soul for comfort, the twenty-five-year-old newlywed underwent major surgery, began grueling cancer treatments, and was told she may not survive. In the midst of it all,

her husband became aware that he wouldn't be taking her back to India anytime soon.

"He was just wonderful," Talat says of her husband. "I can't even imagine how most men would have dealt with it—newly married and his wife becoming very, very sick. He had to cook for me, he had to feed me, and we had not even gotten to know each other well because it was an arranged marriage. We had met each other a few times, but we didn't know each other that well. We were just getting to know each other, and in the middle of all that, the illness. So it was very tough."

Eventually, they accepted that they could not return to India because she had to be under her doctors' care for five years. The traumatic experience became even harder when they decided not to tell anybody about it.

"It was my husband's decision," Talat recalls. "I didn't quite agree with it first, because as we started to make friends, I wanted to tell people what I was going through, I wanted to share it. But he disagreed. His reasoning was—and, in hindsight, he was absolutely right—that he wanted people to know me for who I am, not as a cancer patient. I have started telling all my friends only in the last four or five years. Twenty years after it was all over, I started telling my closest friends. Now I speak about it openly because people see me for who I am."

Talat was born in the Islamic princely family of Rampur in India, as the granddaughter of the state's last ruler, Nawab Raza Ali Khan. She was raised amid comforts and privileges of every sort. There was also no lack of intellectual stimulation for the young princess. The daughter of two professors, she was taught to respect and value herself not because of the rich family she was born into but because of what she could become as a person and, more importantly, what she could contribute to better the society. As a result, she grew up with great expectations for herself.

"My father treated me with so much respect that from the time I was born, I was on a pedestal. I could do no wrong. He felt that there was nothing I couldn't do," Talat says of her growing up years

Her father, Professor Nurul Hasan, was one of the most well known thinkers of the time. As the minister of education and culture in Indira Gandhi's cabinet in the 1970s, he brought far-reaching educational reforms to the country. Later in his political career he was ambassador to the Soviet Union and governor of the state of West Bengal.

"We saw all the top intellectuals, politicians, journalists, writers," Talat recalls. "Those were the types of people who were in and out of my house all the time. It was a 'who's who' of Indian politicians and intellectuals, and I was fortunate enough to grow up among them. I took them all for granted, and now I look back and say, 'My God, the people who were going to be in the history books were all the people I lived with.'

"So unlike a lot of other women, I am probably different in that I came from an amazingly privileged background. I realize now how privileged, not so much in terms of money but in terms of access. Every door was open to me in India. There was no lack of opportunity, but every opportunity I could possibly want."

Himself an Oxford University scholar, Professor Hasan decided his two children would also attend the renowned English university. As soon as she finished her bachelor's degree at Aligarh Muslim University, she wrote the entrance exam for Oxford and got ready for the trip abroad, at age nineteen. Until then, like most Indian girls, she had led a very sheltered life, attending boarding school and then a women's college.

"My father didn't even come to England to drop me off," Talat says. "He just put me on the plane at Delhi airport. He said, 'You have to learn to be on your own, broaden your horizon, broaden your thinking.'"

She came back with a master's degree in experimental physics, specializing in semiconductors. Her father wanted her to develop as an individual, not as an automatic reflection of his views. He therefore advised her not to get married immediately.

"I feel—I say this to my husband and all my friends—that a woman's self-confidence is greatly determined by how her father treats her. To my father, everything was equal for me and my brother. It was never that the boys were treated differently from the girls, which was the case in a lot of homes but not in ours. Everything was equal, including educational opportunities. My father would spend equal amounts of money on both our educations, giving equal emphasis to doing well, having a career, and doing something useful and worthwhile.

"He always said that I can't just sit there and say 'Now I have my education, I am going to kick back and enjoy my life.'

"He just treated me with the idea that there is nothing I cannot do if I set my mind to it. He also insisted we have an obligation to society. He would ask us to give back more than what we have received, no matter what we do, in any walk of life. There was no question of me just sitting at home, doing nothing. Everything else came basically from that upbringing."

Everything, including the courage to found her own company and become the first woman entrepreneur in the semiconductor industry in Silicon Valley.

A short time after doctors pronounced her cancer cured, Talat reemerged as the confident young woman she had always been. Before starting her own company, she worked as a scientist, doing research in the semiconductor field at Signetics Corporation and Philips Research Laboratories.

"If you are different, people will remember you," says Talat. "And if you make a positive impression, people will remember you even more. Now the other side is true, too. If you make a negative impression, they will remember that, too. But to the extent that you can make a positive impression, people will remember that. Being a woman and being a South Asian, you might stand out a little bit. But that is an opportunity, if one uses it well to project a positive view.

"But I found a business environment is different, in the sense that people really don't care who you are as opposed to what you can do. That has been the hallmark of the American system. What can you achieve, what can you contribute? If you can do well, contribute, and work hard, you get rewarded by the society, pretty much as the local people.

"If I want to be a senator or hold a high public office, probably my heritage would stand in the way. But in the business environment it has not. I have been very accepted for what I do," Talat says. She was one of the first South Asian female entrepreneurs in the United States when she started her first business, Prometrix Corporation, in 1983. Her company manufactured semiconductor process control instruments. Later, when her company was acquired by Tencor Instruments, she became the vice president of corporate business development.

Talat founded Sensys Instruments, another company to manufacture products for the semiconductor industry, in 1996. She was the chairwoman and chief executive officer of the company until it was acquired by Therma-Wave Inc. in 2002 and Talat became a member of that company's board.

Her company has made a significant impact on the semiconductor industry. Sensys Instruments makes machines that do not actually make semiconductor chips—the brain and bones of modern

electronic products and computers—but they control the process of making the chips. Working in conjunction with the machines that make the chips, the Sensys instruments collect in real time, very quickly, a lot of information from the semiconductor wafers, and that information is used to control the process of manufacturing the chips. All the semiconductor chip manufacturers—including Intel, AMD, Texas Instruments, and many Taiwanese and Japanese companies—need her company's products. It is a worldwide market.

Getting into the world market is not easy. There is entrenched competition, entrenched ways of doing things. As Talat explains, when you are a little company trying to break into the market, you are asking people to change the way they have been conducting business for a long time, and then you are trying to overcome very large entrenched competitors, with plenty of money and a big share of the market. Finding investors who believe in you and are willing to give you the money you need is a major step. For this kind of business, it takes a long time to develop the technology and get accepted, and investors need to be very patient. That was very hard, Talat admits.

But it was enormously satisfying for her because she opened the door for other women entrepreneurs to take the step and to believe that if she can do it, they can do it too.

"Women carry a greater burden in American society to overcome the image that the American media projects," Talat says. "The purpose for you to be on this earth is to have a positive impact; it does not matter how pretty you are, or what you look like. You have to be healthy, and it is important in that sense to take care of your body. But your purpose in life is not to stand around and admire yourself in the mirror, or to be admired by others because of your looks. Should you seek admiration, it should be for what you do, what you contribute.

"I think it is the responsibility of parents to instill that self-worth in young women from a young age, because if they don't enter adolescence with that self-image and feeling of self-worth, it is probably going to be hard to change suddenly at age twenty-one. I told my children stories of personal experiences I had with my father, why I had to study, why I had to have a good education, why contributing to society was the main purpose in life, and about being a worthwhile person and making a contribution to society. It doesn't necessarily mean a woman has to have a job, but it means you create a value through your home, your life, the type of children you raise, the kind of work you do for the community. We have those conversations on a very regular basis.

"My mother put her energy into her work and her community service, and my father valued it. They passed it on to me, and I try to pass that on to my children."

Mentoring other women entrepreneurs to succeed is one of the passions of this experienced businesswoman. Active on the board of business organizations like Indian Business and Professional Women and The Indus Entrepreneurs, Talat brings her talents and experience to help others move ahead.[2] She has also been active on the board of trustees of her daughters' school.

A great admirer of American capitalism and the principle of free enterprise, she agrees that there is struggle to achieve financial independence. Once you get to the point where you don't have to think about making any more money, then you begin to think about what else there is in life.

[2] IBPW is a nonprofit organization based in the San Francisco Bay Area to provide networking and professional development opportunities for women. TiE is an organization that provides mentoring and other support for entrepreneurs.

"I think, I am at that point where I feel if I am fortunate enough to have made money and achieved wealth," Talat reflects. "Now I can use my money to do something useful. It is really funny that you spend all your life making it, and then you want to give it all away. I am trying to spread it to as many people as I can. If more and more people feel that way, we can make a big impact, rather than pass it on to future generations. I would rather my children struggle and earn their own money."

This longtime resident of Silicon Valley had always wanted to do something for the community—something more than generating jobs and promoting technology. She wanted to bring the precious gift of music, the mellifluous classical music of India, to this center of computer wizardry.

With her husband, Kamil, she established a chair for Indian classical music at the University of California, Santa Cruz. She hopes the endowment will plant the seeds for Indian cultural studies for music, dance, drama, and the visual arts and make the arts more available to future generations of students. Santa Cruz is a university town situated on the shore of the Pacific Ocean, close to the high-tech centers of Silicon Valley. Students there are highly motivated to pursue any study one's heart desires, including music and the arts. In Silicon Valley world cultures thrive, given the right encouragement. It is a charismatic conglomeration of business and technology, bringing together people from every country on the planet to excel, to fulfill their dreams. It is a place where one can hear almost every language spoken on earth and sample ethnic food from any part of the world. It is fertile soil for music and dance of all ethnic origins, of all flavors and rhythms. Coming from an affluent musical background, Talat has plenty of interest and knowledge in the field.

"Rampur is very well known for the patronage of classical music, and that is why I endowed that chair," Talat says. "My grandfather and my

great grandfather not only gave patronage but they themselves excelled in the knowledge of music. My grandfather knew classical music. He had an amazing gift for it. He didn't play any music, but he knew it, he understood it, and he composed music. He also was very fond of Kathak, the North Indian classical dance. All through our childhood, when we went to Rampur during summer and winter holidays, we were all required to sit and listen, and there would be someone singing every night, or dancing. We would sit there, sometimes sleepy, and we were not allowed to get up. So from a young age we were listening to it. It was a wonderful heritage. For my wedding several well-known artists came and performed in our house—we had Kathak, Ghazal, Vilayet Khan on sitar, Shiv Kumar Sharma on santoor."

In her effort to spread her fortune as widely as possible, she has established a foundation in India, the Nurul Hasan Education Foundation, named in honor of her father. The foundation is working with various universities to provide additional facilities and establishing centers in various Indian towns to offer women computer training and job skills training. The foundation also targets women who have not finished high school, giving them the ability to earn a living by offering training in a variety of skills like data entry, embroidery, and secretarial work. For the women who cannot leave their homes, the foundation offers training in sewing and embroidery that can be done as piece work for the big boutiques. Educating a woman will go a long way, Talat points out, because her children are more likely to get educated too.

Talat is a mother of two girls. What professions her daughters will choose is not her worry. Her oldest daughter, Minal, attends college and has decided to focus on family law with the goal of working with immigrants and people who have no money and whose rights are not

being represented. Her younger daughter, Salma, is in high school and has yet to decide what she wants to do.

Talat feels fairly certain both her daughters will make a positive contribution to the society. The society can be their immediate community—it can be as small or as large as they want to make it. But they have to give back.

"I think one of my great contributions is having two children who will, I hope, be contributing to the society as well," Talat says. "My children are expected to contribute to society in a very positive way. It is not enough for them to get by, they have to excel, they have to do their best. Look at yourself in the mirror and say, 'I couldn't have done any better.' You don't have to please anyone else, but you have to be able to live with yourself."

§§§§

Be Yourself

About eight months after starting her own company, Vinita Gupta's business partner decided to leave. Despite Vinita's pleas, the partner's decision was final. Feeling totally abandoned, Vinita had no idea how she was going to handle the business on her own. One day when she was too depressed to get out of bed, her husband, Naren, came to her rescue. He got her out of the bed, took her to work, and promised he would do anything to help her deal with the situation.

He had his own company, but his support and encouragement were strong enough to pull her out of despair. He appraised, debated, advised, reassured, encouraged, and showed her some of the tough choices she had to face.

Another incident Vinita fondly recalls from the startup phase of her business is about her first customer, Federal Express. Every day she would call them to find out if they had installed the product she had sold them, and they would say no. Finally, when they installed the product, it failed to work. It was the last thing Vinita wanted to hear. While Vinita and her partner were scrambling to decide what to do, her husband came in and said, if they could make the product work, that customer would be the best customer ever. Those were the words of wisdom she wanted to hear. And indeed, after the problem was fixed, Federal Express was ready to give them more orders and a good reference.

"If there is anyone I can coolly say has helped me in achieving what I have," says Vinita, "it is my husband. We both started our own individual companies, we are both ambitious. He understands when I am going through tough times, and I understand when he is going through tough times. We have experienced firsthand what it is to start one's own company."

It was her husband who gave Vinita the motivation to launch out on her own. By then his software development company was established in Silicon Valley. It was his wholehearted support that ignited Vinita's entrepreneurial spark, sending her on the path toward being her own boss.

One other person had pushed her along her professional path— her mother. Vinita's parents encouraged their three daughters to develop a profession. Her father was an engineer for the Indian government. Her mother was a housewife who never worked outside her home but wanted

her daughters to be career women. As children, the three girls were always trying to please her, be well behaved, study hard, and develop their ambitions. It was Vinita's mother who later persuaded her to go to America for graduate studies.

"I never thought I was going to be a housewife," Vinita says. "I always thought of myself as working, a career person.

"Because my father was in government service, he was transferred a lot, and we moved every few years to different towns all over India. But we always had neighbors we made friends with, no matter where we ended up. Every evening we played with them. We managed to get friends irrespective of the state boundaries or the different languages. We didn't live any significant amount of time in any one town, but we lived in quite a few different towns. Before I finished high school, I was probably in seven or eight schools in five different states."

After graduating from the University of Rourkee in India with a bachelor's degree in electrical engineering, Vinita came to the University of California, Los Angeles, to earn her master's in 1973. In India there had been one other female student in her engineering class, but engineering was still not the prime choice of college-bound women in America. Her American sisters were noticeably absent from her class, and she spent the graduate school years as the solitary female student.

"I was ambitious, and I thought I was going to take one step at a time," recalls Vinita. "I liked India, I didn't know anything better than India at that time. I didn't have a preconceived idea; but on the other hand, I looked up to the U.S. as a place where people go and have their ambitions fulfilled. But I was uncertain what my life would be like a few years after I graduate.

"The first year was the most challenging because there were social adjustments, food adjustments, loneliness, uncertainty about the future. In

India we had arranged marriages, and I would have wondered how, when, if it would ever happen. Here also there were many uncertainties. I was ambitious, so behind all the uncertainties and changes was the spark of hope that one way or another I was going to make it, although how I would make it I did not know."

Socializing with the other students was a big problem on the campus because her culture was so unlike that of the other students. She did not make them feel comfortable, nor was she comfortable. With no cultural integration, no social connection was possible. She experienced nothing negative from the other students; they knew she was a good student, and if she wanted she could talk to them about course work. But she could not discuss anything else.

"I found the cultural gap to be too much, making it difficult to have friends. Not being able to relate to them and do the same fun things I used to do in India was my biggest disappointment. In India the girls would go out to have light snacks from a corner snack shop or street vendor, but here an outing meant going for a drink—culturally too shocking for me to accept because the drink was always alcohol."

Before embarking on her U.S. study program, Vinita's parents had introduced her to her future husband, Naren Gupta, in the traditional arranged-marriage style. But with her mind focused on UCLA, Vinita was not yet ready for marriage. They met each other again in the United States and were married within a year and a half. By then Naren had finished his Ph.D. at Stanford University.

After working for a few years at various technology companies, Vinita, inspired by her husband, launched her own company, Digital Link, in 1985. They were living in Silicon Valley, an area of California best known for its technological innovation and economic prosperity.

But even in Silicon Valley, very few women fulfilled their career ambitions by becoming chief executives of corporations.

Vinita's company designed and manufactured telecommunication products. It went public in 1994 and grew to become a global enterprise earning more than $54 million by 1998. Vinita was one of the first women to launch her own public company in the United States, and the first South Asian woman to do so.

As the CEO and board chairwoman, her job was to set the future direction of the company and ensure that everything was being done on a daily basis to progress toward that direction.

As one of the first women to trek the high road of technology, Vinita faced some very tough times. Although she was a brilliant engineer holding two U.S. patents for innovative inventions, starting and running a business was a real challenge. Coming from a minority group and being an immigrant had not been helpful either. Yet it was not her identity as a minority immigrant that was the most difficult for her to deal with. On looking back, she appreciates the effort involved in building a company from scratch.

"In the beginning I didn't know how to attract a management team because I had never done it in my life," Vinita describes. "So that was a big obstacle. That probably sticks out in my mind as one of the biggest challenges I faced: the transition from being an engineer to being the CEO of a company. I didn't know what would motivate someone to join our company. Why should they work for me?

"Running a company with 20 employees is one thing, but making the company go beyond that—where you need senior people to whom you can delegate and who really add value to your business—is a major step up. It is learning on the job, but it is more than that. One thing is true in life in general: if you want something too desperately, you never get it.

If you want the other person too badly for your company, you will come across that way—there is no way to suppress it. So your challenge is to convince yourself that you are not going to be so overly excited about any particular person. You need to keep yourself balanced in those conditions.

"The CEO has the ultimate responsibility; the company cannot end up in a mess because of one person unless that person is the CEO. So the buck stops here, as they say. That is also the ultimate satisfaction of this job. If things are not happening, I always look within myself and ask myself what am I not doing right. To do that for fifteen years is a long haul. It is not something you do for one day and forget about it. We are not superhumans; we might make mistakes, which is acceptable. We have to accept the mistakes and go on."

Vinita has what it takes—her dedication is legendary. Once she had to dash, literally, from the corporate boardroom to the hospital labor room. The story still goes around Silicon Valley.

"I knew it was going to happen," recalls Vinita. "I knew I was going to have my baby that day. But the board meeting was very important, and I thought, what would I do sitting at home? So I went to the board meeting, and sure enough, it happened."

She was rushed to the hospital labor room, where her second baby was born.

"I am not sure it is a commitment," Vinita says, "but it is an involvement. You are so involved. You can't disassociate yourself. When I had my first baby, the company was really not doing well at all; it was a young company at that time, and we had many problems. I had a C-section, and the next day when the doctor came to see me, I was talking on the phone to people at work. I just had to, because I couldn't disassociate myself from my duty. It is like having another baby at home,

with nobody to take care of it. Wouldn't you call and do whatever you can?"

By 2000 Vinita's company began slipping down the stock market. In a bold step she decided to privatize the company.

"Mine was the first high-technology company in the valley to get privatized," Vinita recalls. "The investors were more interested in the new Internet-based companies, which had more visibility but no track record. Their stocks were zooming to the sky. So companies with no track record were given the benefit of the doubt, whereas those that had not performed that well in the past were ignored. My challenge was getting visibility and stirring up the minds of the investors.

"So privatization seemed like the most reasonable way to solve the problem. We could offer the stock option at a cheaper price, and as the CEO of the company, I didn't have to worry about the investor community. I could focus totally on readjusting the company, transforming the company into what it could be, putting all my energy into it. It is a hard thing to do in the public light because the public market does not understand it and is not very forgiving. And if the stock takes a plunge, the employees get upset and make the CEO's job doubly hard. So to break that vicious cycle, my husband and I thought privatizing would be a good alternative."

Along with the breath of fresh air the company was given by becoming private again, Vinita decided to give it a new look as well by changing its name from Digital Link to one with a more energetic feel—Quick Eagle Networks. The company grew to become the winner of the 2001 Great Corporate Teams Award. Vinita has high aspirations for Quick Eagle. She hopes to make it a multibillion-dollar company.

As a woman entrepreneur, former CEO, and current chairwoman of a company she founded, Vinita is aware she is in a highly visible

position. She remembers a female boss she once had who taught her that a woman can be herself and still be accepted in the corporate world. She doesn't have to behave like a man.

"Don't lose your feminine self and try to be 'professional' or be 'masculine' to be accepted," Vinita says. "By imitating somebody else a woman might seem inflexible and lose her original charm and sensitivity."

She is not embarrassed to admit her difficulties and failures and even depend on others, including her husband, for guidance and help. She doesn't claim to be a superwoman.

"It is important for women to work so they gain self-esteem and confidence," she says. "I have great aspirations for my daughters. I hope they will work as professionals and become more successful than I am. However, I wish them the best no matter what their dreams are and what career paths they choose."

There was a time when she was working 14, 15, or 16 hours every day at full intensity. Those days, she didn't think there was anything in the world she could not do or could not change. She saw this attitude as a great way to create enthusiasm for herself and the people around her, but it started wearing her down. She learned the importance of being more selective about which battles to fight. Today she approaches her work differently.

"Do not fight every battle," she advises. "Now I seek balance in everything. My office time ends around 6:30 p.m., and I am ready to head home to my children. We go on frequent short trips, especially during the ski season, as skiing is a favorite sport for the whole family. I also find time for community involvement, although not to the extent I would like. Occasionally, I make time for attending cultural programs and parties, and for playing bridge, my favorite card game.

"When I'm faced with a tough decision, I ask myself, 'Am I going to ever regret it?' If I think I might someday regret the decision, then I know I should not be making it. I basically ask myself what my choices are. Once I have made a decision, I stick to it, knowing that it is a path with no return. I will not regret it no matter what happens, because I willfully chose it based on what was on my mind. And that's all I can do."

When she feels overwhelmed, she makes a list of her priorities, draws a line just below what she most values, and drops everything under it. Once a year she makes an inventory of things she should change to do business more effectively. Even so, there are times of tension and stress, when things do not go her way.

"What helps me deal with those times? Prayer. I am not a rigorous, daily prayer person. But prayer makes me acknowledge that I have problems—specific problems that I am concerned about. Prayer reduces tension and brings a recognition that not everything is in my control, because things are going to happen in life, not all of which I can resolve—either I don't have the ability to resolve or it just can't be resolved."

§§§§

When They Underestimate You, Prove Them Wrong

Lubna Jahangiri still laughs when she recalls a client who asked her if she had been educated as a young girl in Pakistan, with the underlying but unspoken question being, had she arrived in the U.S. as an illiterate adult? Lubna believes the client was probably mistaking Pakistan for Afghanistan under the Taliban. Growing up in Pakistan, Lubna followed a tough curriculum pursuing a graduate degree in psychology at the Pakistani university where she studied statistics, experimental psychology, and physiological psychology. She had wanted to become a psychotherapist. She also had dreams of leaving Pakistan and coming to live in the United States. In those days, the early eighties, she felt trapped by the repression of her Pakistani life and offended by the common practice of polygamy.

When Lubna heard some of her relatives describe their travels abroad and how different life was in other parts of the world, she began to pine for an opportunity to leave her country. Her older sister, Humaira, studied at Oxford on a Rhodes scholarship. There she not only earned good grades but also participated in adventurous sports, like parachute jumping, and traveled all over Europe by herself, even inside the Communist bloc countries and behind the iron curtain. Humaira would write letters to her younger sister—exciting and inspiring letters about the outside world.

But when Lubna's parents arranged her marriage to a Pakistani army officer, she thought perhaps she would never leave Pakistan. Not willing to shelve her dreams, she convinced her husband that better things awaited them if they took the difficult initial steps to leave. Within three years she was on her way to her dreamland, alone, with her infant son on her hip and a student visa in her pocket. Her husband was to join her a year later.

The excitement of coming to the United States lasted for about two months. Then reality took over and the adventure began. She was not disheartened by the difficulties nor frightened away by the challenges, because she knew someone who had made a more daring trip years ago—her mother. When she was twenty-one years old, Lubna's mother emigrated from India, traveling from Rampur to Pakistan by herself. In those days it was not easy for women to travel alone, especially in a remote part of Pakistan. She found a job, bought a house, and started living on her own. It was an incredible thing to do in those times, especially considering that her family was very strict about the role of women. She traveled wearing her veil. Eventually, her family joined her, and much later she got married. Lubna admires her mother as a unique woman who continues to live an independent lifestyle. But Lubna found sometimes it was difficult to live up to the example set by her mother.

"Even in modern times, the move was very hard for me. I was on a student visa, and so I couldn't work off campus," reminisces Lubna. "I took my first job at the library for $4 an hour. I was working, studying, and I had a little one-year-old kid. So it was really tough. I handled working full time and going to school at the same time. Compared to the rigorous courses I had back in Pakistan, I found my studies in the U.S. rather easy. But I had no idea how to take care of the baby, because where I came from there were always people to take care of the child.

Fortunately, I was living with my husband's family here, and they were very supportive."

Because the American university did not recognize her Pakistani graduate degree, Lubna had to earn another master's degree in counseling psychology. When her husband joined her, they both studied and worked, keeping a home, making bare minimum wages, surviving as students and parents.

After graduation she began what she had imagined would be the most exciting job she would ever have.

"At first I did some work with severely emotionally disturbed adolescents. That was really stressful, and I was burned out in a matter of seven months. I couldn't do it anymore. These teenagers, who had been in juvenile halls, were taken out and put in group homes. I was a counselor in a group home, and my hours were 3 to 11 p.m. They were violent sixteen- and seventeen-year-olds. They didn't look like children at all. It was a difficult job. So I left that job, and I became disillusioned with psychology. It was turning out to be not as interesting as I thought it would be. Then I became the clinical supervisor of a drug and alcohol rehabilitation program for pregnant women and women with small children.

"I saw how formidable a task it was for the women to get off of drugs. They would come, stay for a few months and then go back. It was hard for us as counselors to see them go back to drugs. And they had little children, and it was sad to see the children taken away and put in foster care. We got attached to the kids, and when the mothers left we didn't know what became of the children. I had stress burnout, so I left that job. Then I started working for a domestic violence shelter and later became the first program director of a shelter for South Asian women.

"Every day I would go there not knowing what I would be dealing with. It was even more stressful. In the domestic violence shelter I would see women coming with black and blue eyes, bleeding, their kids very emotionally disturbed. So it was painful. And the batterers would be pursuing them, looking for them. They would call the shelter. Of course, we wouldn't give out our locations."

Lubna was getting to a point where she was rethinking her career choice. She wished she could have a job with less emotional involvement, something less chaotic. But she still wanted to help people with problems. She noticed that a lot of the women who came to the domestic violence shelter wanted to talk to a lawyer before starting counseling. That made Lubna think that she could offer women more help by being a lawyer. She realized that as a lawyer she could help not just women in domestic violence situations but all women.

Once the idea of becoming a lawyer was planted in her mind, she set to work making it happen. She knew she was up to it. After three more years of school, she became a lawyer.

"I had to achieve more than the rest of the people," Lubna says. "If I were below average, which is usually accepted, I think I would not have made it. So I had to achieve more to prove that I was worthwhile. In the beginning, maybe because I had an accent, people thought I didn't have enough intelligence, and they made it known by their behavior. I felt it. They didn't realize that I was at the top of my class. After three years when I graduated as the valedictorian, I think many people were shocked.

"Even now when I am representing someone, I sometimes feel the party on the other side underestimates me. I think that may be because I am a woman, an immigrant, and a Pakistani. It may also be because my name is recognized as Islamic. They conclude that I am either from Afghanistan or Iran, so they have the image of a very repressed and

uneducated woman, the kind they associate with the Muslim world. It is not open but subtle. But they always misunderstand me in the beginning." Lubna smiles, saying it is always good when your opponent underestimates you.

After working in a law firm for some time, she decided to go solo, to be her own boss. In the law firm culture, she explains, there is a hierarchy, and if you are junior, you are treated as the dumping ground for all the work no one else wants to take on. You have no control over what type of clients you take or what cases you handle. Lubna admits her law firm did occasionally give her important work, but generally a law firm is controlled by the partners and senior attorneys. Although it may not have anything to do with being a woman, Lubna believes practicing law is harder for women because of the amount of work and the pressure to meet the required number of billable hours.

"You have to bill a certain amount of hours per year to the clients," Lubna says, "because it is a business for the law partners. If you can't keep up with that, you don't get good reviews, and you don't get chances to advance. It is especially hard for women because they have kids and families and they are wives. Married women with children can't work until 10 o'clock at night, and they can't work on weekends. That is why there are disproportionate numbers of men in law firms. They can rise to the top because they can sacrifice their families and their time for advancement.

"I didn't want to do that. I didn't want to sacrifice my kids. I was with the law firm for a very short time, about six or seven months. Then I decided to be on my own. Now I have a home office. I am still working a lot. I work weekends and nights. But I am home. When I give my kids dinner, and I know I am there for them, it makes me feel like a good

mother. Then I can go to my office and work. I really enjoy my flexibility."

Lubna's specialty is business and real estate law, and she takes both transactional and litigation cases. She helps businesses set up different forms of entities and write and review contracts, leases, and other business documents. She also works on breach of contract cases, collection actions, and real estate problems, including real estate sales. She accepts some personal injury work as well. The work is challenging but also very satisfying for her.

Lubna's background in counseling psychology also helps in her law job because, she says, "the way I practice law is very client centered. I really like to hear what my clients say, and I ask their advice, their input, because it is their case, and nobody can be more interested than they."

A client might come to her about a breach of contract and need help getting money back. But that's the easy part. The hard part comes when there is emotional involvement. Somebody the client had a relationship with—a family member or former lover, for instance—might be the swindler. Or perhaps client suffered a wrong that was more than having money taken away, because there might be emotional injury as well.

"The best part of my job is forming long-term relationships with my clients," says Lubna. "They are more often business clients, and I get repeat business from them. But I am also someone they can trust and come back to for advice and help. I don't like personal injury work, where I never see or hear from the client again. I like networking and meeting interesting people. It inspires me to see women following their dreams, devoted to their goals, and believing in themselves and what they are foreseeing. That gives me inspiration. I get inspiration from my clients. I

also like when people come to me almost in despair, and if it is legally feasible of course, I show them a ray of hope.

"In some memorable cases I could feel the injustice done to my client, and I know the legal system is frequently used to harass honest, hardworking business owners."

Lubna has developed a network of attorneys and law professors whom she can call if she faces a problem. If it is an especially big case in which she feels she needs more help than usual, she partners with more experienced attorneys.

Today she is happy being in America and living in northern California, although there have been times, while in school, when she wanted to just leave everything and go back to Pakistan.

"I had fantasies about going back, leading a very quiet, simple life in Pakistan," she says. "But now that I have my own practice, I enjoy it so much that I have dropped the idea. I might go back when I retire. But I don't think I can do the same work in my native country. I like going there on vacation almost every year, but not permanently.

"Now, after living for fifteen years in this country, I see many good things in Pakistan that I don't find here. I remember how in my mother's house, neighbors and others would just knock on the door and come in. There was a good sense of community there that is totally missing here. I don't see my neighbors here for months. I am becoming more accepting of the negatives of my native country and more appreciative of the positives."

The American attitude toward aging baffles her. She believes that age has matured her and that life begins at forty.

"I know myself much better now, I am more in control of my environment. Before I was more concerned about other people, what they thought of me. I was doing things that seemed right, not what I wanted to

do. That caused me a lot of unhappiness in my life, because I was trying to do the right thing, not what I wanted to do or what was right for me. I think now I am less concerned about the outside world, am more internally focused, and do things that feel right to me. I have noticed that this change has moved me in the right direction. I do things that may not be very rational but that feel right, and I follow my instinct, which is usually correct. That makes me a very happy and satisfied person.

"But in the Western culture, so much importance is given to youth, and everything is always about young people. How about all the good things that come with age? I think that is something women need to realize and celebrate."

Lubna is also a published writer in Urdu. She wrote and published a novel in the Urdu language—a novel about women's issues in Pakistan and the practice of polygamy. The title of the book is *Bade Mukhalif*, which means *The Wind That Blows Against You.*

"Many educated women in Pakistan who can read Urdu have come to me and said that the book has given them hope," says Lubna. "I consider that as my little contribution. It makes me feel that I have done something worthwhile."

Lubna speaks in women's forums, law forums, and Urdu literary groups. She is an active member of and volunteer for the Democratic Party. She writes letters to her representatives in Congress and expresses her opinion on many issues of interest.

And on weekends, after all her work is done and her children and husband have gone to bed, she takes out her Urdu novel and works on its English translation. Perhaps someday this multitalented woman will become an American author, once again proving wrong all those who underestimated her.

§§§§

From My Perspective

I remember some of the first telephone conversations I had in my engineering lab in the 1980s, when my female voice was assumed to be secretarial, and the person on the other end would speak as if to an imbecile, often demanding that "someone in charge" or "someone technical" take the call. Salesmen were annoyingly patronizing, often explaining technical terms in minute detail. A deadweight seemed to hang from my female shoulders, the heavy burden of having to prove my worth every moment.

Images of old scenes would often emerge in my mind, scenes from the staunchly patriarchal culture I was familiar with, the South Asian type, which curiously, in comparison, seemed more benevolently paternal, softly scolding but protective. In those authoritarian scenarios a woman interacted with a brotherlike, fatherlike, unclelike, or grandfatherlike superior. The alliance grew on dimensions of its own. The relationship was not entirely preconceived but was generally understood and recognized. The fatherlike boss, for instance, showed a great deal of compassion to the daughterlike employee when she went to work in her advanced pregnancy or when she rushed home to her newborn baby. The brotherlike worker warned the sisterlike office mate of potential danger if her lover were of questionable character. A sonlike boss found it intolerably agonizing to fire, or even reprimand, a motherlike or fatherlike employee. The authority of the boss sometimes took ambivalent tones, strangely blending with the aura of a more personal human bond, stretching in many dimensions, commanding, admonishing, punishing, counseling, honoring, obliging. Its ambivalence came from its multidimensionality, its refusal to be bound by the strictly official line

between boss and employee, its tolerance of cultural norms that honored relationship, wisdom, and age above individualism.

A woman wore traditional attire to work, with obvious symbols of her marital status, and expected the same amount of wifely-motherly courtesy as she would be entitled to outside the office. No transformation was needed in outlook or appearance, in philosophy or attitude, for the woman to enter the work world, because she would downplay her personal aspirations and perform her duties just as she would in her domestic world, soft spoken and dignified. She hesitated to speak up, interrupt another's speech, or criticize, even when she knew the other person was dead wrong. While the society rewarded the woman for her dedication to family and her lack of career ambitions, the woman obligingly stayed away from self-definition in terms of her career. There was glory whenever she sacrificed herself for someone else and nurtured no longing for fortune and fame. She learned to habitually suppress her individualistic thoughts, to ignore her creative urges.

When this South Asian woman entered the American landscape, filled with images of free-thinking, confident-looking, freedom-seeking, cigarette-smoking, night-club–going women, she stumbled, unsure of where she should go, what she should do. America's welcoming gift, the legacy of "go out and grab it," crept under her skin and violated her sanctity, her long-cherished abnegation. She stared at TV images for models to follow, to decide how she should live in the society of freedom-loving people and yet protect her own cultural lucidity. Should she go ahead and buy a pair of jeans from K-Mart, for instance, and don them to show her transfiguration and zealous Americanization? Should she, as a first gesture of conformity, cut her hip-hugging hair to shoulder length and curl it or color it blond? Who would be her fatherlike or unclelike authority figure to show her a way of becoming? She so much wanted to

be like her modern counterparts that she turned her mind upside down, as if to start all over, to learn to live the rest of her life. She kept at it, crying or laughing at times of stress, talking to strangers she met at the supermarket, as if they had a clue about her situation, just to regain her equilibrium. The portrait of the divine housewife who, like a goddess, would create a new world of happiness and prosperity for her husband and children, using superhuman domestic skills she earned so painstakingly, now lay shattered on the carpeted floor of her apartment. She wanted to cry at the slightest provocation. She vigorously shook off the thought of going to the bar openly and having a few drinks of beer, which seemed to be the usual way to solve personal problems.

Sometimes a new immigrant woman, as in earlier times, can find no way to resolve her cultural dilemmas and move on to the new vistas promised her by the American school of thought that equates assimilation with success. She has heard stories of people who came to the land of free enterprise and "lite" beer and became millionaires in a matter of years after having landed with a couple of ten-dollar bills tucked in their shoes. So here she is, kept on the pedestal of motherhood, current or promised, worshipped at the altar of matrimony, craving to transform her character beyond recognition, trying to become the American she is not. Being accepted by the society is a challenge she dreams about every night and day, prays for at the temple of self-aggrandizement, stoically, as she looks for someone, anyone, to give her some ideas to show who she is. The choices she faces are many for the woman who wants to do something with her life. Should she be like a man and look over her shoulders or like a woman and look down at her feet? The shyness she carefully nurtured as a virtue, a paramount asset, has become a handicap, a heavy head-load, because she is expected to be talkative and jovial and to always please her bosses. The image of the new woman hangs in her closet, a woeful

skeleton, full of dust, crying for attention and food. The "To Be or Not to Be an American Woman" question dangles in her mind like a long-drawn sword, cutting and damaging her insides. Her hormones rage and make her sick at heart as she tearfully wanders the streets in search of role models.

But there are some who intuitively get it. They throw caution to the storm and pull out, for the curious bystander to see, every strand of inner strength and wisdom, so they can function beyond being an ordinary American and become, thoughtfully at first and later, creatively, an exceptional South Asian American woman of caliber, camaraderie, and character. Challenging the roadside norm of becoming independently recognized women who stand alone and catch the American system by the horns, they willingly and painstakingly employ the cooperation of anyone, including their husbands, to support their endeavors. Looking inward for the stamina that will sustain them, they overflow with the enthusiasm of a newborn learning to grasp the world in her tiny fists.

Chapter 6

LOOKING BEYOND THE FENCE

We Are One Family

 It was the 1970s, and Jimmy Carter was the American president. He appealed to automakers to design and build small cars to combat the economic woes that mounted as oil prices spiraled upward. While international diplomacy and domestic productivity rose to record highs under the Carter administration, so too did inflation and unemployment, and the nation struggled to maintain economic optimism.

It was during this period that Achamma Chandersekaran, a confident, self-assured graduate, with a brand-new MBA degree and a few years' experience in her pocket, started looking for a job in the Washington, D.C., area where she lived. Frustrated by the limitations the

current economy imposed on employment opportunities, she decided to express her feelings to someone high up in the nation's capital.

So she sat down and wrote a letter to President Carter, asking him to do something to stimulate the economy, because even people with her education and experience were unable to find jobs. Although it was not a request for a job, the letter was taken seriously by the White House and sent to the federal Office of Personnel Management. She was asked to send an application to the federal government and was offered a job— as simple as that.

Anyone who knows Achamma would be surprised if her letter did not persuade the White House, or anyone else for that matter, to take some action. Frank, forthright, and open in her approach to problems and people, she has an unusual vitality about her. Achamma does not think she would make a good politician because "I am too straightforward," she says. "If I see something black, I call it black. That is not a politician's way of doing things."

She might be right about politicians, and politics in general, but her interest in things political cannot be underestimated. She is astutely aware of the political process in this country, and she knows how important political involvement is for anyone, especially an immigrant.

Having come to the United States from India as an undergraduate student, Achamma staunchly believes that immigrants should assume the civic and social responsibilities that come with the rights defined by the U.S. Constitution.

"Is it the good life here that makes us take the easy way out and live as immigrants rather than take the responsibilities of a citizen for twenty, thirty, or even forty years?" she asks. "Or is it because we are not mature enough to make a choice when we are not forced to make one?"

Quoting words she heard spoken by Dinesh D'Souza,[1] Achamma argues, "'The main reason for Asian Indians in America to consider becoming citizens is that as people who reap the enormous benefits of living in this society, we should assume part of the responsibilities that make possible such liberty, prosperity, and human dignity.'

"The best thing we can do for our children is to give them the sense of being counted. Political participation is perhaps the best way for this," she asserts.

She often reminds people of some of the hard facts of American history. There was a time when American women were not allowed to speak in public, own property, attend university, vote, or be on a jury. If a woman was married, she had no existence apart from her husband, no right to sign documents, no earning power. There was a time when, if you were an African American, you could be auctioned as merchandise in the town square, your entire destiny sold and bought like a chicken by any white male who could afford it. Every American right has been fought for, every privilege earned through sacrifice.

Achamma is the first and the only woman to become the national president of the Indian American Forum for Political Education (IAFPE). She constantly appeals to all immigrants not to take our freedoms for granted but to remember that sacrifices were made by many groups to earn each and every freedom, benefit, privilege, right.

Associated with the IAFPE from its inception, Achamma remembers the first time the group went before the Senate Committee on Immigration to argue for the fourth preference for immigration—that is, the right of a U.S. immigrant to bring brothers and sisters to this country.

[1] Dinesh D'Souza is the author of several books, including *The End of Racism*, *The Virtue of Prosperity*, and *What's So Great About America*.

"That was the first time any Asian American group had gone before a Senate committee to testify," says Achamma. "Until then we did not have an organization with a political angle. So this was something unique in that sense. From that first meeting with the Senate committee, we learned the importance of meeting with our legislators. Once when IAFPE members went to meet a congressman in Michigan, he was so surprised to learn that so many Indians had been in the country for more than twenty-five years. 'Where were you all these years? How come this is the first time you are coming to see me?' he had asked. At that time the U.S. government was supplying all kinds of weapons to Pakistan, and some Indian Americans were trying to lobby against the arms deal. That was the beginning of getting involved politically."

The first political conference for Asian Indians was organized by the IAFPE at the biennial conference of the National Federation of Indian Americans (NFIA). Speakers included representatives from the Republican and Democratic parties and the White House. Achamma reminisces, "One thing they advised us was not to go with just one party. Lyn Nofziger, an aide to President Reagan, told us 'If you go with just one party, then that party will take you for granted and the other party won't care about you.' That was good advice about political activity." Achamma cherishes the memories of those first political lessons.

Achamma would energize women's groups by speaking at women's forums, where she would ask women to expand their horizons. She would urge women not to be satisfied with day-to-day domestic duties but to reach out to a bigger world, become part of the mainstream. Among her suggestions: volunteer in a local school or nursing home, coach soccer, or become politically involved by helping to organize election campaigns, raise funds for a worthy cause, or register voters.

Sometimes she would hear amazing stories from the women in the audience. One forum she paneled was attended by many immigrant women who had been in this country for years, earned a decent living, and yet had not thought about issues outside their daily lives and families. Some of them were struggling to resolve personal issues that held them back.

"My husband keeps my salary. He does not let me have a bank account of my own—he gives me the money when I need it. I don't even have a checkbook," said one woman in the audience.

"I don't drive. My husband takes me to work and back. How can I even think about doing community work?" asked another.

"My husband does not like me going out to do community work. He thinks I am neglecting my home. I think he is jealous," another woman spoke up.

The discussion seemed to invigorate the immigrant women into speaking up, telling others about their lives in America, the problems they still needed to overcome before they could consider larger roles. Achamma did not have answers to all their problems, but the forum took on a life of its own, opening the women's eyes to their situations and what they were missing. Achamma was undoubtedly a perfect role model for the women who had gathered there.

The sixth of eight children born in a rural middle-class family in Kerala, India, Achamma did not grow up in an environment of privilege and luxury. Her parents were both teachers, and at one time or another, everyone in the village was a student of either her mother or father. A small village by the Arabian Sea, Arthunkal was inhabited mostly by fishermen and their families and had a fairly large community of Catholics. As part of the Catholic community, Achamma and her brothers and sisters participated in all the village festivities as they grew up, often

providing music for the events with the encouragement of their father, who was the church choirmaster. With her father playing the violin and the children singing or playing other instruments, it was always festive around the house. They practiced, sang together, had fun.

The children were at the forefront of every community event. Whether it was a visit from the bishop, a school anniversary, or a church event like the famous festival of St. Sebastian, all were occasions for them to get involved. Christians from all over Kerala undertook the pilgrimage to the church at Arthunkal during the church's festival.

"The community involvement as a child was a great help," Achamma says. "It helped me in pushing to the forefront of larger communities and taking on larger commitments in America. I would say my mother was my role model. When no other woman worked outside the home in the village, my mother was a teacher. Because of that we— the five girls—realized that women could do more than getting married, keeping house, and having children."

When Achamma and six of her siblings were teenagers, Arthunkal did not have a high school, so the family sent the children to boarding schools. But this meant that her parents could not afford to pay for college. Achamma and her sisters decided to become elementary school teachers because getting a teaching credential did not require a college education.

As a teacher in her own village, she was able to establish a new, more adult, relationship with the villagers. By participating in organizations like Catholic Action and the Deepika Children's League, she expanded her world and extended her hand to the community. Most of the village fishing families were poor and knew nothing about saving money. When the monsoons came, as they did every year, many starved.

The director of the Catholic Action group in the parish, the late Monsignor Paul Louis, started a small savings scheme. Achamma was in charge of the money collected in her panchayat ward.[2] Earlier, the villagers had experienced losing everything to the rich who had started chitti schemes in Arthunkal.[3] The poor had paid into the chittis in return for promises of big money in times of need, but those promises proved baseless, and the villagers were naturally wary of any new scheme. Achamma taught the women the concept of saving through a passbook account. Slowly they realized that the passbook saving scheme was a different project and that they would get the money back. For the first time in their lives they held passbooks in their hands that showed how much money they had saved, which was invariably exciting to them. Some women would ask Achamma to hide their passbooks from their husbands, like hidden treasures.

Through her involvement with the Deepika Children's League, Achamma acquired the philosophy that would eventually become her guiding principle. The league's motto, "We Are One Family," gave her the inspiration to go beyond religious and national boundaries, became the ideal she strove for, and guided her later in the U.S. when she became the chairperson of the Asian American Voters Coalition, an organization serving more than eight million Asian Americans.

Her greatest achievement, in her own eyes, is that from an ordinary middle-class family in a small village in India, with only a high school education, she was able to come to the U.S. on a full scholarship. She started dreaming about America and American universities while working as a teacher in Arthunkal. Fully aware that the financial burden of

[2] A panchayat is a local governing body in a village.
[3] Chitti is a financial scheme of collecting small sums of money for several months, or years, from participants, and paying back a large designated amount to one "winner" each month.

a college education was too much for her parents and that she needed help, she began collecting information about the few American colleges that offered scholarships for an undergraduate degree. After persevering for three years, she finally received letters of acceptance from two colleges: the first offered a full scholarship, the second a partial.

She accepted the first offer she received, and in 1962 she came to the U.S. to attend Barat College in Lake Forest, Illinois. It was a manifestation of her belief that if one wishes very hard for something, it will come to pass.

In America she became a graduate in English, a postgraduate in teaching English as a second language, an MBA, and an employee of the federal government. She also got married to a bright young Ph.D. from the University of Illinois, C. S. Chandersekaran.

But Achamma had bigger dreams—much bigger than what most women dared to consider possible. She dreamed of getting a national memorial for Mahatma Gandhi erected in Washington, D.C., on public land. This would be the first national memorial in America for the man whom the world called "The Great Soul," who inspired Reverend Martin Luther King Jr. and the nonviolent methods of the civil rights movement, and who was the role model for Nelson Mandela in his fight against apartheid.

She knew it was a worthwhile dream but realized it was also an uphill struggle with bureaucratic and political hurdles. When she assumed the position of national president of the IAFPE, she publicly announced her intentions and later became the chairperson for the Coalition for a National Memorial to Mahatma Gandhi.

In 1988 a bill authorizing the IAFPE to establish the memorial was unanimously passed by the House of Representatives, only to be tossed aside by the Senate Rules Committee. Before it could reach the full

Senate, the bill fell through because of the objection of the ranking minority member, Senator Ted Stevens. Achamma caught up with the senator as he left the committee meeting to find out why he objected. He told her that both the National Capital Planning Commission (NCPC) and the National Capital Memorial Commission (NCMC) had voted against the memorial and that she should work with them to get their support before attempting to reintroduce the bill. The senator also cited opposition from the International Dalit Support Group and said he wanted to hold a hearing.[4]

With her colleagues in the coalition, Achamma first went to work convincing every member of the NCPC that the memorial was good not only for Washington, D.C., but also the country. She then contacted K. R. Narayanan, then the vice president of India, who requested B. R. Nanda, a Gandhi historian, to discount the arguments made by the International Dalit Support Group against the Mahatma. Mr. Nanda countered every one of the group's accusations, citing quotations from Gandhi's speeches with dates. Achamma produced a 100-page document for the Senate and had seen the conditions made right for the approval of the memorial when the Indian Embassy took over the project.

"Though I am happy that there is a Gandhi Memorial in Washington, D.C., I have one regret," Achamma says. "As much as the memorial was to honor Mahatma Gandhi and create better relations between the U.S. and India, it was also for the Indian American community to be recognized by the U.S. Congress as part of this society. That goal was not achieved when the embassy took over the project and

[4] *Dalit* refers to people formerly called "untouchables." Ironically, Gandhi coined the word *harijan* (meaning "children of God") in his effort to remove the stigma of "untouchability" from Indian society.

Congress authorized the people and the government of India to establish the memorial."

Ultimately, what would have been the proudest achievement for Achamma and the whole Indian American community became a political affair. Yet Achamma is, undoubtedly, the fire that propelled the political engine to this end, and the flame that sustained it.

As the national president of the IAFPE, Achamma regularly communicated with the State Department on issues that concerned the Indian American community. For instance, in 1987 she wrote letters expressing concern about Pakistan's nuclear program and the U.S. policy of helping Pakistan through economic and security assistance. In 1988 she addressed similar concerns and suggested a presidential visit to India to foster a better relationship between the two countries. In one of the responses she received from the State Department, Robert A. Peck, deputy assistant secretary for Near East and South Asian affairs, wrote, "I appreciate the continuing interest the IAFPE and you personally have taken in Indo-U.S. relations. The impetus provided by the Indian American community can be a great help in building our long-term relationship with India."

Achamma remembers that when she was nominated to be the national president of IAFPE, the first woman to be so honored, someone told her point blank, "I don't think this is a position for a woman." Looking back, she can laugh at such comments.

"Not a position for a woman," she chuckles. "At the same time, I had done things most of the men who followed me didn't do. I established chapters very systematically, and those chapters are the lifeblood of the organization today. I visited every chapter and, as one chapter chairman put it, 'breathed life into the organization.'"

Achamma hopes that her experiences, her success in the face of prejudice, will help the next generation of young immigrant women make even greater achievements. She says, "In doing what we are capable of, we let them know that this can be done. This is one of the contributions I would think I have made."

Achamma approaches all situations with openness and a disarming candor. Once at a meeting, she and a few other women were discussing a seminar they had planned. While talking about how difficult it would be to draw men to seminars organized by women—with the assumption that they would only debate "women's issues"—Achamma asked, "How can they (the men) stay away? After all, most of our problems are because of them." It was a statement without malice or prejudice, but it contained the vibrancy of a simple truth.

This direct, honest attitude probably helped her in her effort to bring together diverse groups of Chinese, Indian, Korean, Filipino, and Vietnamese Americans under one umbrella organization called the Asian American Voters Coalition. From 1993 to 1995 she chaired the coalition—a tough job, she admits, because of the vastly different languages, customs, philosophies, foods, dress, and so forth that render defining the label *Asian American* impossible. She tried to enhance voter registration among the various groups by meeting with them in temples, churches, and mosques. Voting is important, she would tell them, voting is a right that cannot be taken for granted.

"As immigrants our role in American society is the same as that of other groups of women who came here before us . . . ," Achamma once told an immigrant group. "We benefit from the hard-won rights of the Civil Rights Act in the workplace, and we are protected from discrimination based on national origin. . . . Nothing was given to them. They had to fight for every benefit, and we now reap the rewards."

She reminds all immigrants about the importance of giving "our time, our effort, our ideas and our support to better this society as all the other groups have done before us.

"To increase our stature in the society, we need to give of ourselves. . . . We have not paid our dues, and we must if we are to play a significant role. We cannot live like guests in this society. We need to take ownership of where we live and start taking out the trash." The words of her speech were, and still are, powerful and electrifying.

"First of all, step out of the confines of our own community and introduce ourselves," Achamma advises immigrants. "Make the next party a potluck luncheon at home. Make sure your guests are of your own level in education, profession, and economics so that you feel comfortable with each other. They should be made to feel comfortable in your house so that they can ask questions about the pictures on the wall, your job, your last vacation, or whatever. Try to find common grounds, rather than differences.

"Others have to get to know you to realize that you have qualities that make you a good human being and a good addition to this society. The society doesn't care how many Mercedes Benzes you have or how expensive your home is or what Ivy League schools your children attend. We need to demonstrate a willingness to contribute our time to causes beyond those of special interest to us."

The people listening to Achamma's speech must have found it difficult not to get enthusiastic about community involvement. "Get involved. Coach soccer or softball, register voters, join a county commission, teach children, work for the homeless." There is no lack of ideas, if one wants to volunteer for the community, she insists.

After a twenty-two-year career with the U.S. government, Achamma has now retired. Her last job at the Office of Service Industry

in the Department of Commerce was to market American education in foreign countries through catalog shows, trade shows, and American education expositions. She worked with colleges and universities in the U.S. to recruit foreign students. As English has become the language of international trade, she encountered enthusiastic support from countries all over the world to get English teachers from the U.S. to teach their children the valuable skill of conversing in English.

Now living with her husband as a new retiree, and her only son at MIT studying biology, she is already planning other projects—projects that will spread the idea of harmony among ethnic groups. No project is too big for her, as long as it involves people of all creed and color, all ethnic groups and beliefs. As she encounters each new person, one thought comes to her mind: "We Are One Family."

$$\S\S\S\S$$

Unity Is Strength, and Diversity Is Beauty

Firmly holding the conviction that political activism is essential for an immigrant community, Anasuya Prasad, also known as Anna, is an activist willing to stand up for her beliefs.

"Just being Mr. or Mrs. Nice Guy who is there to socialize or get pictures taken with politicians is not going to take the community far," asserts Anna. "But there is nothing wrong with socializing and picture

taking as long as it is combined with a political purpose. Legislators should be informed that they are going to be watched closely on future voting records. Democracy only ensures people of an opportunity, whereas getting involved in the political process ensures the desired outcome to its people.

"First, we should educate legislators constantly by writing them letters. Each letter is considered to carry the opinion of twenty to thirty people. It is important to write a letter every time there is something of concern or interest.

"Second, an activist should maintain grassroots contact. As a political activist one should keep in touch with other members of the community in their constituencies. A group of at least twenty members in each constituency should be formed, and they should send letters on issues of concern to their local congressperson.

"And last, one should be involved in political action. No political process is complete until and unless one gets involved in campaign committees and fund-raisers and supports the candidates who run for the issues one is interested in. It is essential to ask questions of the candidate for whom the funds are raised. Ask the candidate's views and prior voting records on major amendments, and let the candidate know you are knowledgeable and aware."

Anna is a long-time Republican activist.

"Republican values are conservative values, about family and education," says Anna. "I think people who leave their country and family and travel thousands of miles, give up many things, and get established in a new country, must be doing it for freedom, better economic opportunities, and a better education for their children.

"I strongly believe that every immigrant is a Republican at heart. Whether the Republican Party reaches out to them to convey this message

or not is yet to be seen. But the fact remains that Republican values are dear to every immigrant. The Republican Party believes in personal responsibility, which I strongly believe in, too. It is a myth that under the Democratic Party the ethnic communities will do better.

"It may be true that many Republicans are rich. Maybe for some, wealth was passed on from their parents or grandparents. But most are successful today because of the responsibility they have taken for themselves. May be the values their parents instilled in them were helpful. But they decided what they wanted for themselves, and they worked hard to get it. I admire the discipline of the Republicans."

As a delegate from Southern California attending the 2000 Republican National Convention in Philadelphia, Anna was full of hope for candidate George W. Bush. And she was in her element, surrounded by people engaged in discussions, analysis, and dialogues.

Anna loves discussions, debates, talks, lectures, and speeches. She relishes occasions where people get together and deliberate on issues serious enough to be debated; she enjoys getting involved in hot issues of national interest and international prominence; she delights in being in the middle of political conventions.

After immigrating to the United States in 1979, Anna moved in a small circle of old friends she had known in India and new friends she made in the U.S. Soon she became the president of an Indian cultural association. Such associations cater to the cultural needs of Indians by bringing together people who come from a certain region of India, speak the same language, and cultivate a regional microculture of their own. New immigrants can meet at these associations to indulge in a collective nostalgia for the land they left behind and reminisce about their families, festivities, and common ancestry. They encourage children to learn

classical and folk dances, speak the language of their parents, and generally be proud of their Indian culture.

By becoming the president of an Indian cultural organization, Anna moved to a position of visibility in the whole Indian community.

"When I became the president of the Karnataka Association," Anna recalls, "it opened my eyes to a whole new world of Indian people, which was exciting for me. I met a number of people from different parts of India, people who had lived here a long time, people who were deeply involved with the community. That changed my life completely. With a new community feeling, I really wanted to be more involved and make a difference. I like to do things for the community. In India I met people with the same background as mine. Here, while meeting people of diverse backgrounds, I could go back to my roots and rediscover and redefine the term *Indian*."

Eventually, Anna became active in a wider community of Indians in America—the Federation of Indo-American Associations (FIA).

"The FIA was a fantastic concept for Indian Americans," says Anna, "because when you first come to another country, you want to meet with people who have some commonality. We have Kerala, Karnataka, Bengali, Punjabi, and many other regional organizations."

Americans living abroad might behave similarly, forming a California Association, a Texas Association, or a New York Association, each group celebrating its native culture while remaining aware of a common American heritage. Unlike such American groups, however, not all Indian associations speak the same language.

"India is more than the sum of its parts," explains Anna. "So the need arose for an organization that would go beyond the regional associations and generate a broader perspective. Let us say we had a hundred different organizations. If you have to have a national Indian

event, which organization would do it? When that question came up about twenty-five years ago, it was agreed that there has to be one umbrella organization to represent all the organizations in celebrating national events like India's Republic Day, Independence Day or in honoring a national hero from India. That was how the FIA was formed."

Anna Prasad became the president of the FIA in Southern California in 1998, its first woman president.

"Unity is strength, and diversity is beauty," says Anna. "Indians are so diverse in their ways of thinking, areas of strength, the festivals they celebrate, the languages they speak, and the religions they practice. Yet they are so similar when it comes to caring for people, family attachments, and tolerance for people of other religions and culture.

"For the first time in my life I started thinking of the word *Indian.* Who is an Indian? And since I cannot speak to someone in Indian—there is no such language—unless I know English I cannot even talk with most other Indians. To me that was a fascinating idea, and I started learning more about Indians through experiences of working with them. I learned about the Gujaratis' business acumen, the intellect of the South Indians, the Punjabis' adventurous spirit, and the Bengalis' cultural sensitivity."

The FIA brought together myriad Indian associations, but still there was no national voice addressing the political concerns of Indian Americans. Thus was formed the National Federation of Indian American Associations (NFIA).

"What does the National Federation do?" Anna explains. "When the FIA started its activities in many different states, and as Indian Americans became more visible, it was imperative for the community to explore the political front. Furthering Indo-U.S. relations became a passion for many Indian Americans. Now we were established Indians, and we wanted to have the ability to influence the White House and the

legislature on issues. The NFIA provided a platform to address issues and to network among Indian Americans throughout the country.

"Conceptually, the NFIA is the best grassroots organization—the primary political voice to address issues of concern to the diverse, vibrant, and successful Indian American community, and to play a major role in Indo-U.S. relations."

Anna is happy more and more people from the Indian community are getting involved in the political arena. However, sacrifices will have to be made before any major goal is achieved, before a community member is sent to the U.S. legislative body. Anna warns that when it comes to grassroots work, there is no glamour, only sacrifice.

"In a democratic setup, when you are serving the community, you have to learn to live with different points of view," says Anna. "The other person's view is a different point of view, not necessarily the opposing point of view. When it is a different point of view, they no longer want to support what you are doing. This kind of understanding would come only from experience.

"Either their point of view is going to win, or my point of view is going to win. Then you realize that you have to mobilize enough support for your point of view. When you have enough support for your point of view, if you have enough people seeing you are right, you have earned a leadership role. In a democracy you rarely have 100 percent support, opposition being almost a certainty. But your success depends on how close you come to getting 100 percent support."

Another important part of political action for Anna is lobbying for a cause and educating legislators about an issue that she is passionate about. In her early years Anna's major concern was ensuring that congressional representatives knew enough about India and Indian issues to be in a position to provide help. When one congressman asked her why

India should be concerned about the U.S. supplying arms to Pakistan, he obviously did not know the two countries are adjoining. Even today many legislators may not know that India is the largest democracy in the world.

"We still have a lot of work to do to educate the public about India," asserts Anna. "It is easier to start with legislators. At the national level we need to communicate with the Senate, the House of Representatives, and the White House. There was a time when they thought we were lobbying for India.

"Today we have come to a stage when they know it is important not only for India but also for America that the two countries remain allies. Now they understand that we lobbied for democratic values. I am speaking not only as somebody of Indian origin but also as an American when I say it is good for America to have India as an ally, because in the long run people with democratic affiliations should come together. That is the only way we can achieve global peace."

Lobbying for Indian American ties has been a long process of talking, questioning, understanding, educating, and reevaluating. This is the work of Indian Americans in general, the work of not just one organization but many organizations and the Indian American community at large. Anna believes there are probably a hundred different groups throughout the country that met with their legislators, invited them to local events, and educated them on India and related issues.

Then there is the Indo-American Council, a political awareness organization Anna founded in Los Angeles for the sole purpose of educating lawmakers about India.

"Out of the 450 or so members of Congress, we were able to work with about one-third," Anna points out. "That was done all over the country. Although a lot of money came from a few wealthy people, the education came from everywhere.

"Today Congressman Ed Royce is the Republican cochair of the India Caucus, which plays a very powerful role in U.S. legislation on Indian issues. When we met him about ten years ago, he didn't know much about India. We cannot expect every legislator to know about every place in the world. India was not very important to the United States.

"We thought we should meet the congressman and educate him about what India is, what Indian Americans are, why it is important for the U.S. to have India as an ally. Today he knows it is important for U.S. interests as well, not just for India. So what we were saying about India made a lot of sense to him. He was convinced of India's democratic values, and he said he would be the voice for Indian issues in the Congress.

"Once he agreed to speak on Indian issues, he talked with legislators about his position on the India Caucus. It was a lengthy and gradual process. Similar processes were happening around the country with different legislators."

Politics was not something Anna grew up with in India, but a strong sense of community was. She was raised in a middle-class family in Bangalore, with three brothers and one sister. And she had many friends in her neighborhood. She grew up among some strong women.

"I always look back and see my mother, with the little education she had, as a strong woman," says Anna. "She is a very intelligent woman. I think, it is the discipline and the toughness she had that makes her a survivor. In our immediate neighborhood, even our friends' mothers played a significant role in bringing up the children. So it was very fortunate for us that we saw the strength in our mothers. They have influenced us in shaping our lives and deciding how far we can go. Even some uneducated mothers with their five, six, or seven children in those days took charge of the whole family, never complained, and made sure

everybody had an education and had enough to eat. For a middle-class family to raise that many children was not easy. Even now it amazes me as I look back, how much inner strength they needed to do that."

Anna's mother and a few women friends started a school, which the women ran entirely on their own. Anna remembers her mother actively raising funds to start the school, which became her personal fulfillment. The school is still in operation today, run by women, nationally recognized and competent. It has elementary, middle, and high school divisions. Anna's sister is the principal of one of the divisions.

Anna was teaching math at the Mount Carmel College in Bangalore University when she got married and moved to Calcutta. In 1979 she and her husband, Guru Prasad, decided to leave for the United States. Here she enrolled at the New Jersey Institute of Technology for her master's degree in computer science.

But a nine-to-five job was not her dream. Her outgoing personality balked at the thought of sitting at a computer desk all day. She wanted to be with people. She was accidentally introduced to some people working in real estate, and after talking with them she felt she had found the perfect job. Getting her real estate license turned out to be to be easy for her sharp mind. Her math and computer science background also helped her in dealing with real estate issues.

"I did very well in real estate," Anna confirms. "I got my broker's license, although I never opened my own office. It was good for me, and it gave me a lot of free time to pursue other interests."

Her enthusiastic approach helped her receive real estate's top Hall of Fame Award three years in a row.

"The biggest asset I have now that I didn't have when I started is the ability not to look in a critical way at anybody's actions or speech but to give them the benefit of the doubt. Then I try to understand them. I

don't say that people are against me but that they are doing what is right for them or whomever they represent. I think this helps me put things in perspective and handle things better. Community service is the most humbling experience you can have.

"People are people, they do what they want do, and you cannot change them. If we ever think we can change people, we are totally wrong. But we can help them evolve in a certain way and guide them. I can look back at a couple of people I have met in my life who have helped me evolve, find my inner strength and passion to work for issues I care about. They have made me a free and creative thinker, and my actions have made me a better person.

"Improving Indo-U.S. relations is such a big issue. How are you going to do it? But you don't think of Indo-U.S. relations when you sit down with a congressperson and talk. You are talking only to that person, one on one, about what you know, trying to convey your message. I always take one day at a time. So I don't look at the whole and feel overwhelmed. I visualize a long-term goal, and I break it down into steps. Then I follow those steps one by one. Besides, when I am doing my work, other people are working somewhere else. It is not my job to do alone. So when I look at it that way, when I personalize it, have fun with it, be sincere about it, and put my best to it, it is done. The overall picture is there, the vision is there, but every time I cannot let it intimidate me. If I do the small things, the big things will take care of themselves."

Believing in such practical philosophy, Anna does not find any undertaking too hard.

"You have to listen to the last 'stupid' idea," she argues. "Then you have to try to convince everybody and come up with a consensus in a democratic way. That takes a lot out of you, and it doesn't come right away. It comes out of experience."

Being a candidate for a political office is not in the forefront of her thoughts, at least for the time being.

"Running for an office is not the ultimate goal of political activism," she insists. "But before I decide to run, I have to pay the dues—carry out the grassroots work by doing community service. One has to create a platform and mobilize support. But in the end of it all, I have to convince myself that I will be able to win. Another way you can reach a goal is to have somebody else run and stay in the background and support that person.

"We always believe, in India, that truth will eventually win," says Anna.[5] "That is what we were taught from day one. The United States has gone around the world to realize that in the twenty-first century, it is only India, the world's largest democracy, we can rely on. If we want America to continue to be the leading country in the new millennium, we have to choose the right partners for that. I think we are on the right path for it, and it makes me happy that I had some role to play in it."

<div align="center">§§§§</div>

From My Perspective

The focus of the early immigrants was making a livelihood and protecting their cultural identity, both of which required enormous effort. Author

[5] "Satyam eva jayate" ("Truth alone triumphs") is India's national motto, displayed on its currency and national emblem.

Kartar Dhillon, in her story about an immigrant family who made their home on the West Coast, writes:[6]

> My parents had five sons and three daughters, and it was the daughters who worried our mother the most. Whatever we did that was different from the proper behavior of young girls in her village in India signified danger. And because most things here were different, I was in constant trouble.

Bringing up their daughters and sons to respect their heritage was a continual struggle for many South Asian immigrants, especially in the early times, because they numbered so few. Perhaps the only worry they had stronger than maintaining their cultural identity was making enough money for a decent living.

As more South Asians began to make their homes across the U.S., these two concerns seemed to solidify in their daily toil, influencing their every act. Participating in the economic opportunities the country offered continued to be a strong desire for them, although equally tugging at their heartstrings was the hope that their children would uphold the parents' cultural values. Conflicts arose regarding the shift in matrimonial alliances, with the traditional arranged marriage giving way to the modern self-arranged "love marriage." Another area of conflict was children's individuality and freedom. Parents' whole philosophy of life transformed right before their eyes when the pressure to recognize their offspring as individuals rather than as forever their children gained momentum during the children's teen years. Many immigrants learned to live with the daunting fear that their children, while reaching higher and higher for

[6] Dhillon, "The Parrot's Beak," in *Making Waves: An Anthology of Writings by and about Asian American Women*, edited by Asian Women United of California (Boston: Beacon Press, 1989), 215.

academic and economic attainments, would disobey them or dishonor them by going against their own cultural heritage.

As economics and culture dominated their thinking, it was hard to be enthusiastic about looking beyond the domestic fence to the larger landscape of political involvement, although there was a strong need to become politically active. It was important to educate the lawmakers of the country about faraway places so they would remember names like India and Pakistan and they would not ignore the needs of the small population of South Asian Americans.

There has to be lobbying for the causes minority groups hold dear, whether those issues revolve around immigration or the relationship between two countries. Educating the public about who they are as a group, and about their contributions to this country and the world at large, is also important to immigrants.

Author Helen Zia writes:[7]

> It's not easy for Asian Americans to make themselves visible and politically relevant when they are still considered peripheral to white-and-black society. In Washington State, as in California, Asian Americans have surpassed African Americans in population. But a surprising number of people still view Asian Americans as aliens.

As a relatively new group of immigrants, South Asians have a long way to go in terms of gaining visibility in the political arena. According to the 2000 U.S. census, the Indian American population is about 1.7 million, which according to analysis by the India Abroad Center for Political Awareness (IACPA) is roughly equal to the population of the

[7] Zia, *Asian American Dreams: The Emergence of An American People* (New York: Farrar, Straus and Giroux, 2000), 290.

State of Nebraska.[8] Nebraska has three congressional representatives, whereas Indian Americans have none. The IACPA also indicates that since the Indian American population is currently about 0.6 percent of the U.S. population, this community should be represented by at least forty-five state legislators nationwide instead of the present two.

It becomes a monumental task for South Asians to introduce themselves and raise awareness among the various sections of American society. It takes vision and dedication to accomplish the task, not to mention the constant communication channels that must stay open between citizens and their representatives. It takes tremendous energy to overcome the frustrations, and to push through the narrow horizons of our daily lives.

The two women in this chapter, Achamma and Anna, have taken the initiative to go beyond the domestic fence and introduce themselves and their communities, and by doing so they have changed the landscape of South Asian political activism.

[8] http://www.iacfpa.org.

Chapter 7

NURTURING THE SPIRIT

Spirituality Is About the Highest Universal Good

In one of the busiest streets of Chicago, lined with hundreds of stores, restaurants, supermarkets, offices, and sidewalks filled with shoppers, there is a place where one can walk in and forget the busy crowds outside, the clamor and the noise, the dust and the traffic. In this sanctuary one is surrounded by a soothing aura, a feeling of serenity and quietness of mind.

The storefront on Devon Avenue gives a hint of the story of this sanctuary, with pictures of a goddess in the window and a sign with the words *Gayatri Mandir* ("Temple of Gayatri"). Just beyond the sparsely furnished front room, one is immediately captured by the exuberant

colors, the brightness, the fragrance, the chanting, and the presence of men and women seated on the floor. This is a temple—a Hindu temple dedicated to the worship of the goddess Gayatri. At the far end of the room is an altar with a large picture of the goddess, and on either side of her picture are photos of the founders of the Gayatri Mission in India, Pandit Shree Ram Sharma Acharya and his wife, Mata Bhagvati Devi Sharma. The pictures are decorated with garlands and flanked by lamps and incense on either end of the altar. The whole area is embellished with colorful cloth and other beautiful objects.

Men and women are seated cross-legged on the carpeted floor. Although most of the devotees are Hindus wearing Indian-style clothes, it is not unusual to find non-Indian men and women sitting in rapt attention, chanting.

In the center of the carpet is an object that looks like a square box but is actually a two-foot-square frame holding the enclosed space of a holy yagna. A yagna is a ceremonial group ritual done for self-development and to bring unity, cohesiveness, and moral inspiration to society. It is an ancient form of worship that involves offering fragrant herbs, ghee, rice, and other sacred material to a sacrificial fire burning in the enclosed center of the frame, which is called the yagna center. The chanting of all the participants accompanies the offering.

Each person sitting around the yagna center chants the sacred Gayatri mantra and drops a few grains of colored rice or other materials into the fire. The leader of the process is a woman, a priestess, wearing a saffron-colored sari, sitting to the side and holding a microphone before her. She initiates the chanting while giving keen attention to the whole process—the chanting, the placing of the rice in the fire, and the repetition of the mantra by the others. She is aware of everything that is happening in the temple but never misses a word of the mantra. She

switches from Hindi to English as she explains some the meanings of the ritual. She is Kusum Patel, the founder of the temple.

Everybody is welcome to join the chant. At the end of the yagna, one of her assistants gets up and lights a special lamp. Kusum moves the lamp up and down in a circular movement before the dais. Everyone present gets a chance to hold the lamp, called an aarti, before the pictures of the deities, as the priestess recites the mantra over and over again. Then food, an offering to the goddess, is served on paper plates to all the devotees.

The ritual, which is personal and collective at the same time, has been around for more than five thousand years. The temple, founded in 1989, is part of an organization called Gayatri Parivar Yugnirman, and Kusum is its priestess, organizer, and chief administrator. From her one-room office inside the temple building, Kusum runs the organization, creates newsletters in three different languages, sends out flyers about an upcoming public yagna in a Chicago neighborhood, and speaks to newspaper reporters about her work. She seems to have the energy of a dozen teenagers, working continuously, from the office, from her van, and even from home late into the night.

"From time to time I get inspiration and guidance from my guru as to what to do next and how to carry out my responsibility," Kusum explains. He inspired her to start two newsletters: *Yug Dhrushta Atma Vani* (*Voice of the Guru*) and *Nari Yug* (*Era of the Woman*). The two publications, which she started ten and five years ago, respectively, are still published regularly in Gujarati and Hindi. In 2000 she started publishing a newsletter in English called *The Learning Torch.*

"If we learn to think rightly, we will be free of all the ills and evils of the present-day world. We will get rid of undue violence, hate crimes,

all kinds of abuses, clashes, conflicts, and even cutthroat competitions," Kusum said at the ceremony launching *The Learning Torch*.

When she conducts a public yagna in a neighborhood of Chicago, with long rows of yagna centers around which the participants congregate, thousands of people from all walks of life gather to perform the ancient ritual, and microphones boom with the chanting of the Gayatri mantra. Kusum travels to other parts of the country to perform the ritual in people's homes and at community gatherings.

Her life revolves around the temple of Gayatri. The mention of the temple energizes her like nothing else does, and she knows no boredom, no fatigue.

When Kusum Patel came to the United States in 1978 to join her husband, she was a young wife from the state of Gujarat, India. The mother of a six-month-old son, she immersed herself in the busy life of a dedicated homemaker in her adopted country. After a few months in the U.S., Kusum, a chemistry graduate, started working in a food-manufacturing company as a laboratory technician. She plunged into the American life as a workingwoman, wearing dress suits and cutting her hair in professional style.

But she felt an uneasiness deep inside, a despair she could not erase, a dissatisfaction she could not explain. Although she traveled to India often to visit family and regularly attended temples near Chicago, she could not dispel her strong craving for some deeper fulfillment.

"I was not totally unhappy or anything," Kusum recalls, "because I was with my husband. I was not really lacking anything. I was performing all my routine duties, but something was still missing."

During this period her older sister, Shanta, sent her a magazine from India called *Yug Sakti Gayatri*. Kusum's curiosity was awakened by what she read about spirituality. Then she started receiving more literature

from other people about happenings in the distant Himalayas, in the holy places called Hardwar and Mathura.

She learned about a mission started by Pandit Shree Ram Sharma Acharya, the founder of a new movement in Mathura based on ancient knowledge from the *Vedas*, the oldest scriptures in the world. He believed that all the problems of the world were caused by "perverted thinking" and could be solved by a global thought revolution. Through his new movement he sought to revolutionize the human thought process and expand human awareness.

Acharya started the movement in 1936. One of his methods to combat perverted thinking was to popularize an ancient Vedic ritual known as Jnana Yagna ("Light of Knowledge"). *Jnana*, which in Sanskrit means knowledge or wisdom, is symbolized by a lighted lamp. Just as a lamp makes itself and all objects visible and knowable by removing darkness, knowledge makes itself and the world known by expelling ignorance. To symbolize the light of knowledge, Acharya created the Torch of Learning, known as the Gyan Mashal, which he lit at the site of the movement—a place called the Gayatri Tapobhoomi ("Sacred Earth of Gayatri").

In 1989 Kusum felt drawn to the mission of Gayatri and guru Acharya. She decided to listen to her inner voice to be part of the mission even more. Giving up her $50,000-a-year job with a major pharmaceutical company, she chose to dedicate all her time and energy to setting up a temple in her neighborhood.

"I kept getting these messages from my guru," she says. "I wanted to establish a temple, but there was no money. I had to get $25,000 for the down payment on a building. I asked my husband for $5,000, and then I approached my friends. Finally, I made the money and

got this building in Devon Avenue. In the beginning there were only 500 devotees, and now there are 10,000."

Students from Chicago's schools visit her temple on Devon Avenue to learn about Hinduism. The temple's intimate atmosphere allows them to get a closer look at the various rituals. And the sight of a woman as the priest can be refreshingly novel and inviting. Newspapers like the *Chicago Tribune* have paid visits to the unique temple in their neighborhood and have interviewed the priestess.

Kusum lives in a suburb of Chicago with her husband and two children. At home Kusum is a housewife and mother, cooking for the family, cleaning, taking out the trash, shopping for groceries, and hosting out-of-town visitors. She is comfortable in using her computer, which she carries back and forth between her home and the temple. She finds time to cook for the temple, where she offers homemade food for the devotees after the worship and rituals are over. Her husband, Chimanbhai Patel, works for the Federal Reserve Bank in Chicago. Her son, Devanshu, a graduate in political science, worked for President Clinton as a legislative officer for eighteen months. Mother is pleased to show the picture of him shaking hands with President Clinton. Kusum's daughter, Nidhi, a high school student, accompanies her mother to the temple rituals and discussions, sitting next to her. She learned the Gayatri mantra by heart when she was very young.

Kusum travels to India every year to visit the Gayatri Tapobhoomi, where her guru, Acharya, first established his mission. In her future trips she is planning to take groups of young American college students so they will get a chance to see the roots of the ritual.

Kusum, respectfully referred to as Vandaniya Bhagini ("Revered Sister") received the Torch of Learning from the current guru, Pandit Leelapat Sharma, at the Gayatri Tapobhoomi in 1998. In accepting this

symbol of the movement, she has undertaken the responsibility of spreading the guru's message in the United States and other countries in the world. Kusum keeps the torch, a long staff with a flame-shaped tip, at the temple as a reminder and symbol of this awesome commitment.

"I know pretty well that the task entrusted to me is huge for my tiny shoulders and hence I solicit your help and support. I am quite sure you will never hesitate to lend me your gracious hand," writes Kusum in *The Learning Torch*, addressing the devotees and well-wishers.

In July 1995 Kususm was the convener of a large-scale Ashwamedha Yagna, attended by about 24,000 people at Soldiers Park in Chicago. It was perhaps the first time a woman had organized an event of this nature in the world. In India, traditionally, large yagna rituals were always organized my men.

The gyan yagna ritual, performed frequently, is done to the accompaniment of the Gayatri mantra, believed to be the holiest of mantras. Acharya wrote more than three thousand books on the principles and practices of his movement and the significance of the Gayatri mantra.

Known as the universal prayer, the Gayatri mantra is believed to possess infinite potential and enormous power. The words from the *Vedas* are as follows:

> Om
> Bhur Bhuva Svaha
> Tat Savitur Varenyam
> Bhargo Devasya Dheemahi
> Dhiyo Yo Naha Prachodayat

This roughly translates into "May the omnipresent God that pervades each and every particle everywhere, that bright, exquisite, divine power, enlighten our intellect and lead us on the righteous path."

Goddess Gayatri is believed to be the Divine Mother and the force that illuminates and animates all life. Chanting of the mantra at different times in a day is supposed to remove the illusion caused by ignorance, strengthen intuition, and bring righteous wisdom. The mantra is the foundation of a three-fold worship consisting of praise, meditation, and invocation. The philosophy of Gayatri says that the ritual of yagna is an essential part of the worship. Yagna is a celebration that aims at the highest universal good. The Sanskrit word *yagna* has three meanings: *divinity*, meaning refined personality; *organization*, referring to cooperation; and *charity*, implying generosity, embracing the whole universe as one's family. Thus the essence of a yagna is universal peace and happiness.

Kusum's faith in the power of the yagna and the mantra must be profound because she was able to bring people of many faiths and religions together when her community faced a crisis brought on by racial violence.

In the summer of 1999, several areas in Chicago were shocked by a shooting rampage, perpetrated by a man named Benjamin Smith. A massive citywide effort began to bring peace and solace to the community. In one of the interreligious, interracial conferences held in the Chicago area, Kusum Patel represented Hindus and mobilized Hindu members of the community to join the effort. She chanted the Gayatri mantra at the gathering that focused on comforting the families affected by the killings and the whole community. She undertook the commitment to bring the neighbors together and to affirm the shared responsibility of fostering the religious and cultural diversity of Chicago's neighborhoods. By showing courage and faith in her mission, she was able to counter the racism of one man who killed four people.

Kusum also organized a Divine Conference of World Religions in 1999, drawing people from Hindu, Catholic, Muslim, Sikh, Protestant, and

Jewish faiths to celebrate their shared values, such as tolerance, cooperation, responsibility, and a vision for peace. In 2000 she similarly brought the Hindu community together and addressed their shared concerns with other religious communities in Rogers Park on the north side of Chicago.

Kusum received the Millennium Leader for Religious Harmony Award in 2000 from the president of the Federation of Indian American Associations (FIA), Sohan Joshi. That same year the Interfaith Alliance Foundation honored her with the Walter Cronkite Faith and Freedom Award for her courageous actions. The award, says the foundation's brochure, "encourages people of faith and goodwill to stand up for religious freedom and to demonstrate the healing and constructive force of religion in American life. The award recognizes individuals whose courageous actions have embodied the values of civility, tolerance, diversity, and cooperation in the advancement of public dialogue and public policy on traditionally controversial and divisive issues."

The Interfaith Alliance Foundation further states that the foundation "builds bridges across diverse faith communities by bringing people together for honest and respectful dialogue about the direction of our communities and our nation. We celebrate our diversity as a source of national strength." The award selection committee included such eminent men and women as President Gerald Ford, Bill Moyers, Cokie Roberts, and Elie Wiesel. Kusum received the award from the esteemed television journalist Walter Cronkite

Says Kusum, "I believe God sent me here, to the U.S., for a special purpose, to teach the divine culture of India here. So the question is not whether I want to go back. But if God wants to send me back to India, or anywhere else in the world, there may be a reason for it."

§§§§

Build a Future Village of Optimism

boona cheema likes her name written in lowercase letters.

"I used to be an arrogant kind of person," boona recalls, "because I could make things happen, because I am blessed with so many skills. But instead of being humbled by them, as a youth and young woman I was fairly arrogant about them. But about ten or twelve years ago, I started using lowercase letters for my name because this is such humbling work. I thought, this is one small thing I can do to say that I have grown, that I have learned, that I have changed, that I really, truly feel blessed and humbled by the opportunity."

boona is the executive director of Building Opportunities for Self-Sufficiency, also known as BOSS, a large nonprofit organization in northern California dedicated to meeting the needs of homeless and otherwise disadvantaged people. Today BOSS provides shelter beds, transitional housing, and subsidized housing. It gives people job training and helps them find employment. In addition to working with the homeless, BOSS helps youth, the mentally ill, people with substance abuse problems, and those with HIV.

"To me," says boona, "a real honor and a continuous inspiration is that the possibilities in a human being are unrealized only because the right support and resources are not there. With the right support, guidance, and mentoring, people facing extreme barriers can rise above them like the phoenix. This organization is committed to hiring people

that have gone through our program, so 60 percent of my staff have personal experience of poverty, drug addiction, mental disability, and domestic violence, and they are doing such great work."

boona knows what it is to rise from poverty and desolation. She has experienced it all—political turmoil, war, devastation, poverty, homelessness, fear, divorce, single parenthood.

boona was born in Peshawar in a middle-class Sikh family in 1945, two years before India gained independence from the British and the adjoining country of Pakistan was created as an Islamic nation. Millions of people who were not Muslims, fearing execution, fled to India across the Pakistani border. Two-year-old boona became a refugee when her family, being of the Sikh faith, decided to leave their home in search of safety.

Her family was forced to establish a new home and new roots in a new country. It was boona's first experience of homelessness and, she recalls, the beginning of a new kind of learning.

"We ended up living in a huge household. At times, there were over thirty people. Although I was very young, I was able to see how decisions were made collectively, how to work democratically, and how to use participatory methodology to get the family's work done, the community's work done, and the nation's work done. And I was very inspired, I would have to say, by all of my family members who went to India as refugees. Their strength and courage and the resettlement process had a great influence on me."

Although boona was trained to be a journalist, earning a master's degree from Punjab University, women were hard pressed to find good jobs as journalists in the late 1960s. Because she was interested in politics, she decided to go to South Vietnam in the middle of the Vietnam War. In 1969 boona left India to work with refugee children in war-torn South

Vietnam, once again experiencing what it feels like to lose one's home. She lived among refugees, napalm-burned children, and families torn apart by the war.

"I was feeling very drawn to that area," she reminisces, "and to understanding how a nation like the United States could be involved in that level of genocide in a Southeast Asian country. I worked a year-and-a-half there with a group that was sending children severely burned by napalm from South Vietnam to San Francisco General Hospital. Eventually, the children came back to us, and we had to resettle them with their families or wherever we could find. Most of the time, by the time the kids came back after being treated, their villages had disappeared."

In South Vietnam she met her husband, an American who had been doing community work there for seven years.

"We went to India and had a big Sikh wedding, which was wonderful," boona recalls. "Then we went back to Vietnam to continue our work, and we got kicked out. Actually, when we came we were hoping to work in Vietnam for another ten years. We had to leave during the war because of our antiwar politics—attacking the U.S. government, attacking the South Vietnamese government, being out on the streets, and being part of the Buddhist peace movement in South Vietnam. Those were all the reasons they didn't want people like us anymore. So we went back to India and stayed with family for a while; but there were no opportunities in the late sixties, early seventies. There were not a lot of opportunities for women who were progressive, liberated. So it made sense to come to the U.S., my husband's country."

They moved to the United States in 1971, when boona was pregnant with their son. Her husband entered at the University of California, Berkeley, for pre-med studies.

"It was very interesting to come to Berkeley at that time," boona says. "It was an extremely politicized city, and I fit right in. I got involved in local activity from early on. We were in the middle of the counterculture movement—actually the tail end of it. I found people who, I thought, were better informed, more involved in all the issues—racism, antiwar, civil rights—than I had in any other place. Of course, now I know if I had stayed in India I would have probably ended up doing something like this anyway. But it seemed so overwhelming—trying to find a way to use my passion and compassion and skills and politicization in India. Berkeley was absolutely the right place for me."

However, life in those years was a struggle. Jobless and pregnant, boona came very close to homelessness.

"My husband was a student, and I had no job. We found ourselves barely able to afford a place to live. I was pregnant at the time, and I had no idea where I was going to deliver the baby—in India I could have gone to any hospital, but it was not so in the United States, where one could do nothing without adequate medical insurance. So I was making enquiries about which hospital to go to and all that. I was in need of housing and medical assistance. I was desperate."

One day she came upon a place called the Berkeley Streetwork Project on Telegraph Avenue, where she saw an intriguing sign that said, "If you need help, we can help you today. If you need a miracle, it will take a week."

She walked in and received all the help she needed. The Berkeley Streetwork Project was started in 1971 to provide basic services, including temporary shelter, to the mentally ill released from hospitals. But the project also tried to meet the continuous needs of Vietnam veterans as well as people who were mentally disabled, homeless, or unemployed.

boona and her husband divorced five years after they settled in Berkeley. boona became a welfare mom. But she accepted different jobs, including cooking for the people at the Streetwork Project, to support herself and her son. She wanted to be self-sufficient and independent.

She attended college, received a master's degree in divinity, wanting to become an urban minister with the Unitarian Universalist Church. "I thought that the base the spiritual school would give me and the study of world religions would provide the grounding for this work," she says.

The committed staff and volunteers of the Berkeley Streetwork Project were able to provide essential services to the needy at a much lower cost than could the city. Realizing this, the city of Berkeley blessed the project with a grant. Changing its name to Berkeley Support Services, the agency was able to expand the services it offered poor people with disabilities and special needs.

Eventually, boona moved up from cook to counselor, and within eight years she was the agency's executive director. With the understanding gained from her own experience, she brought a new awareness and a renewed sense of dedication to the cause of homelessness. But running the organization was a brand new challenge for her.

"I could not believe it when it happened," boona reflects. "I didn't know what to do, even though I rose through this organization from cook to counselor to coordinator of the shelter. But when I became the executive director, I felt this great sense of responsibility that I was being given something to grow and nurture into a real asset to the community. I think that is when I became a woman—you know how, in a woman's life, she grows from child to girl to young woman. I think that was a real awakening to womanhood—a full awakening to being a

woman, being responsible and accountable to my community and aware that the responsibility I have been given needs to be taken seriously. That was a real turning point."

In the 1980s the word *homeless* became an accepted part of the American vocabulary as more and more laid-off industrial workers turned to homeless shelters. Many became unable to afford their own homes. Scarcity of affordable housing came to be known as a larger issue causing homelessness than many other social problems like alcoholism and drug use.

boona faced a tough challenge of securing enough funding for meeting the increased demand and maintaining the existing services. It was important to create new programs for the growing number of people seeking aid. In 1986 the agency expanded its services to the city of Oakland and changed its name to Berkeley Oakland Support Services (BOSS). Additional services were added to include self-help programs, new shelters, and transitional housing for the mentally ill.

After further expansion in 1988 to include the city of Hayward, the organization decided to change its name again. Incorporating a clever wordplay, the name became Building Opportunities for Self-Sufficiency, thus retaining the old acronym. BOSS became bigger, sturdier and a recognizable name, and with a budget of $7 million and a staff of 200, it was a national success story.

As the boss of BOSS, boona is known for her participatory and collaborative approach to planning and decision making.

"I am a different kind of executive director," boona says. "For me it is about really understanding that there is accountability to the people who are my bosses, the board of directors, of course. Then there is accountability to all the people who give us money. But there is a higher accountability—to the people we provide the services for. And so I make

my decisions not always based on what might be financially good for the organization; first, they have to be the right things, the best things to do for the people who need us and need our services.

"I would say that what I do best is stay close to our clients, listening to them, and also hiring as many of them as possible. I also like to take ideas from different cultures, ages, and languages, from both staff and clients, because we are very multicultural. And people who come for service also engage in a dialogue for social justice and social change. I am different from mainstream executive directors who are usually extremely removed from the people they serve."

One of the many honors she has received is the 1988 Woman of the Year award from the National Women's Political Caucus of Alameda North, "for her resourceful and committed service to people without homes, in need of care and help." In 1992 she was honored again by being elected chair of the California Homeless and Housing Coalition, a statewide network of local organizations addressing the issues of housing and homelessness.

boona is also involved internationally through her work with OXFAM America,[1], the Seva Foundation,[2] and Food First.[3]

"My father was the agricultural commissioner for India at one time," she recalls. "While he taught me political analysis, my mother allowed me to be who I am, and really gave me the courage to be a woman—a strong woman that had an agenda. She was a great guide. My

[1] Oxfam America is an international development organization dedicated to creating lasting solutions to hunger, poverty, and social injustice around the world (http://www.oxfamamerica.org/about/art1281.html).

[2] Seva is a small, nonprofit, nongovernmental foundation based in Berkeley, California (http://www.seva.org/index.html?events.html).

[3] The Institute for Food and Development Policy, better known as Food First, was founded in 1975 by Frances Moore Lappé and Joseph Collins, following the international success of Lappé's book *Diet For a Small Planet* (http://www.foodfirst.org/who/).

mother, who still lives in India, was always involved in doing work for the villagers.

She is thankful that her parents were very supportive of their children's education and allowed them the freedom to express themselves. They taught her that, as a woman, she was just as capable, if not more so, than any man because women bring spirit and compassion to the world. "They were real feminists," says boona. "They may not have known, but they were."

Her father's death in 1987 was a major change in her life. "He was very engaged in the farmers' movement and making changes in the agricultural policy and all those things," she relates. "He was my teacher and guide when he was alive, and when he died I felt that now I had to carry on his work continuously. That is why I stayed involved in international development issues, women's issues, and food security."

Besides her own mother, several female freedom fighters from India have had tremendous influence on boona. She especially admired Vijayalakhsmi Pandit—Jawaharlal Nehru' sister—who was India's freedom fighter and an ambassador to the United States and other countries. She became the first woman president of the United Nations General Assembly in 1953. Indira Gandhi was another inspiring leader boona looked up to.

"I really think I come from a tradition where women have played a significant role in building the nation," boona says, "That is not true for most of the nations that have become independent. Indian women were willing to go to jails, and they were willing to sacrifice their lives for the movement. I believe that movement is continuing all over the world, because the movement is in terms of liberation, independence, and autonomy. I would say I have been inspired more by Indian women than

by anyone I can think of in this country because they stood shoulder to shoulder with men to win India's independence."

The person who has influenced her the most, however, is the Dalai Lama, whom she met when she was very young.

"He has influenced me a great deal," boona says. "The whole essence of nonviolence, compassion, service, and prayer have all been very much a part of my life. So I read a lot of materials that come out of the spirituality movement because I think if we are not spiritually whole, then we can't do this work—I mean I have been doing this work for over thirty years, and if my spirit were not centered in it, I would have suffered classic burnout."

boona has been asked questions like "How can you work with street people?" "How can you touch someone who might have lice?" and "How do you find the energy to go on doing this kind of work day after day." Full of humility, her answer to each question is the same: "I don't have a choice. I just feel that it is part of my spirituality, part of my purpose; it is part of being in this world at this time with so many great needs, and this is my real calling."

Taking her cue from the Gandhian approach of fasting for a cause, boona called for the Fast for Survival in May 1991, asking people to give up a day's meals and donate the money they would have spent to a fund to be divided among community service groups. She herself fasted from sunrise to sunset for three weeks.

Today, sitting at the helm of the largest nonprofit agency to help the homeless in northern California, and having created a model for other communities to emulate, boona looks to the future with enthusiasm and optimism. She is thinking of creating a small village in Berkeley that has some deep principles of unity and respect, where people at different

stages in their lives, in emergency situations and transition situations, can live, learn, and work together as a community.

"This work is spiritual work, any way you look at it," boona says. "Because the spirit moves us, we end up doing service—it is seva, as taught to us in the *Guru Granth Sahib*, the Sikh holy book."

<div align="center">§§§</div>

From My Perspective

My grandmother used to tell me the story of an insightful young boy who insisted that God lived in everyone, in everything, even inside a pillar and a rust particle. This boy was the son of a king who, in contrast with his son, was arrogant enough to demand that his subjects worship him as the ultimate source of power. There was no god mightier than the king himself, he proclaimed. So the boy had to disobey his father, because in his prayers only the all-pervading God was present, not his own father. One day the infuriated king demanded that his son prove his God's presence in the pillar. Saying so, the king broke open the pillar, God jumped out in the form of a lion-man, and He destroyed the king.

For my grandmother the story made the point the boy was trying to make to his father—that God did exist in every bit of substance and vacuum in the universe. I believed her, and so did my cousins, who would sit with me on the floor in grandmother's house listening to her stories. We learned to worship the tree and the plant, the cow and the serpent, the sky and the earth, the water and the air. We also learned to revere those around us. Lessons in spirituality were, in fact, lessons in living, although we did not consciously think in those terms.

Spirituality was very much a part of our daily living. There was no need to search for it, to contemplate it, because it was everywhere, and we were deluged by it. Life was engulfed in spirituality. Our day-to-day living was full of rituals that seemed to carry us to a dimension beyond the humdrum routines. It was as if we could reach beyond the daily cares by stretching our minds to that extra dimension where we would stand side by side with the powers of the universe. The spiritual world was not unattainable to us, we didn't have to wait till the end of our lifetime to touch the edges of divinity. Nor was it accessible only to the learned and the wise.

As children we used to recite a Sanskrit verse before getting up in the morning, allowing us to recognize the presence of the earth as the Divine Mother who sustained us all:

> Oh, the one who wears the oceans as her dress
> And carries the mountains on her bosom
> My salutations to you, Goddess Earth!
> Please forgive me as I step on your body sacred.

The mornings began with this whispered prayer to the Goddess Earth, who would be there to support us every day of our lives and without whose benevolence we would not be able to live. Getting up in the morning with this prayer was one of the first rituals we were taught as children. We would reach down and touch the earth in salutation before we stepped down from our beds. The rituals were such that they became a part of our lives effortlessly and gradually transformed into habit.

Every activity seemed to be a sacred ritual rather than a chore, even boiling milk. I remember sitting by the side of the clay stove, my flowery dress bunched together between my knees. Right in front of me was a roaring raw fire. The cemented floor was cold, and its hardness pushed against my naked ankles. The milk pot sat on the wood-burning

stove, set on the kitchen floor. I was learning the first lessons of cooking, a skill I had to acquire before I could engage in more elaborate domestic dreams.

There was a lot to learn about milk boiling—it always boiled over if I didn't keep stirring, and with the open fire, I had to know how and when to remove the pot. If the milk spilled over, wetting the firewood with white froth, the kitchen aroma would quickly become sharp and choking. Then I would have to reach over to gather a handful of cold water to sprinkle on the turbulent milk waves, allowing them to withdraw timidly, noiselessly. I couldn't let my attention wander to the surging orange flame that licked the sides of the bronze pot black, or to the smoke that swirled up in a slow, intertwining dance toward the barred window above. But in the end my mother removed the pot anyway, because she was afraid I would burn myself either from the fire or from the milk bubbles.

When the milk boiled I would offer a few drops of it to the fire god. I had learned about the sacredness of fire, one of the five elements of nature that I was taught to honor every day. The other four elements are earth, water, air, and sky. I learned the spiritual connotations of everyday events, even milk boiling, because life's essence, I was told, is spiritual.

I learned to respect food, honor its place, and appreciate its power. As children we were initiated to solid foods through an elaborate ritual. We participated in another ceremony before we began formal learning. Such an environment fostered in us a rugged sense of the spiritual nature of life, and it gave us some tools to help us balance the materialistic urges that would engulf us later in life.

My American life, on the other hand, gave me a startling awareness of an entirely different kind of life—a life seeped in

materialism. One South Asian woman I met told me her attitudes changed dramatically after she started living in the U.S.

"When I first came here, I heard little kids saying, 'Oh, I wish I had a million dollars,'" she said. "I was shocked because I had never heard people say things like that where I came from; they seemed satisfied with whatever they had. I remember thinking, if I had a million dollars, I would not know what to do with that. And I really meant it. But now, after living here a few years, I see myself thinking, 'Oh, I wish I had a million dollars.' And my children are getting so much into materialism that I think they have forgotten the simple pleasures of life."

I heard a similar sentiment from another South Asian woman.

"American materialism changes all your morals and values," she said, "like a big octopus holding you so tightly it is difficult to come out of it. Consumer reports say that about 46 percent of Americans do not pay their credit cards, or pay only the minimum. If you cannot afford it, why do you buy things, or go on vacations? The system makes you greedy even if you are not to begin with."

To me, materialism is not the desire to make a decent living. Nor is it the aspiration to live in a nice home or drive a comfortable car. It is the pervasiveness of the thought of money, it is the constant focus on the paycheck, the acquisitions, the ranking of billionaires. It is the ever-expanding "wish-list" mentality. It's almost impossible to ignore the "call of the sales" in the U.S.A., sometimes referred to as the United States of Advertising, where consumers have nightmares about not being able to enter a department store on the day of the big sale. Where consumerism runs the country, and shopping is the number two pastime after television. Where tempting invitations to buy goods lurk behind every highway twist and turn. Where not shopping becomes a sin before major and minor holidays. Where the market dictates the cultural rituals—

flowers for Mother's Day, drilling tools for Father's Day, chocolates for Valentine's Day. Where we learn philosophy through ready-made greeting cards and we long for the love printed on the faces of Valentine cards. Where our thinking gets transformed into a form of mass hypnosis and we forget we have the freedom to think differently. Where even spirituality gets disguised into another commodity that has to be advertised and sold.

Here I find myself thinking of spirituality often, making a conscious effort to do what should be as natural as breathing.

The stories in this chapter are of women who have rediscovered a deep sense of spirituality. They live their lives happily, simply, in the midst of all the blinding materialistic glare. I find their stories empowering; if they can do it, perhaps there is hope for me.

Chapter 8

CONCLUSION

In this book I attempt to capture the essence of being an immigrant woman—a woman who comes from ancient civilizations to the dazzling newness of America, torn between the dichotomy of tradition and progress to emerge extraordinary—strong and vital, contributing to the well-being of society and the world beyond. Little has been written to acknowledge and honor such women for who they have become and what they have achieved. Almost every book in the market about Asian or South Asian immigrant (meaning first-generation) women focuses on the sorrows of alienation and exclusion from the society. They mourn the immigrant woman's isolation and her struggles for integration and acceptance. But it is equally important to validate her contributions, because as Prema Mathai-Davis said, immigrants revitalize this country.

Another reason I began interviewing these exceptional South Asian immigrant women and writing their stories was to know them as fellow first-generation South Asian Americans. My own contributions are

nothing more than humble. But I share with them the same 5000-year-old cultural background and ethnicity. We have all left behind our venerable traditions that still remain alive and vibrant. In a sense, their story is also my story. Nothing empowers like a flattering self-reflection.

America needs to know the multiethnic texture of its population, not from a sweeping stereotypical sketch depicting a general characteristic, like hair color or eye shape. We need to demystify our neighbors even when they wear different styles of clothing, speak unfamiliar languages, or sing uncommon music. In a recent television show the host humorously asked a few men and women about their cultural/ethnic/sexual/religious identity. They answered "Jewish," "Black," and so on. When he reached a woman with brown skin, she replied, "Indian." The man's immediate question was "Gandhi or Sitting Bull?" She answered, "Gandhi." Even though in this particular show such a scene could be viewed as funny, this type of information bit is too often all we seek to understand a fellow American. We feel satisfied knowing that so-and-so is a "Gandhi," which brings other stereotypical images to our minds, like curry or loincloths. One man dressed in a turban becomes any man in a turban, and one woman in a sari becomes any woman in a sari. We forget the complexity of the individual and her ethnic makeup. We neglect to ask about the hundred varieties of dance her ancestors used to perform or the twenty-nine languages her people spoke.

From an American point of view, the women in this book may all come under the same cultural umbrella—the South Asian umbrella. But in reality they are not a homogenous group, and the differences are not superficial. The complexity of the region's culture can be appreciated if one stops to think for a minute. The twenty-one South Asian women I have included in this book share among themselves six different religious identities—Christian, Hindu, Islam, Sikh, Buddhist, and Zoroastrian.

Their belief systems are as varied as the languages they grew up with speaking, reading, and writing. Among them they have learned and practiced at least fourteen major languages—Punjabi, Bengali, Urdu, Gujarati, Hindi, Marathi, Konkani, Parsee, Telugu, Kannada, Tamil, Malayalam, Sinhala, and of course, English. Each language comes with a rich history and supports its own literature and regional culture.

What they inherited is not a simple, flat, single-threaded South Asian culture but an abundant, bewildering composite of many ancient languages, stories, traditions, rituals, mythologies, folklores, music, art, and philosophies. The numerous foreign invasions and the influx of colonialism add a rather modern aberration to their background. Perhaps it is this complexity and the depth of their indigenous culture that make their transition to the more amalgamated American arena even harder.

On the other hand, the soil they grew up on has become enormously fertile, evolving through thousands of years, giving them a certain innate wisdom, which they articulated to me simply, without a trace of arrogance. For instance, Lata Shah told me about a routine practice she had noticed growing up—breast-feeding. She decided to breast-feed her babies despite the disapproval of her U.S. doctors. She followed her instincts and, recalling the experience, she commented, "Now the doctors here know of the benefits of breast-feeding babies. We had known it all along."

Safia Rizvi was reaching back to an age-old female insight when she talked about the profound transformation that happened to her when she became a mother and felt responsible for raising her baby. "I stopped being a girl and became a woman," she said. "I became a responsible, anchored, confident woman. Until then I relied on my parents and depended on them. But after I became a mother, I made some conscious

choices, and I had to keep them in the forefront." For her, there was no looking back. She was ready to face the future.

I heard other women, too, speak about "awakening into womanhood" when they found themselves responsible for the well-being of their families or communities.

When Lubna Jahangiri said, "I do things that may not be very rational but that feel right, and I follow my instinct, which is usually correct. That makes me a very happy and satisfied person," she was of course confirming the importance of "woman's intuition." It is remarkable that, in this country where everything—success or strength or courage, for instance—is measured from a masculine logic, we have a successful immigrant woman who proclaims the power of her instinct.

Other women told me how listening to their intuitive voice, rather than what someone else said, helped them make the right career decision. Because of this self-assurance, these women do not think of their professions as either masculine or feminine, appropriate or inappropriate, despite being in a country with a long history of labeling every activity into distinct masculine and feminine categories. Neither do they feel the need to compete against men or prove their worth. With an amazing level of self-acceptance, these women seem to have a keen awareness of who they are combined with a joyous realization of everything they can be—balanced, without a struggle.

They were not hesitant about requesting help from others whenever necessary, nor in fact, acknowledging the help, inspiration, and strength they received from friends, family, and even strangers. As Anna Prasad put it, one has to listen to the last "stupid" idea. But more than a practical philosophy, it is also traditional wisdom to share, to create bonding, and to collaborate. I heard words of humility from them, stressing that without the support of many people—husbands, children,

other family members, friends—they would not have been able to achieve what they have. It is as if their ideas of success do not clash with their notions of cooperation and dependence—perhaps a better term would be "inter-dependence."

Ginny NiCarthy, a well-known American author and activist who wrote some of the first books on domestic violence issues, made the following comment after reading the first chapter of this book:

> In both my personal and political life, I have been, I suppose, on the extreme edge of typical American individualism, focused on civil rights and civil liberties, as well as my own right to independence. Yet even way back in college, I was intrigued by the question of whether freedom or security is more important. And once again, in our American political life, those questions are at the core of foreign and domestic policy (insofar as it is not about the simpler matters of greed and power and chicanery). When I view the issues through an American lens, they seem not so terribly complex. But turning to a South Asian (or American Indian or Latin) prism, the complexities and paradoxes and tensions of freedom/security are writ large.

Recently, America has been engaged in a few wars. Amazing as it might seem, it took two or three wars for some of us to know where Afghanistan and Iraq and Kuwait are. We are gradually beginning to understand these countries, their people, and the cultures they cherish. But there are easier, less expensive, less damaging ways to understand other countries and their people. I believe one fascinating way is to learn the life stories of first-generation immigrants. After all, America is their land. It is my hope that the stories in this book provide an opportunity to learn from these women's lives and their meanings, the mixing and mingling of cultures, the evolving nature of human interaction, art forms,

and relationships, and the powerful intermarriage between traditions and modern myths.

It is also my hope that this book offers new immigrant women guideposts, images that evoke pride and optimism, so they too can create dreams. For a life lived holds better promises and a brighter beacon than any story imagined.

BIBLIOGRAPHY

Avis, Joan, and Evans, Susan. *The Women Who Broke All the Rules.* Naprville, Ill.: Source Books, 1999.

Asian Women United of California, ed. *Making Waves: An Anthology of Writings by and about Asian American Women.* Boston: Beacon Press, 1989.

Chow, Claire S. *Leaving Deep Waters: The Lives of Asian American Women at the Crossroads of Two Cultures.* Dutton and The Penguin Group, 1998.

Flinders, Carol. *At the Root of This Longing: Reconciling a Spiritual Hunger and a Feminist Thirst.* New York: HarperCollins, 1998.

Friedan, Betty. *It Changed My Life: Writings on the Women's Movement.* Cambridge, Mass.: Harvard University Press, 1998.

Haeri, Shahla. *No Shame for the Sun: Lives of Professional Pakistani Women.* Syracuse, New York: Syracuse University Press, 2002.

Nana-Ama Danquah, Meri, ed. *Becoming American: Personal Essays by First Generation Immigrant Women.* New York: Hyperion, 2000.

Reid-Merritt, Patricia. *Sister Power: How Phenomenal Black Women Are Rising to the Top.* New York: John Wiley & Sons, 1996.

Rustomji-Kerns, Roshni, ed. *Living in America: Poetry and Fiction by South Asian American Writers*. Boulder, Colo.: Westview Press, 1995.

Sochen, June. *Herstory: A Woman's View of American History*. New York: Alfred, 1974.

Takai, Ronald. *Strangers from a Different Shore: A History of Asian Americans*. Boston: Little, Brown and Company, 1989.

Ward, Geoffrey C. *Not for Ourselves Alone: The Story of Elizabeth Cady Stanton and Susan B. Anthony*. New York: Knopf, 1999.

Women of South Asian Descent Collective, ed. *Our Feet Walk the Sky: Women of the South Asian Diaspora*. San Francisco: Aunt Lute Books, 1993.

Zia, Helen. *Asian American Dreams: The Emergence of An American People*. New York: Farrar, Straus and Giroux, 2000.

INDEX

Order your copies of

Spices in the Melting Pot

from

http://www.orangetreepublishing.com

Printed in the United States
88232LV00003B/106/A